paint

paint

illustrated techniques
for every medium

Edited by Amy Jeynes

NORTH LIGHT BOOKS
CINCINNATI, OHIO
www.artistsnetwork.com

Other fine North Light Books are available from your local bookstore, art supply store or direct from the publisher.

11 10 09 08 07 5 4 3 2 1

DISTRIBUTED IN CANADA BY FRASER DIRECT
100 Armstrong Avenue
Georgetown, ON, Canada L7G 5S4
Tel: (905) 877-4411

DISTRIBUTED IN THE U.K. AND EUROPE BY DAVID & CHARLES
Brunel House, Newton Abbot, Devon, TQ12 4PU, England
Tel: (+44) 1626 323200, Fax: (+44) 1626 323319
Email: postmaster@davidandcharles.co.uk

DISTRIBUTED IN AUSTRALIA BY CAPRICORN LINK
P.O. Box 704, S. Windsor NSW, 2756 Australia
Tel: (02) 4577-3555

Library of Congress Cataloging in Publication Data
Paint : illustrated techniques for every medium / edited by Amy Jeynes.
 p. cm.
 Includes bibliographical references and index.
 ISBN-13: 978-1-58180-870-4 (pbk. : alk. paper)
 ISBN-10: 1-58180-870-4 (pbk. : alk. paper)
 1. Painting--Technique. I. Jeynes, Amy.
ND1471.P35 2007
751.4--dc22
 2006029211

Designed by Guy Kelly
Production coordinated by Matt Wagner
Editorial intern: Amanda Wheeler

F+W PUBLICATIONS, INC.

The material in this compilation appeared in the following previously published North Light books (the initial page numbers refer to pages in the original work; page numbers in parentheses refer to pages in this book).

Adams, Norma Auer. Pelican demonstration appeared in Artist's Photo Reference: Boats and Nautical Scenes © 2003 Gary Greene. Page 127 (221).

Baird, Cecile. Painting Light with Colored Pencil © 2005. Pages 8 (69), 53 (187), 57 (183), 81 (191).

Deutschman, Mary. No Experience Required: Water-Soluble Oils © 2005. Pages 51 (60), 53 (176), 61 (179), 63 (37, 193).

Greer, Hugh. Acrylic Landscape Painting Techniques © 2002. Pages 19 (36), 67 (205), 71 (207), 76 (39), 77 (209), 79 (211), 81 (213), 85 (217), 122 (39).

Kemp, Linda. Watercolor Painting Outside the Lines © 2003. Pages 75 (197), 77 (133), 110 (201).

Kincaid, Elizabeth. Paint Watercolors that Dance with Light © 2004. Pages 14 (82), 25 (77), 36 (106), 37–40 (95–98), 43 (97), 59 (143), 71 (47), 74–75 (48–49), 77 (53), 78 (22), 87–88 (54–55).

Nelson, Craig. 60 Minutes to Better Painting © 2002. Pages 29–30 (100–101), 58 (37), 65 (203), 90–91 (58–59), 96 (62), 98 (63).

Roycraft, Roland. Fill Your Watercolors with Nature's Light © 2001. Pages 14–17 (70–71), 20 (73), 29 (135), 59 (79), 101 (141), 141 (139).

Toogood, James. Incredible Light and Texture in Watercolor © 2004. Pages 25 (92), 27 (90), 33 (93), 63 (131), 76 (142), 123 (94).

Weber, Mark Christopher. Brushwork Essentials © 2002. Pages 29 (39, 163), 30 (40), 32 (162), 51 (155), 54 (157), 57 (158), 59 (159), 61 (161), 87 (167), 93 (165), 102–103 (152–153).

Acknowledgments

Thanks to the top-notch painters whose work appears in this book: Norma Auer Adams, Cecile Baird, Mary Deutschman, Hugh Greer, Linda Kemp, Elizabeth Kincaid, Craig Nelson, Roland Roycraft, James Toogood and Mark Christopher Weber.

Thanks also to Greg Albert, who expertly demonstrated myriad painting techniques for the photographs in chapter four.

Dedications

To my dad, Ross Bachelder, who embraces life and art to the fullest.
—Amy Jeynes

To the memory of my wife, Mary Beth, who will always be my guiding spirit, and to our children, Greg and Elizabeth, who give meaning to my art.
—Greg Albert

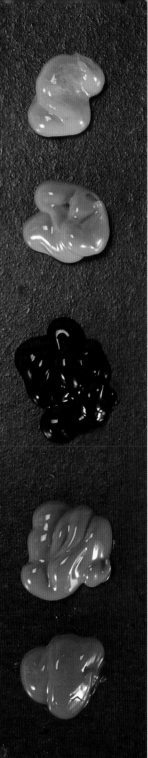

contents

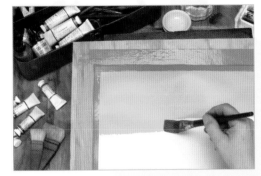

materials

setting up your workspace

Plan a room where you can set up your studio; it's much easier than dragging out all of your materials each time you want to paint. If you don't have an entire room to devote to painting, take part of a room and create a separation with a room divider. However you do it, make a space and call it yours.

A U-shaped workstation is efficient. Create one with a main worktable and two smaller tables on either side of your chair. A wheeled chair puts your work surfaces within easy reach.

Good lighting will make it easier to judge color. Light from a north-facing window is ideal because north light is the most consistent in brightness during the course of the

day and the least apt to have strong color casts. Supplement the natural light in your studio with fixtures containing full-spectrum incandescent light bulbs. Full-spectrum bulbs simulate the color of natural light and let you view colors accurately.

Ventilation is important also. Some art materials give off fumes that can affect you. Open the windows and use fans, and do the most troublesome tasks, such as spraying fixative, outdoors.

Round out your setup with a collection of taborets and bookshelves for reference books. Don't forget to use your walls, also: Frame your art and hang it for decoration, inspiration and motivation.

paper

**colored pencil on a
medium-tooth paper**

**colored pencil on
Dura-Lar Matte
polyester film**

1 Single color applied
to front of sheet
2 Second color applied
to back of sheet
3 Same color applied
to front and back

Different kinds of paper and board accept colored pencil in different ways. If you know how the different surfaces behave, you'll be able to pick the one that will work best for you.

Paper's roughness is referred to as its "tooth". The more tooth a paper has, the more colored-pencil pigment it can hold. Cotton rag paper with medium tooth, such as Stonehenge by Rising, holds lots of color yet still allows you to fill in the texture to create a smooth look. If you want a heavier weight, look for Strathmore Museum Board and 500 Series Bristol Board (regular surface). Try a variety of brands until you find your favorites.

Make sure your paper is acid free. Using only the best archival surfaces helps ensure longevity for the art you work so hard to create.

support the paper with a board
Tape lightweight paper to a waterproof backing board so that it doesn't bend. Taping your paper to a separate board rather than to your drawing table gives you more flexibility. You can turn your drawing easily and can put it away when you're not working.

other useful paper products
In addition to traditional papers and boards, you can also use colored pencils on tracing paper, graphite transfer paper and even clear acetate. Try doing your initial drawing on tracing paper, then transferring the drawing to your final paper. This saves wear and tear on your "good" paper.

characteristics

Colored pencils suitable for the fine artist fall into three basic categories:

WAX-BASED PENCILS use wax as the binder for the pigment.

OIL-BASED PENCILS use oil as a binder and can be used together with wax-based pencils.

WATER-SOLUBLE PENCILS use water-soluble gum for a binder. You can use them dry or in combination with water to create a watercolor-like effect.

All colored pencils are semitransparent, allowing for the layering of colors with each layer showing through the one on top. But each brand of pencils has its own properties and color palette. The smooth, rich look of

burnishing (page 113) requires thick layers of color made by the softer pencils. Detail work, on the other hand, is easier when you use thinner, harder leads. Below is a short list of what's out there. Visit your local art supplier and experiment for yourself.

some colored pencil brands

OIL-BASED, SOFT
Smooth-textured, with rich color
• Faber-Castell Polychromos
• Lyra Rembrandt Polycolor

WAX-BASED, SOFT
Used for burnishing. Wax bloom, a whitish haze, is commonly seen but easy to remedy with fixative (page 15)
• Derwent Signature
• Sanford Prismacolor
• Sanford Prismacolor Art Stix
• Van Gogh

WAX-BASED, HARD
Ideal for detail work
• Sanford Prismacolor Verithin

WATER-SOLUBLE, WOOD-CASED
Can be used dry or combined with water for watercolor-like effects
• Daler-Rowney Artists Watercolor Pencils
• Derwent Watercolour Pencils
• Sanford Prismacolor Watercolor Pencils

WATER-SOLUBLE, WOODLESS
Good for broad strokes and large areas
• Derwent Aquatone Watercolour Pencils
• Faber-Castell Albrecht Dürer Watercolor Pencils

accessories

In addition to the pencils themselves, there are a few other items that you'll need to take full advantage of your colored pencils.

keep your erasers clean

Clean erasers frequently to avoid smearing unwanted color on your work. If rubbing the eraser on scrap paper doesn't do the job, try rubbing it against fine sandpaper.

erasers
Vinyl, Pink Pearl and gum erasers are all useful. For erasing in tight spaces, trim a hard eraser with an art knife or rub it on sandpaper. Kneaded erasers can be shaped to erase in small areas.

electric erasers and erasing shields
Electric erasers are a must for cleaning up edges and removing color from large areas quickly. Small battery-powered erasers give you terrific control for going into tight places. Use an erasing shield with your power eraser to create a very precise edge.

pencil storage
Keep a wooden carousel beside your drawing table. A pencil case that rolls up is perfect for traveling.

electric pencil sharpener
Compared to handheld sharpeners, electric sharpeners save time and cause fewer broken leads. Prolong the life of your sharpener by cleaning it often with a brush and solvent. Cordless sharpeners are handy to take to workshops.

adjustable drawing surface

Save your back by using a drawing board that adjusts from flat to vertical.

colorless blender

A colorless blender is basically a pencil with no pigment. It allows you to burnish or blend layers of color together without changing the hue (page 112). Both wax-based and oil-based blenders can be used with all pencil brands.

color lifters

Tape, mounting putty and kneaded erasers can all be used to lift color from a drawing. Masking tape works well for large areas. Test any tape on a scrap piece of your drawing paper to make sure the paper will not tear.

desk brush

Brush your work often to remove the dust that colored pencils create. A brush is preferable to using your hand (which will cause smudges) or blowing on your paper (which may send drops of saliva onto your work).

solvent

Solvent dissolves the wax or oil that binds the colored pencil pigment so that color can spread and blend. Apply solvent to your painting with a brush or cotton swab (page 113). Always use adequate ventilation with solvents.

fixative

Fixative will come in handy not only to preserve your colored pencil paintings, but also to eliminate the whitish haze called wax bloom.

ruler and triangle

Don't hesitate to use a ruler for drawing straight lines. A triangle used in conjunction with a ruler can help you make perfectly vertical, horizontal, parallel or perpendicular lines.

paper

Great watercolor paintings require quality paper. Use 100 percent cotton rag paper. Paper made from machine-milled wood pulp will only lead to disappointing results.

stretching paper, step by step

An illustrated guide to stretching watercolor paper appears on pages 122–123.

paper weight

Paper buckles when wet. The heavier the paper, the better it will resist buckling. Look for 300-lb. (640gsm), 200-lb. (425gsm) or 140-lb. (300gsm) papers. Lighter, 90-lb. (190gsm) paper is acceptable for tests.

paper finish

Most watercolor paper comes in three finishes: hot-pressed, cold-pressed and rough. Hot-pressed is the smoothest, rough is the roughest, and cold-pressed falls between the other two. A stroke of paint looks very different on each of these surfaces; which one you pick is up to you depending on the look you want to achieve. Sampler packages of paper are an inexpensive way to try different paper finishes.

stretching watercolor paper

Most weights of paper benefit from stretching to prevent buckling, especially if you plan to paint lots of wet washes. The process of stretching paper is explained step by step on pages 122–123.

paints and palettes

paint

Look for artist-quality watercolor paint in tubes. Buy large tubes so that you'll be more willing to paint freely. It's difficult to paint in a loose or bold manner when you're stingy with paint.

palette

You can use almost any shallow white tray or dish as a palette. Small white ceramic dishes give you separate areas to mix different pigments. A larger white butcher's tray or a ceramic platter is excellent for general mixing. Commercial palettes of all kinds are available, too.

watercolor paints: what to have

A good basic palette of watercolors would include a warm and cool version of each primary color, plus a few browns and a gray. Color names vary from one manufacturer to another, but here is a sample list:
Cadmium Yellow Lemon
Cadmium Yellow Light
Cadmium Red
Alizarin Crimson
Cerulean Blue
Ultramarine
Raw Sienna
Burnt Sienna
Payne's Gray

not all paints are created equal

Many manufacturers sell two different grades of paint: a "student" grade that is less expensive, and an "artist quality" or "professional" grade that costs more.

It may be tempting to economize by using student-grade paint, but resist that temptation. You'll get better results with artist-quality pigments. Artist-quality paints contain a higher proportion of pigment to binder for rich color. Artist-grade paint is also more likely to be lightfast, meaning your artwork will fade less over time.

Good watercolor brushes give you freedom and control to express yourself in your painting. Brushes can be pricey, so before you part with your money it's worth your time and effort to learn something about their various characteristics and capabilities.

fiber types

Brushes are made with natural fibers, synthetic fibers or a mixture of the two.

NATURAL FIBER BRUSHES are excellent for watercolor because the natural hairs have lots of little quills on them that create more surface area and aid in the absorption of liquid. Most watercolor painters consider brushes made from kolinsky sable to be the finest. Kolinsky brushes are typically handmade and therefore quite expensive.

SYNTHETIC BRUSHES have manmade fibers. Synthetic brushes do not come to a point as well as natural fiber brushes. They also hold less liquid than natural brushes do, because the synthetic fibers are smooth. But synthetic brushes have excellent spring and are very durable.

NATURAL/SYNTHETIC BLENDS are a good compromise in price and offer some of the benefits of both fiber types. Several companies make these brushes, which typically have a golden color to their hairs.

brush shape

The most common shapes for watercolor brushes are flat and round. Both kinds can be made from either natural or synthetic fibers.

ROUND BRUSHES are made from several materials, including kolinsky sable, red sable (a lesser grade than kolinsky), squirrel hair, synthetic hair and a combination of natural and synthetic hairs. Each type has its strengths, so experiment to find the ones that best meet your needs. A good round kolinsky sable is the best tool you can use for fine detail work. Kolinsky sable is highly absorbent, comes to a beautiful point, has exceptional spring and will readily release paint to paper.

Round brushes range in size from the ultra-small size 000 to as large as size 38 (which is so large you might need two hands to pick it up). For general purposes, use a no. 3 round or

larger. The smaller brushes do not hold enough liquid; you will have to re-load your brush too often, or, worse yet, you may run out of paint right in the middle of a stroke.

FLAT BRUSHES may be made of kolinsky sable, sable blends, synthetics, squirrel, even badger and ox hair. Flat brushes can be soft and fuzzy or have sharply cut edges. Among other things, they are extremely useful for doing broad washes. Many watercolorists use flats almost exclusively.

Flat brushes range in size from about ¼ inch (6mm) to about 3 inches (76mm), sometimes wider. The wide ones are excellent for wetting the paper or for painting washes over large areas. The smaller ones are useful for painting rectilinear shapes and can be used in a calligraphic manner to paint a stroke that varies in width.

Besides round and flat brushes, there are several specialized brush shapes that you may find useful for certain effects or subjects:

FAN: The spread-out bristles of a fan brush are good for painting textures such as grasses. A soft fan brush is great for softening edges.

FILBERT: The filbert brush is like a flat except that its tip is oval. It's excellent for painting curved shapes or for cutting around them.

LINER: Basically a very small round brush, a liner is used to paint fine lines. This brush is sometimes called a *rigger* because of its suitability for painting ships' rigging in nautical scenes.

SCRUBBER: A scrubber is like a flat or a filbert, but it has shorter, stiffer bristles. It's used for "scrubbing" or lifting color from an area that's been painted.

supply list: brushes

For starters:
- No. 3 kolinsky sable round
- No. 6 kolinsky sable or natural/synthetic blend round
- No. 10 natural/synthetic blend round
- 1-inch (25mm) synthetic flat
- 2-inch (51mm) badger hair flat
- 4-inch (10cm) bristle flat

As you progress, you might like to add:
- No. 4 sable liner for fine strokes
- Additional sizes of flats and rounds
- Nos. 8 and 12 filbert brushes for cutting around shapes
- A Chinese hake (pronounced hah-KAY) for wetting your paper or for washes over large areas
- Various sizes of scrubbers for lifting out paint

testing new brushes

Most good art supply stores will let you test a brush before purchasing. Wet the brush, then snap or flick it. If the hairs flop over (below, left), the brush does not have sufficient spring. Next, lay the bristles on the back of your hand and twirl the handle. A good brush will have a nice point and hold its shape (below, right).

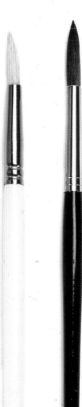

which brush should i use?

Generally speaking, artists use flat brushes for washes and round brushes for details. Of course, both types are very versatile. Large round brushes can be used to lay down a wash, and flat brushes can make interesting shapes that can liven up your paintings.

Use your whole arm when you paint, holding the brush lightly so you can create varied strokes with a turn of your wrist. Above all, practice: The brush needs to become an extension of your hand, arm and thoughts.

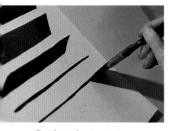

flat brushes
Flat brushes can cover a large area with just a few strokes, and fewer strokes mean a smoother wash. You also can use flat brushes in an expressive and lively way. They can make strokes in a large range of widths. Notice how the shape of the line changes depending on whether the brush is held horizontally or vertically. The wider rectangles and parallelograms work well for buildings.

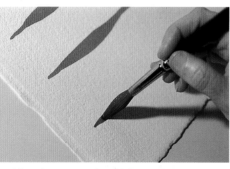
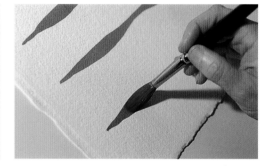

round brushes can paint thick or thin
Slight pressure on a round brush (above, left) results in a thin line. Increasing your pressure (above, right) creates a thicker line.

combination of control and freedom of movement
Round brushes can draw flowing lines as well as straight ones. They're great for laying down organic shapes and expressive washes.

brush position

Holding the brush at different angles to the paper creates an infinite variety of effects.

vertical

Hold the brush vertically and angle your wrist up. Cup your hand and grasp the brush between your thumb and fingers. This position lets you paint flowing lines with control.

less than vertical

Hold the brush between your thumb and fingers. Lean the brush toward the direction you want to travel, then pull in that direction. Holding the brush this way lets you control pressure as well as shape.

point the brush the right way for a smooth line

Pointing the handle of the brush in the same direction as your stroke creates a smooth line. Holding the brush at a right angle to the stroke you're painting will create a rougher stroke because you're limiting your mobility and because the brush hairs are more vulnerable to jamming against the rough paper and making a jagged line.

45 degrees

Holding the brush at a 45-degree angle to the paper and varying the pressure allows a continuous variation between thick and thin strokes.

nearly horizontal

Holding the brush nearly horizontal to the paper creates a broken, textural stroke. This technique works best with cold-pressed or rough paper, which has more texture.

paint properties

Paint properties vary from brand to brand and from color to color. The following information will help you choose the best paint for any job.

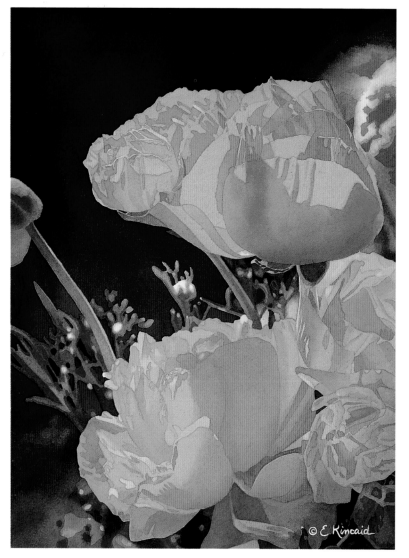

opacity

Opacity means the ability of a paint layer to block light. Some painters like opaque colors because they want to paint colors directly and quickly with few layers. Other painters use layering techniques such as glazing (page 128) that require the paint film to be transparent, like stained glass.

staining

Staining refers to the ability of a pigment to bond with the fibers of the paper. Staining colors tend to stay put; nonstaining ones can be lifted off to varying degrees. Paint that stays on the paper surface will more easily lift and mix with subsequent layers, which can muddy the work and reduce its luminosity. Test your paints to see how they behave. You will find that there is a continuous scale from completely staining to completely nonstaining, and each pigment falls somewhere along that continuum.

transparency comes first

The artist achieved these luminous greens by first glazing transparent Aureolin Yellow where the greens would be warm. The dark and light greens were established with glazes of transparent, staining Thalo Blue. Then the artist glazed final layers of diluted, opaque, nonstaining Sap Green for areas that were to be very warm or olive green. Sap Green was left for last because this paint lifts easily; if you try to glaze over Sap Green, it tends to lift and travel.

Ranunculus Gold
Elizabeth Kincaid · Watercolor
14½" × 10½" (37cm × 27cm)

permanence

Some colors can be fugitive, or not permanent. Over time they will fade from exposure to light or some component of them will fade so that they change color. This is not a problem with early student experiments but becomes serious when you produce work that needs to last, such as when you start to hang work on your wall, give it away or sell it.

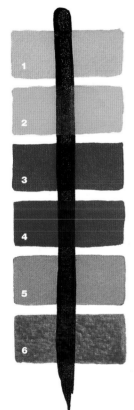

test for transparency

Place a band of permanent India ink on a piece of watercolor paper. Paint full-strength strokes of your watercolors over the dried ink. Allow the paint to dry. If the black of the India ink shows through a color clearly, then that paint is transparent.

Here you can see the Aureolin Yellow contrasted with Cadmium Yellow Light, Winsor Red with Cadmium Red, and Thalo Blue with Cerulean Blue. Each color was used close to full intensity. Of course, opacity of watercolor paint is relative; any paint will become more transparent if diluted with enough water.

1 Aureolin Yellow
2 Cadmium Yellow Light
3 Winsor Red
4 Cadmium Red
5 Phthalo Blue
6 Cerulean Blue

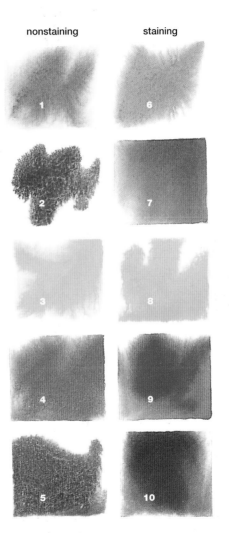

nonstaining staining

check the label

Most paint manufacturers label their colors with ratings for transparency, staining, opacity and permanence. If the paint tube doesn't provide this information, ask your dealer for the manufacturer's brochure.

nonstaining vs. staining

This chart shows a selection of nonstaining and staining paints. All paints fall somewhere along the spectrum from very liftable to very staining; many don't have either quality to an extreme degree. Phthalo Blue is very staining, but Sap Green can vary in its behavior depending on the brand.

1 Sap Green
2 Manganese Blue
3 Cadmium Yellow Pale
4 Cadmium Red
5 Cobalt Deep Violet
6 Winsor Green
7 Phthalo Blue
8 Aureolin Yellow
9 Winsor Red
10 Winsor Violet (Dioxazine)

opacity: a closer look

opaque colors

Heavy-bodied paints, ones that block the passage of light, are referred to as *opaque*. These weighty pigments not only conceal the paper, but they cover any underlying layers of color as well. Glazes done with opaques may be too heavy, but it is possible to glaze with opaques if they are greatly diluted with water. Once dry, opaques are difficult to remove, not because they have stained the paper, but because of their heavy weight. The large particles of an opaque pigment separate and settle into the pockets between the fibers of the paper. This is called *granulation* or *sedimentation*.

Opaque paints are marvelous for depicting solid, dense objects such as soil, tree trunks and rocks. When mixed indiscriminately with transparents, opaques often are responsible for the heavy, dull mixtures that watercolor painters call "mud."

mixing transparent and opaque colors

The addition of a small amount of white, or any opaque color, to any transparent color will create an opaque.

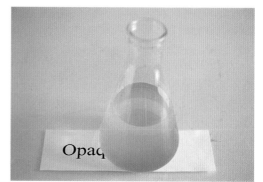

dispersed opaques
A quick rinse of a brush loaded with opaque paint will leave your water cloudy. Notice that the label under the flask is obscured.

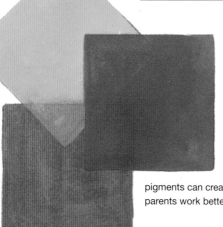

glazing with opaque colors
Opaque pigments obscure previous layers of paint. Notice that a light-value color, such as yellow, is capable of covering a hue of darker value. Multiple glazing with opaque pigments can create mud and imprecise edges. Transparents work better for multiple glazed layers.

sedimentary colors settle out
After resting undisturbed for several hours, the water is now clear. The heavy opaque particles have settled to the bottom of the flask.

transparent colors

Glowing, delicate glasslike colors that allow light to pass through the paint and reflect off the surface of the white paper to the viewer's eye are described as *transparent*. Pencil work and underlying hues remain visible even when glazed over with several layers of transparent color.

Transparent paints are the most effective for glazing. The multiple layers increase in value, change hue, or shift in intensity. They are also the best choice to suggest water and objects made of glass.

glazing with transparent colors

Transparent pigment glazes let underlying colors glow through. Imagine that you are painting with glass. The light passes through even when there are several layers of paint.

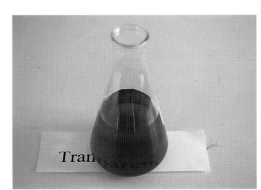

dispersed transparents

As transparent color disperses, the water remains clear, permitting the passage of light. There is little settling out as the fine particles remain suspended in the water. The letters on the label are visible through the water even after several hours.

transparent colors and layering

Transparent colors work best for building multiple layers; you can build many layers without creating mud.

exercise: diffusion of staining pigments

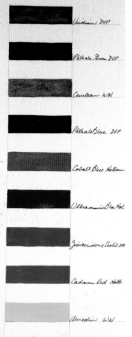

Staining transparent pigments are the rich jewels of watercolor, providing deep, lush darks. A distinctive and exciting quality of staining pigments is their tendency to diffuse and blend when re-wet. To determine which of your paints will bleed when re-wet and which are more sedentary and passive, experiment with your pigments using the following test.

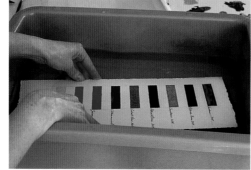

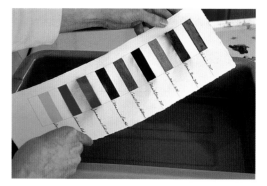

2 wet the strip
Dip the dry test strip into a basin of fresh water. Some samples will bleed immediately; others will not.

3 remove the strip and observe
Remove the paper from the water a few seconds after color movement begins, tipping it so that any bleeding colors run into the white spaces between stripes. Let the test strip dry on a flat board.

1 paint a test strip
On a narrow piece of 140-lb. (300gsm) watercolor paper, paint a heavy stripe of each color on your palette. Use very little water, just enough to make the paint spread. Allow the stripes to dry completely, then label each with color name and manufacturer.

test results

After your sample is dry, examine the results and note which paints stain and bleed. Below are some typical results associated with certain pigments. Your results may vary, as manufacturers may use different ingredients, even in paints with the same name.

- Phthalo Green: This fast moving stain diffuses quickly when re-wet.
- Phthalo Blue: The first color to bleed, this is a potent stain that moves very quickly.
- Quinacridone Violet: Although slightly slower to start moving, this stain diffuses extremely well.
- Viridian, Cobalt Blue and Raw Sienna: These tend not to diffuse.
- Cadmium Red, Ultramarine Blue and Cerulean Blue: These opaques do not bleed when re-wet because the heavy, sedimentary particles settle into the paper. Staining paints work well when layered over another transparent. However, if you attempt to layer another color on top of these virile stains, the color reactivates and permeates any upper layers.

pigments: a closer look

Looking at applied paint up close makes it easier to understand why watercolor pigments behave the way they do. Shown on this page are three different blues applied to watercolor paper. The samples were magnified with a microscope. Here's what you can learn from each one:

COBALT BLUE is a transparent, nonstaining pigment. The finely ground particles of Cobalt Blue pigment float on the surface of the paper. The paper fibers do not absorb any color, as is evident by the appearance of glistening white threads. This sample proved to be difficult to photograph because of the strong light reflected off of the surface. It is reflected light that makes transparent colors seem to sparkle in paintings.

PHTHALO BLUE is an extremely powerful transparent stain. The fibers of the watercolor paper absorb the dye-like color, and the paint travels along the length of the thread similar to the way water is drawn up by a plant stem. Paint that behaves in this manner is difficult to remove and is justly referred to as staining. The pockets between the fibers remain white in comparison to the other two samples in which the pigment has settled into the depressions in the paper.

Images on this page were photographed by John J. Heikkila, Ph.D.

ULTRAMARINE BLUE, a semi-opaque sedimentary paint, settles into the tiny pockets of the paper as well as coating some of the fibers. The heavy particles are lodged within the spaces, and it is difficult to release these trapped granules later. As successive layers of opaques are added, the weighty particles create a dense, solid appearance that blocks light from traveling through to the surface of the paper.

cobalt blue:
transparent,
nonstaining

phthalo blue:
transparent,
staining

ultramarine blue:
semi-opaque,
sedimentary

tools for masking

Many tools will work for applying masking fluid. Your choice depends on how large an area you need to cover.

AN INEXPENSIVE BRUSH: Never use expensive brushes for masking, as they will be destroyed.

AN OLD BRUSH: One that is past saving.

A RULING PEN: A finely crafted, two-pronged device once commonly used by drafters and illustrators, the ruling pen made controlled ink lines before the invention of mechanical pens. This pen is becoming harder to find but it is still sold in drafting sets. The ruling pen can make very fine lines, a definite advantage as a tool for applying masking fluid.

A SHARPENED BRUSH HANDLE: Use like a ruling pen to apply mask.

A TOOTHBRUSH. Great for spattering mask to create natural textured effects.

Whatever masking tool you use (with the exception of the toothbrush), hold the tool vertically. The masking fluid seems to flow easier this way, especially if you use a light touch. Move the tool quickly and smoothly.

tip

To slow down the destruction of a brush used for masking, soap the bristles before dipping them in masking fluid. Masking fluid will clump on the brush, so wash the brush out occasionally as you work and after you're finished.

1 Ammonia (clear only)
2 Masking fluid
3 Old masking fluid bottle cap
4 Ruling pen
5 Toothbrush
6 Paintbrush handle, sharpened
7 Permanent waterproof fine-tip marker
8 Rubber cement pickup
9 Drafting tape
10 Scissors
11 Masking film

solutions to common masking problems

CLUMPY APPLICATION: Masking fluid tends to clump, and it can flow unevenly on the rough surface of most watercolor paper. To get around this, draw a bead quickly along the edge of an area with a fine-tipped tool and then fill in the area behind it. If the masking fluid isn't thin enough to flow smoothly, thin it with ammonia or replace it.

MASK THAT SPREADS: Another characteristic of masking fluid is its tendency to "settle down" after it is applied, spreading outward from where you intend it to be. For this reason, it is helpful to apply it just slightly to the inside of your drawn line and to use a fine-tipped tool.

MASK THAT FAILS TO HOLD BACK THE PAINT: When paint gets past the masking fluid, it's usually because the masking fluid hasn't been applied thickly enough. Pile the masking fluid on generously and avoid spreading it over a wide area.

AIR BUBBLES: Air bubbles can form in masking fluid, drying into tiny pinpricks in the latex film. These appear almost white in the pale color of the masking fluid. If you see any white spots, apply a second coat of masking fluid.

SEMI-DRY MASK LIFTS OFF: Masking fluid sets quite quickly. When it is half set, it picks up easily. The skin on the surface will stick to the application tool, so use a light touch and avoid direct contact between your tool and the semidry masking fluid on the paper.

stir, don't shake

Masking fluid consists of microscopic particles of latex floating in ammonia. Shaking knocks the particles into each other, and they stick together. Once this happens, the particles won't come apart again.

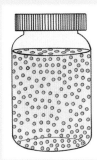

Latex in suspension

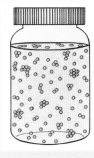

After shaking

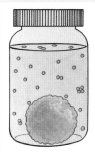

After repeated shaking

beware of old goods

Check new masking fluid before leaving the store. Don't assume it's in good condition.

- Tip the bottle gently to make sure the fluid has not solidified.
- Watch the liquid as it moves. Masking fluid should flow like cream; if it's more like honey or even thicker, it's too thick. Sometimes thick masking fluid can be thinned with ammonia, but it's better to buy a fresher bottle.
- Use tinted masking materials with caution, especially the darker gray brands. The tinting agents aren't supposed to stain your paper, but sometimes they can. Pale yellow masking fluid can also stain. Test new masking fluid on a scrap of your watercolor paper before risking it in a painting.

the masking process

Masking fluid is typically used in stages. Areas of white paper may initially be masked, but painted areas are also masked after subsequent washes where the artist wishes to protect a pure color or keep adjacent colors from contaminating each other. Here's a basic example of how the process works.

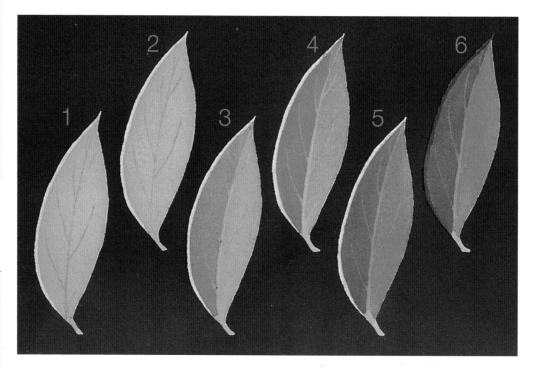

1 protect the leaf edge
Draw a simple leaf shape on watercolor paper with a pencil. Using a ruling pen (see the tip on this page) or another tool with a sharp, fine point, apply masking fluid to the edge of the leaf. Let the mask dry thoroughly, then paint the leaf Aureolin Yellow.

2 mask the stem and veins
Again using the ruling pen, draw with masking fluid to create veins and a stem on your leaf. Let dry thoroughly.

3 apply the next washes
Paint a light wash of Phthalo Blue over and around the entire leaf. This will create a green leaf color and a blue background. Once the entire leaf is dry, paint another light wash of Phthalo Blue over the shadow side of the leaf only to make that side a darker green. Remove the masking fluid from the veins on the shadow side only with a rubber cement pickup.

4 darken the shadow side
Paint another light wash of Phthalo Blue over the shadow side of the leaf. Now the veins on that side will become green, but not as dark a green as the rest of the leaf. Once everything is dry, remove the masking fluid from the rest of the leaf veins (but not the masking fluid protecting the leaf edge).

5 layer the whole leaf
Paint a light wash of Phthalo Blue over the whole leaf and let it dry. The masking process has created cumulative layers over different areas of the subject, making for a range of light and dark greens.

6 paint the leaf edge
Remove the masking fluid from the leaf edge and paint this area Winsor Red. The contrast of red and green, which are complementary colors (see page 46), creates dimension and visual interest. Without masking, it would not be possible to preserve that narrow strip of white paper for the leaf edge, and the note of Winsor Red added would be less pure and have less impact.

masking with the splattering technique

You can create interesting textures by splattering paint over a partially masked area—or even by splattering the masking fluid itself. One method of splattering is to knock a loaded paintbrush against your finger, a technique that gives you some control over the splattering pattern. You can create wilder patterns by simply flicking the loaded brush, but don't forget to protect surrounding surfaces. Yet another way to splatter is by running your fingertip across the bristles of a toothbrush loaded with mask or paint.

a fine masked line
For a fine line of masking fluid, use a fine-tipped tool, like the ruling pen shown here, held vertically. Draw quickly with a light touch.

brushes

handles

Brushes for oil and acrylic have longer handles than those made for watercolor. This is because oil and acrylic painters typically work standing at an easel, with some distance between them and the work (unlike watercolorists, who sit at a flat table, close to their work).

shapes

Study the brush shapes on the facing page to learn what each has the potential to do.

picking the best brush for the job

Each brush shape makes a distinctive mark. These characteristics can come into play in all sorts of applications, especially when creating loose and painterly passages. Rather than painstakingly delineating and filling in areas of color, you can deftly suggest many things with the proper use of a single stroke of the right shape brush.

As a guide, brights and flats make a crisp square shape for the beginnings of strokes. The smooth oval tips of filberts are perfect for creating strokes with rounded ends. Bristle fan brushes are good for multiple streaks, like wispy clouds or grassy areas, while soft-haired fans are great for careful blending.

supply list: brushes

For starters:
- Four bristle flats ranging from $1/4$ inch (6mm) to 1 inch (25mm)
- $1/4$-inch (6mm) and $3/4$-inch (19mm) bristle filberts
- $1/8$-inch (3mm) and $1/4$-inch (6mm) soft-haired flats
- Small synthetic liner

As you progress, you might like to add:
- 1- to 2-inch (25–51mm) soft-haired fan
- 1- to 2-inch (25–51mm) bristle fan
- A few bristle brights
- Additional sizes of flats and filberts

anatomy of a brush

1 Hairs or bristles
2 Ferrule
3 Handle
4 Tip
5 Body
6 Outer edge

bright
Both brights and flats have a square tip, but the bright, with its shorter hairs, is stiffer. Brights, especially bristle brights, are superior for scrubbing and for carrying large loads of thick paint.

flat
Because their bristles are longer than those of brights, flats are more flexible and come to a finer point, making them easier to control for smoother blending and details.

filbert
The flat bodies and nicely rounded tips of filberts create distinctive oval-ended marks. They come in varying bristle lengths, so remember that shorter means stiffer and longer means more flex. Good filberts are smoothly and evenly rounded.

worn brush
As they wear, some brushes develop new and handy characteristics. A small synthetic bright could morph into a short-haired filbert great for sketching in the initial lines of a painting. A really raggedy bright might be perfect for painting foliage.

round
The sharply pointed tips of rounds make them excellent for rendering careful details, while their relatively short hairs give them the strength to manipulate fairly thick paint.

script liner or rigger
An elongated cousin of the round, the script liner or rigger is ideal to use with thinned paint for rendering very fine, long lines, such as branches, telephone wires and ship rigging. They are also good for painting small dots.

fan
Blending paint that's already been applied to a surface is the fan brush's primary function. The sable and soft synthetic fans don't have enough strength to do more than that, but the bristle fans can also be used for quickly creating streaky and splotchy effects.

house brushes
House brushes are handy for scrubbing or blocking in large areas and, if skillfully used, can create interesting textures and mottled areas. A few are sold in art stores and far more are available in hardware stores.

brush fibers

work from large to small

Start off an acrylic or oil painting with the largest brush you can handle, and work your way down to the smaller brushes as you progress to finer details.

natural vs. synthetic

Oil and acrylic brushes can be made with synthetic fibers or natural hairs. Each fiber type has its strengths.

NATURAL: The combination of softness, spring and control of red sable makes it the premiere choice for soft-haired brushes, but camel, squirrel, badger and mongoose hair are also used. Hog's hair is used to make bristle brushes.

All natural hairs absorb water, which reduces their strength and spring to varying degrees. Some are reduced to wet-noodle uselessness. For this reason they become more difficult to use with acrylics or water-soluble oils if you thin the paint with too much water or rinse the brush often as you paint. Bristle brushes in particular swell up and become unmanageable mops.

SYNTHETIC: Modern technology has brought us synthetic fibers that can be used to fashion incredibly soft brushes or rough-and-tumble bristles. Synthetics are nonabsorbent, so their spring and shape are little affected by water. The hair of nearly all synthetic brushes, especially the softer varieties, will sooner or later begin to curl outward. This renders the brush useless for fine control unless you trim off the offending hairs.

Since synthetics are less expensive, they can be an attractive choice for painters working in acrylic—which dries fast and is therefore rather hard on brushes. Brushes made with a mix of natural and synthetic fibers can provide some of the advantages of both at a lower price than pure natural-hair brushes.

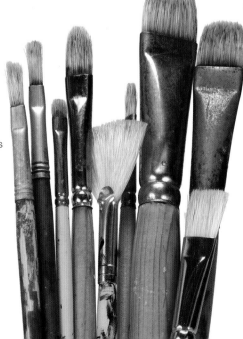

bristle brushes

synthetic brushes

bristle brushes vs. soft-haired brushes

Bristles, natural and synthetic alike, have certain properties in common. And the soft brushes, both natural and synthetic, share a set of strengths and weaknesses.

Bristle brushes are made of thicker, stronger hairs than the soft brushes. The resulting strokes leave larger but fewer grooves in the paint, creating more noticeable brushwork. Sables and soft-haired brushes are crafted from thinner, more flexible fibers that form more and shallower grooves in the paint, achieving smoother and less obvious brushwork.

It's important to take into account these qualities in approaching a painting. When working on a smooth surface, stiff bristles slice through the wet paint to the dry surface below. If you want smooth, even coverage instead of that scratchy appearance, a soft-haired brush is the better choice.

On the other hand, rough painting surfaces such as coarse-weave canvas or rough-textured gesso will chew up fine sable brushes. Bristles will stand up to a beating far better.

long vs. short handles

Short-handled brushes are used primarily for close-up, careful work that requires a lot of control. Long handles make it possible to get farther back from your work for a better overall view while you paint, and you can work without having your hand smack in the middle of what you're looking at. You can also make longer, more sweeping strokes with long-handled brushes.

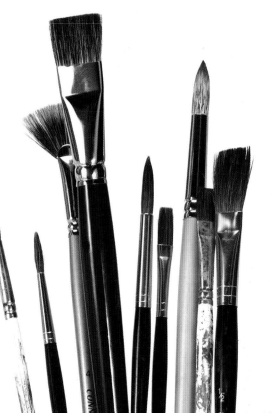

long-handled vs. short-handled

soft-haired brushes

brushwork

use the largest brush you can

Economy of brushstrokes keeps a painting looking fresh and spontaneous rather than overworked. To minimize the number of brushstrokes, use the largest brush you can for any given passage. This will create the effect of effortless application while also making the process more enjoyable.

brush confidence

John Singer Sargent had admirable facility with the brush. His sensuous strokes convey authority, conviction and the utmost confidence. This type of confidence can be achieved only through constant practice and repetition.

There are many factors in great brushwork. These include the painting surface, the consistency of the paint, whether the stroke is applied to a wet or dry area, the amount of paint on the brush, how much pressure is applied during the stroke and the type and quality of brush used.

Practice will help you develop an instinctual feel for the brush.

Properly used, brushwork brings out the characteristics of the subject. For example, firm edges do a good job of depicting crisp forms such as architecture. Soft edges may be better for sensitive turning of a form, as when painting a figure or fabric. Ragged or textural edges might help indicate foliage or trees. Flat strokes may show flat planes, and wet-into-wet strokes may show softer color and value changes such as clouds.

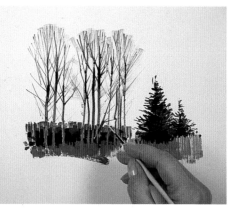

match the brush size to the subject

A ⅛-inch (3mm) flat brush was used to create the trunks of the trees. The finer limbs at the tops of the trees were done with a splayed ¼-inch (6mm) or ⅛-inch (3mm) flat brush. Fine linework in the tree limbs was done with a variety of liners.

Forest Study
Hugh Greer · Acrylics
6"× 8" (15cm × 20cm)

developing your own style of brushwork

What kind of brushstrokes do you like the most: the lyrical strokes of Vincent van Gogh? The staccato style of Claude Monet? The rich textural work of Nicolai Fechin, or the powerful blocky work of California painter Edgar Payne? Experiment with brushstrokes in your own work; you may develop your own signature style.

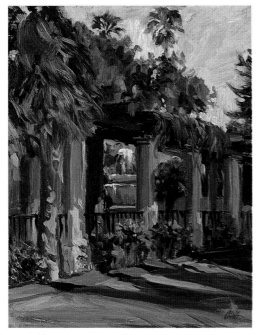

varied brushstrokes

In this study, the architectural columns were created with a firm vertical stroke. The foreground grass is relatively untextured. The free, organic character of the foliage was achieved with a light grip on larger bristle filberts and flats with varied stroke directions. The railing and the smaller foreground plants and flowers were painted with a no. 1 bristle filbert and a no. 1 bright.

Mission Light
Craig Nelson · Oil
14" x 11" (36cm × 28cm)

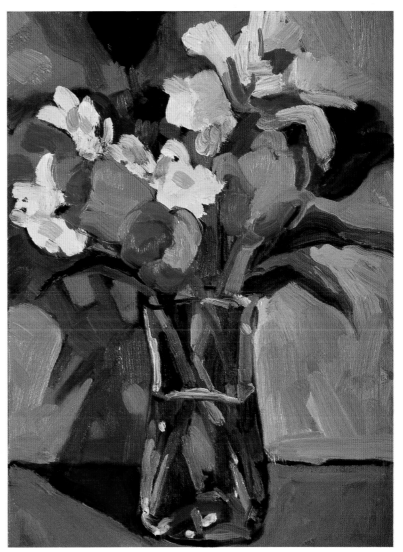

bold, uniform brushwork

This stylized floral painting shows obvious brushstrokes even in the background. A variety of rounds and filberts were used; the roundness in the resulting strokes creates an organic feel. The obvious direction of the strokes indicates the direction of the forms.

Spring Bouquet With Tulips
Mary Deutschman
Water-soluble oil
12" x 9" (30cm × 23cm)

paint consistency

The type and character of the brushwork you can do is determined in part by the viscosity, or consistency, of the paint being used.

Some paint brands are pretty stiff, while others can be quite fluid. Even within each line of paints, individual colors can vary in viscosity. Earth colors tend to be thicker and a bit grainy, while transparent colors such as Rose Madder are more fluid.

straight from tube medium viscosity very thin

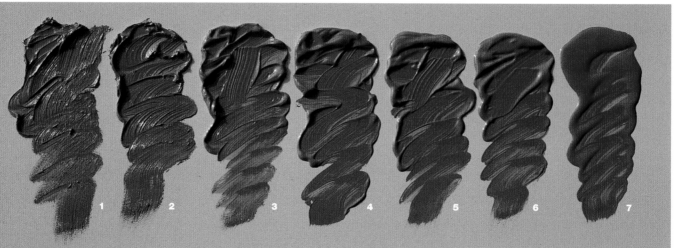

consistency continuum
These paints have increasing amounts of medium, beginning with straight tube paint at the left. A common kitchen ingredient of equivalent thickness is listed for each swatch.

1 Margarine, peanut butter
2 Sour cream
3 Mayonnaise
4 Dijon mustard
5 Ketchup
6 Tomato sauce
7 Cooking oil

mediums and solvents: easy does it

You can paint yourself into all sorts of corners by overzealous use of paint modifiers. A surprisingly small amount will go a long way. You might think that combining equal parts tube paint and medium will result in a mix of medium consistency. In fact, such a mixture will yield a pretty drippy no. 6 or 7 consistency.

thick consistency

Thick-consistency paint lends itself to wonderful textural passages that can energize a canvas. Paint thinned with little or no medium retains more body for thick brushstrokes. Since thick paint is more opaque, it covers well. Being undiluted with additives, it is less likely than thinned paint to experience yellowing and deterioration.

achieving successful impasto

Highly viscous paint won't stick when applied to a thick layer of thinner, more buttery paint (1); it's like trying to spread peanut butter over jelly. Instead, put down a thin ground of viscous paint, letting some of the canvas peek through; then apply the impasto strokes (2).

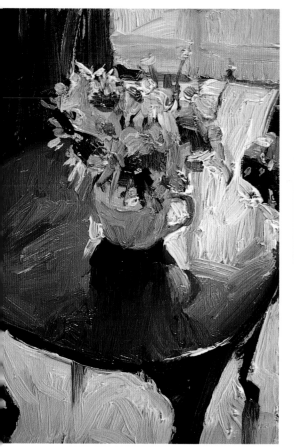

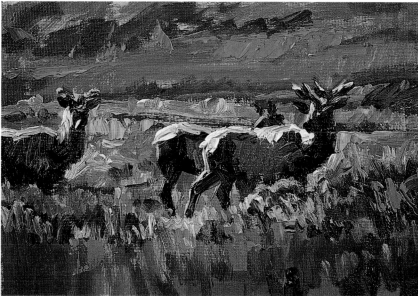

impasto lends energy to a still life

This quick little study was painted with nos. 2 and 8 bristle filberts. The lights were finished with the no. 2 and a fair amount of white paint applied in the impasto style.

Color on the Table
Craig Nelson · Oil on canvas
7" × 5" (18cm × 13cm)

quick impasto execution for studies

A thick, impasto paint application enabled the artist to complete this color and value study in about 40 minutes.

Point Reyes Tule Elk
Craig Nelson · Oil on canvas
7" × 11" (18cm × 28cm)

thin consistency

Larger amounts of medium increase paint's fluidity, making it easier to apply and blend smoothly. As color is thinned by medium, it becomes more transparent for glazing and scumbling. Thin-viscosity glazes can create dazzling rich colors and translucent effects.

But there's another side to the equation. In oil paints, a greater proportion of linseed oil leads to more yellowing. Higher levels of varnish increase the brittleness of the paint film and add to the yellowing. Using too much medium in acrylic paint will cause imperfections in the paint film. The key with either kind of paint is to add medium slowly, a bit at a time, so that you achieve the desired benefit without running into problems.

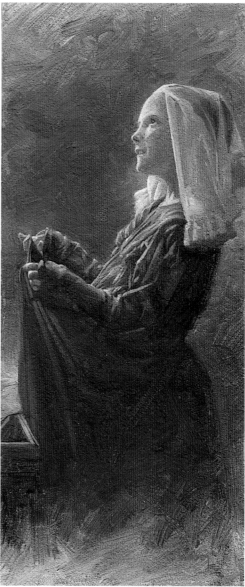

detail
Adding more medium to the paint increases its fluidity, facilitating washy brushwork, as in this example.

Gown
Mark Christopher Weber
Oil on panel
18" × 7" (46cm × 18cm)
Collection of the artist

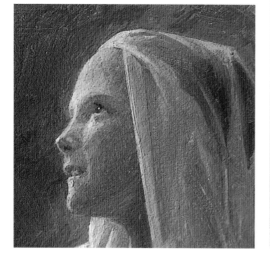

the effect of surface tooth

Your brushwork is very much affected by the degree of texture, or tooth, your painting surface possesses. A fine-weave canvas or a smoothly sanded gesso panel allows for fluid, easy blending during paint application. This type of surface texture is a spectator to the painting process. The rougher the surface texture used, whether coarse linen or panels textured with modeling paste, the greater the effort required to work paint into the low points of the surface tooth. Blending colors on a rough surface is usually more demanding, but you gain possibilities for interesting interplay between surface texture and paint. In effect, the texture becomes an active participant in the painting.

smoothly sanded gesso panel
This surface gives only the very slightest texture to the paint. Blending is easy.

medium-weave acrylic-primed canvas
This slightly-textured surface allows modest painterly effects. A bit of effort is required to work the paint into the tooth.

other painting surfaces

Many artists experiment with a variety of painting surfaces before finding one that works best for their individual style. Some alternatives to consider:
CANVAS PAPER is linen-textured heavy paper sold in pads. It's an economical alternative to canvas. Canvas paper must be affixed to a stiff backing for framing.
CANVAS PANELS are stiff boards with canvas glued onto them. You won't get the springy feel of painting on stretched canvas, but the surface texture is comparable.
MASONITE PANELS are less expensive than canvas and perfect for travel. Pre-primed panels are available. You can also prime your own: Sand the edges; coat the panel with gesso on front, back and edges; sand with fine sandpaper; coat with gesso; and sand again.

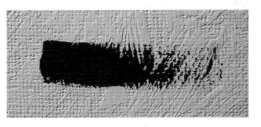

medium-coarse linen canvas with roughly applied oil ground
The possibilities increase for interplay between the surface texture and paint. Extra effort is needed to work the paint into the weave.

brush grip

The way you hold the brush is partly a matter of personal preference and partly determined by the type of stroke you are making. Two basic grips are used in oil and acrylic painting: the pencil grip and the baton grip.

PENCIL GRIP: The pencil grip allows for finger control of the brush. Holding the brush near the ferrule gives you maximum control for careful detail work. Gripping the brush at the handle's end makes it possible to comfortably hold the brush perpendicular to the canvas for long, sweeping strokes that require touching the surface with only the bristle tips, as in very light blending.

BATON GRIP: The baton grip operates more with arm and wrist than fingers. Don't look to this grip for fine motor control. Its chief advantage is in making all manner of paint applications with a low brush-to-canvas angle, including all strokes created by the various body-loading methods, far easier than the pencil grip. The baton grip is also well suited for light, skimming strokes.

stand back and move around

For both baton and pencil grips, holding the brush at the handle's end makes it possible to stand farther back from the canvas to have a continuous overall view of how the picture is developing.

Standing back also lets you involve your entire body in the act of painting. Step forward and back as needed, and let your brush be an extension of your arm. The result will be more fluid and expressive brushstrokes.

pencil grip near ferrule
This grip allows maximum control for very careful, detailed brushwork.

pencil grip at handle's end
With this grip, you can hold the brush perpendicular to the canvas to skim the surface with sweeping, blending strokes.

baton grip
The baton grip works best for paint applications with a low brush-to-canvas angle.

brush angle mechanics

A steep brush-to-canvas angle is required for smooth paint application and blending and working paint into surface texture. A shallow angle is necessary for thick brushwork. The following hows and whys will give you a better grasp of what's happening between brush, paint and canvas to help you get the results you want.

STEEP ANGLE: When you hold a brush perpendicular to the painting surface, you exert more pressure on the paint because all of the pressure is concentrated in one spot. This allows for smooth and even paint application and blending. With a steep angle it is easier to control the paint application, because you touch the surface with only the very tips of the hairs. You can see and feel exactly what they are doing.

SHALLOW ANGLE: A brush held at a low angle to the canvas (say, 30 degrees) spreads your pressure out over a larger area, so it can't press nearly as hard as a steeply angled brush. Therefore it can't make the paint as smooth, either. If you angle the brush low and press lightly, the paint will keep its mass and shape, which is exactly what is needed for thick brushwork such as impasto. A shallow angle also reduces precise control, making more organic-looking brushwork possible.

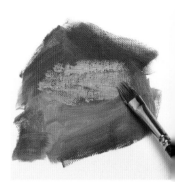

more about brushstrokes

A shallow-angled brush is the key to the skimming technique, shown here. For much more information on this and other brush techniques for oil and acrylic painting, turn to pages 148–165.

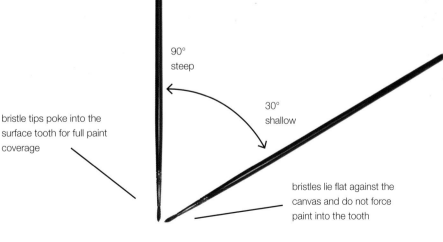

90°
steep

30°
shallow

bristle tips poke into the surface tooth for full paint coverage

bristles lie flat against the canvas and do not force paint into the tooth

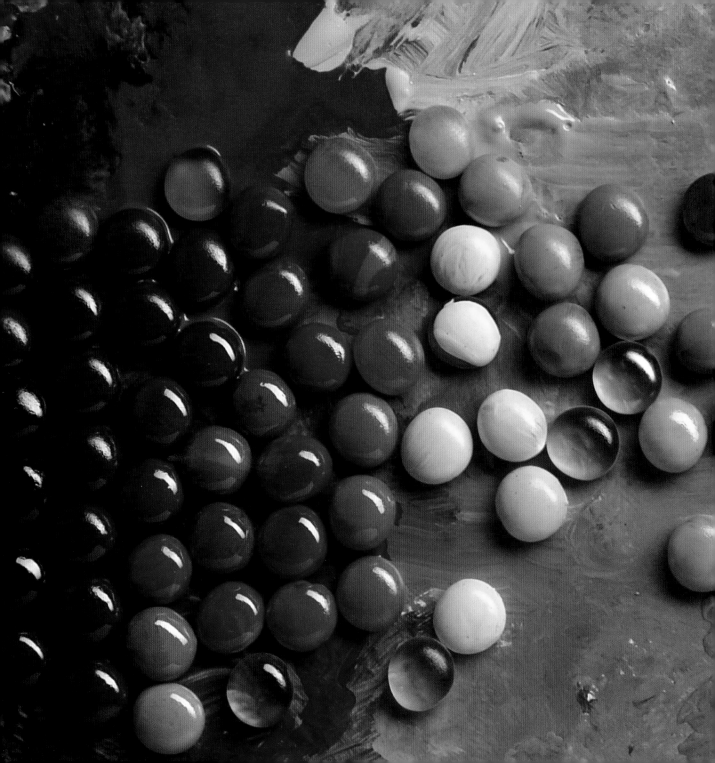

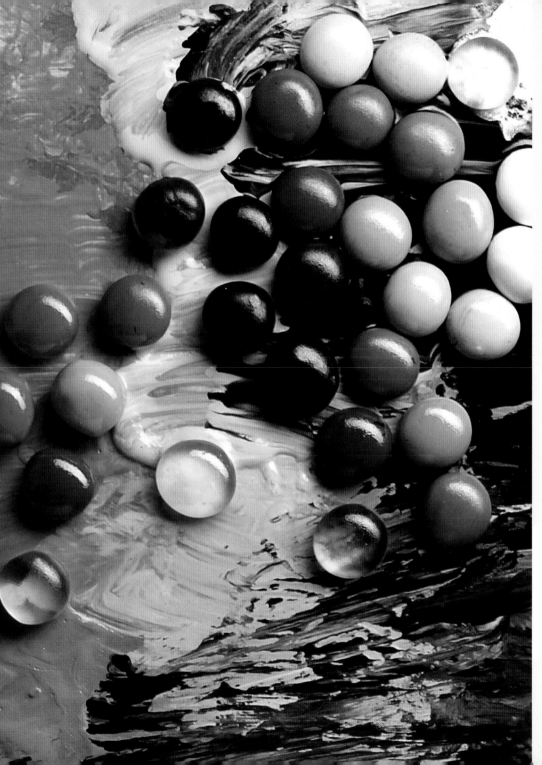

color and value

color basics

complements
Complementary colors side by side "vibrate" and attract the eye. You can use this to direct attention to what's most important in your painting.

Knowing the color wheel and some basic color terms will help you avoid many painting problems.

ANALOGOUS COLORS: Colors within one or two steps of each other on the color wheel.

COMPLEMENTARY COLORS: Any pair of colors opposite each other on the wheel. Placed side by side, complements create vibration, contrast and interest. Mixed together, they tend to create neutral tones.

HUE: A color's name, such as red, yellow or blue-green.

INTENSITY: How saturated or strong a color is. Also called *chroma*.

TEMPERATURE: How warm or cool a hue is. Reds and yellows are warm and aggressive; they appear to come forward. Blues and greens are cool and reticent; they seem to recede into the picture.

VALUE: How light or dark a hue is.

PRIMARY COLORS: Red, yellow and blue. With these primary colors, it is possible to mix all other colors. Your palette should include a warm and a cool version of each primary color.

the color wheel
This color wheel was painted with watercolor and has adjacent warm and cool versions of each primary and secondary color.

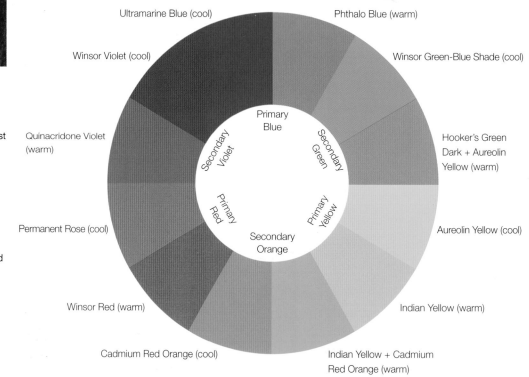

Ultramarine Blue (cool)

Phthalo Blue (warm)

Winsor Violet (cool)

Winsor Green-Blue Shade (cool)

Quinacridone Violet (warm)

Hooker's Green Dark + Aureolin Yellow (warm)

Primary Blue

Secondary Violet

Secondary Green

Primary Red

Primary Yellow

Aureolin Yellow (cool)

Permanent Rose (cool)

Secondary Orange

Winsor Red (warm)

Indian Yellow (warm)

Cadmium Red Orange (cool)

Indian Yellow + Cadmium Red Orange (warm)

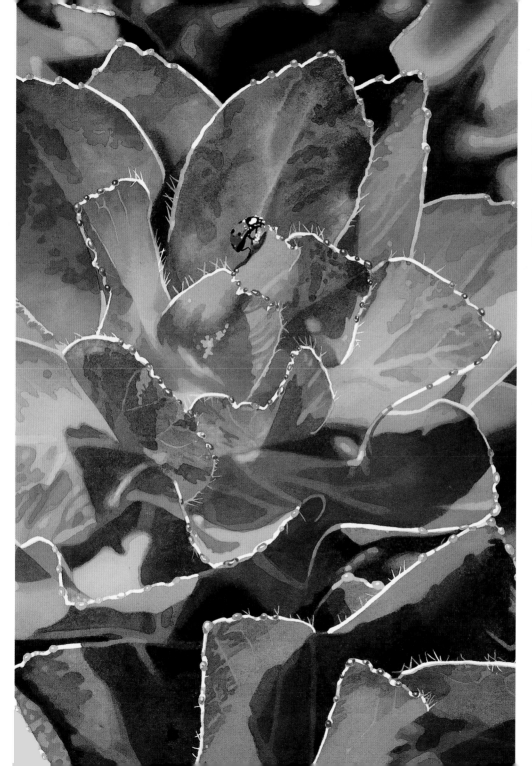

complementary colors

This painting is a field of greens with contrasting complementary reds along the leaf edges. The contrast of complements brings the image to life.

Ladybug World
Elizabeth Kincaid · Watercolor
21" × 13½" (53cm × 34cm)

color temperature and perspective

Color has temperature. Adding red or yellow to a color will warm it up; adding any blue will cool it. Color temperature has power for the painter. Cool or grayed colors tend to move back in space, while warm or intense colors tend to advance.

If you understand relative temperature, you can manipulate the illusion of space on flat paper. Temperature is an important part of *atmospheric perspective*, which means the way temperature, value and edges work together to create the appearance of depth. Warm colors come forward, while cool colors recede, and as objects move into the background, they weaken in value and their edges become softer or out of focus. All of these, combined with linear perspective, create the illusion of real space. Leaving out any of the perspective components tends to result in a flat-looking image.

know your color temperatures
As you travel on the color wheel from blue toward either red or yellow, color becomes warmer. On this wheel, the coolest spot is between Ultramarine Blue and Phthalo Blue because Ultramarine Blue has a slight red bias and Phthalo Blue has a slight yellow bias.

1 Quinacridone Violet
2 Winsor Violet (Dioxazine)
3 Ultramarine Blue
4 Phthalo Blue
5 Winsor Green (Blue Shade)
6 Hooker's Green Dark + Aureolin Yellow

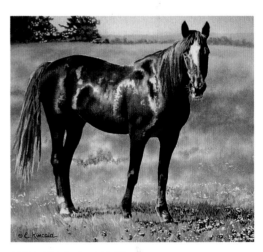

atmospheric perspective
The field behind the horse becomes increasingly blue and the value contrast between elements is reduced as your eye moves into the background. These color shifts create the illusion of real space on paper.

Bo
Elizabeth Kincaid · Watercolor
10½" × 14½" (27cm × 37cm)

dominant color temperature

Choosing a dominant color temperature helps produce a strong painting. An equal division between warm and cool colors in a painting can be static and uninteresting. In addition, too much of any one thing tends to weaken its impact.

A dominant color temperature can also strengthen your painting by inspiring emotion. Blue can feel serene, yellow can feel cheerful and red can feel passionate or active.

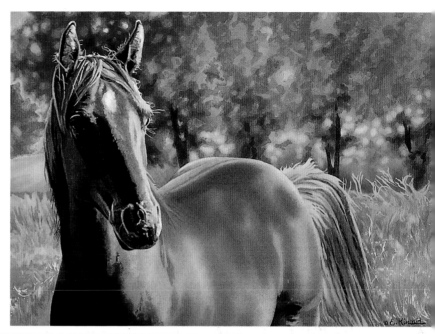

golden horse bathed in sunshine
With background colors of Indian Yellow, Red Oxide and Sap Green, the young horse seems to dance in the sunlight. The contrasting bits of blue sky enhance the overall warmth.

Little Joe
Elizabeth Kincaid · Watercolor
13½" × 21" (34cm × 53cm)

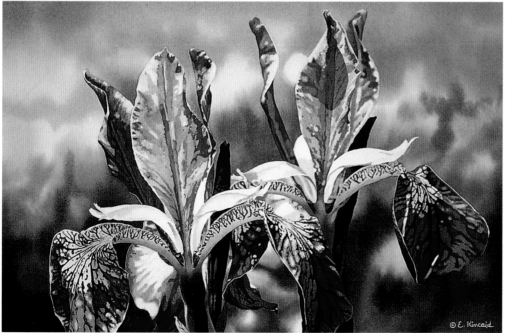

blue on blue
This painting takes its cue from the cool blue irises. The background contains cool Winsor Green and Phthalo Blue, Ultramarine Blue and Winsor Violet. The touches of warm, soft reds, Aureolin-based greens and light Indian Yellow washes enhance the coolness.

Two Blue
Elizabeth Kincaid · Watercolor
13½" × 21" (34cm × 53cm)

value: the watercolorist's guide

The *value* of a color is its lightness or darkness. When you paint with watercolors, you alter the value of a color by changing the proportion of water to paint. Some colors have a greater inherent value range than others. A limited value range can be a problem when you need to indicate light and shadow through value contrast.

value patterns

Without an effective value pattern, a painting will seem chaotic and lose its impact. Plan the values before you begin painting with a value sketch (page 77). Some artists suggest turning a value plan upside down so that you can judge its effectiveness without being distracted by your perceptions of the subject matter. A good value plan will look balanced and interesting even upside down.

colors have value

Value defines more than the range between white and black. It also applies to color. Notice that some hues have a greater range of value. While yellow has a severely restricted range, remaining high in value, violet can extend from light to dark.

1 White
2 High Light
3 Light
4 Low Light
5 Middle Value
6 High Dark
7 Dark
8 Low Dark
9 Black

changing value with glazes

Because watercolor is transparent, you can combine colors optically by layering one color atop another. The only requirement is that a layer be completely dry before the next one is added. The glazing technique is described in full on page 128, but here's an example of how it could be applied to a landscape painting.

The glazing technique is described in full on page 128

tip

Layering transparent watercolors produces darker values, but you will usually need to "push" this effect by decreasing the amount of water in your paint mixture for each successive layer. Using thicker paint for each layer will produce a greater shift in value than if you simply used the the same paint mixture for each layer.

1 first layer

Starting near the lower edge of the paper, paint an even wash of Viridian using a soft flat wash brush. Drag the strokes horizontally across the surface. Let dry.

2 second layer

Dilute Viridian with slightly less water than you used for step 1 and apply a second layer directly over the first. Leave strips of the initial light value and the white at the bottom. Let dry.

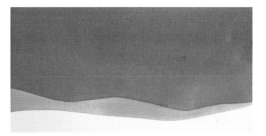

3 add more layers

Continue to build layers from bottom to top, using less and less water in the paint mixture each time. The final layer has been diluted with only enough water to permit the paint to spread.

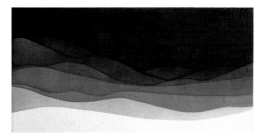

intensity

Intensity, also called *chroma*, is different from value. Intensity describes the purity of a color in terms of its brightness or dullness. A hue of high intensity appears vivid and saturated; it has not been lightened with water or darkened with black. A low-intensity color will appear more neutral—like complementary colors mixed together. In other words, a low intensity color appears grayed.

pure, high-intensity color
Clean, pure color is intense and considered joyous, bold and aggressive.

neutralized color
When you want to lessen a color's intensity, your goal is usually duller—not darker. To accomplish this, neutralize with the complement, not with gray or black. Here, pure yellow has been neutralized with increasing amounts of its complement, violet. Blue has been mixed with orange, green with red and so on.

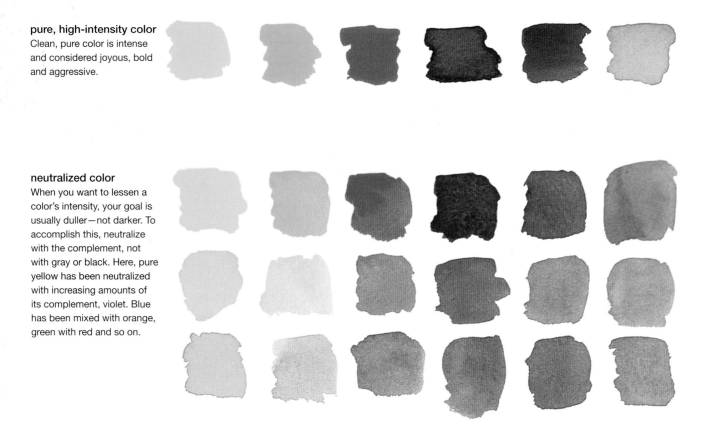

maintaining intensity

The following guidelines will help you keep your bright colors bright.

AVOID GLAZING THREE PRIMARIES. Any mix of the three primaries will create a neutral gray, brown or olive green.

AVOID MIXING COMPLEMENTS. Since any pair of complements contains all three primaries, layering complements is like layering the three primaries.

GLAZE WITH ANALOGOUS COLORS. Analogous colors are adjacent to each other on the color wheel. You can use these neighboring colors in two ways: Glaze one color on top of another, or paint these colors side by side in your painting.

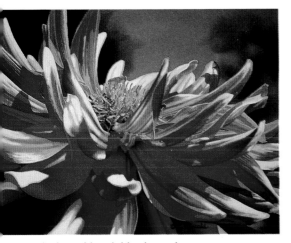

glazing with neighboring colors
A red flower might have a series of connecting shapes painted in a succession of Winsor Violet, Anthraquinoid Red, Winsor Red, Cadmium Red Orange and Permanent Rose.

Dahlia Fire
Elizabeth Kincaid · Watercolor
10½" × 14½" (27cm × 37cm)

use the color wheel as a guide
Glazing with analogous colors helps preserve intensity. For instance, if your color is orange and you want to maintain its brilliance, you need to limit how far around the color wheel you travel away from orange to find the colors you'll use to glaze. You can use any of the reds or yellows, but stop short of any color with blue in it.

1 Permanent Rose
2 Winsor Red
3 Cadmium Red Orange
4 Indian Yellow + Cadmium Red Orange
5 Indian Yellow
6 Aureolin Yellow

creating the illusion of light

translating color into value and light

To fully appreciate the power of value, choose a photograph and make a painting of it using only black paint and water. You'll have to translate all the colors in their environment full of light and shadow into white, a series of grays, and black, helping you to see the value inherent in each color.

Value is the key to creating the illusion of light. Value contrasts establish the existence of light and darkness. Strong sunlight produces strong value contrast between lights and shadows. The soft light of a misty day produces much lower contrast between the darkest darks and the lightest lights. If there isn't much difference in value between the lit and shadowed sides of an object, the painting will lack a feeling of light.

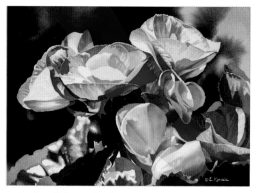

color has inherent value

This painting makes it clear that all colors have value. Value alone, independent of hue, can indicate light and shadow and create form.

Made in the Shade
Elizabeth Kincaid · Watercolor
10½" × 14½" (27cm × 37cm)

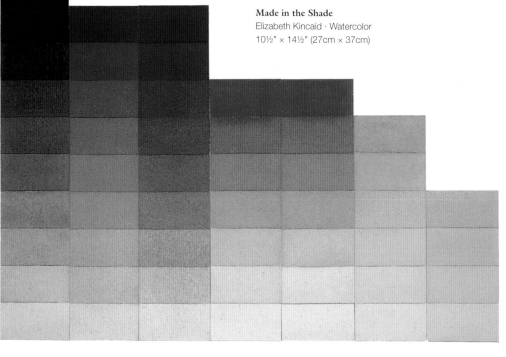

matching to a gray scale
Here, tints (diluted mixtures) of various colors have been matched to a ten-step gray scale. At the top of the gray scale is pure Ivory Black. As you can see, most colors at full concentration aren't as dark in value as pure Ivory Black.

shadows reveal form

Shadows reveal both form and light. Accurately painting shadows creates the illusion of our three-dimensional world on the flat surface of your paper. Therefore, shadows are an important piece in the design puzzle. Handled badly, shadows can weaken an otherwise strong painting and break the illusion. For this reason, you should seek them out in nature and study their shape, color, value and texture.

shadow terminology

When developing shadows for depth, remember these terms:

- *Cast shadow*: The dark shape on the surface under the object, created by the object blocking the light.
- *Core shadow*: The shadow found on the side of the object that faces away from the light source.
- *Core dark*: The darkest part of the core shadow, often at the center of the shadow shape in round objects.

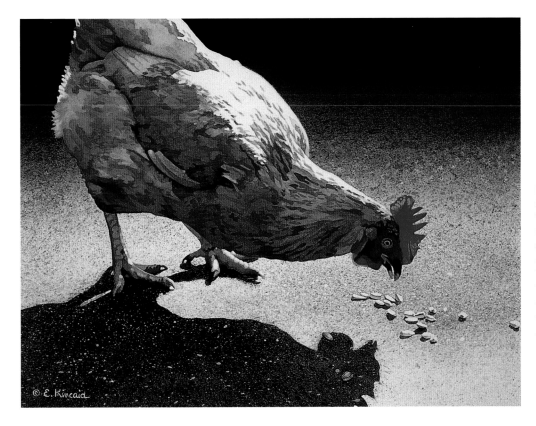

© E. Kincaid

look for interesting shadows

When the light source is behind or to one side of your subject, as in this painting, dramatic shadows result. These shadows reveal the form of the object and can also become exciting design elements in themselves.

Visit From a Neighbor
Elizabeth Kincaid · Watercolor
10¾" × 14½" (27cm × 37cm)

color basics

Knowing the color wheel and some basic color terms will help you avoid many painting problems.

ANALOGOUS COLORS: Colors within one or two steps of each other on the color wheel.

COMPLEMENTARY COLORS: Any pair of colors opposite each other on the wheel. Placed side by side, complements create vibration, contrast and interest. Mixed together, they tend to create neutral tones.

HUE: A color's name, such as red, yellow or blue-green.

INTENSITY: How saturated or strong a color is. Also called *chroma*.

TEMPERATURE: How warm or cool a hue is. Reds and yellows are warm and aggressive; they appear to come forward. Blues and greens are cool and reticent; they seem to recede into the picture.

VALUE: How light or dark a hue is.

PRIMARY COLORS: Red, yellow and blue. With these primary colors, it is possible to mix all other colors. Your palette should include a warm and a cool version of each primary color.

acrylic color tip

When choosing acrylic colors, remember that acrylic paint tends to dry slightly darker than it appears wet. This is caused by the acrylic emulsion in the paint. Acrylic emulsion gives the paint its milky luster when wet. As the paint dries, the emulsion becomes completely clear, and the paint looks darker. Darker colors tend to be affected more than colors that have a lighter value. Try adding a dab of White to your mixtures to negate this color change.

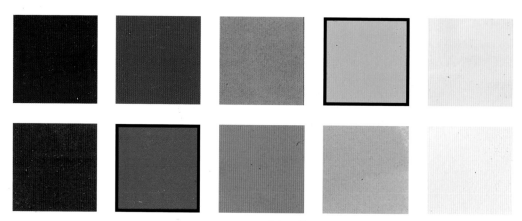

intensity

Intensity, or chroma, describes how brilliant or subdued a color looks. Within the yellow hue, a lemon has more chroma than a banana. The boxed colors show the high chroma colors; these swatches are the paint taken right out of the tube. The colors to the left of the pure pigments are darkened with black. The colors to the right of the pure pigments are lightened with white.

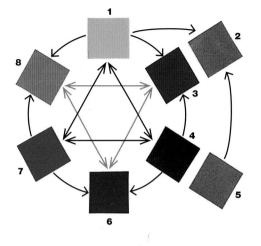

a basic palette

This color wheel shows a basic palette in acrylics. The secondary colors were mixed from the primaries in about a 50/50 ratio. Your paints may have different names depending on brand and whether you are using oil or acrylic, but the basic principles are the same.

1 Diarylide Yellow (primary)
2 Green mixed with Diarylide Yellow and Cerulean Blue (secondary)
3 Green mixed with Diarylide Yellow and Anthraquinone Blue (secondary)
4 Anthraquinone Blue (primary)
5 Cerulean Blue (alternate primary)
6 Violet (secondary)
7 Quinacridone Magenta (primary)
8 Orange (Secondary)

an expanded palette

The basic palette shown above is in the center of this diagram. Around the outside are examples of the kinds of tube colors you can add to your palette. These are a shortcut and can really save you time because you don't have to mix all of your own colors. However, it's best for a beginner to use fewer colors and mix them in order to learn to achieve a harmonious painting. Expand your palette one or two colors at a time as your experience grows.

1 Hansa Yellow Medium
2 Jenkins Green
3 Phthalo Blue (Green Shade)
4 Ultramarine Blue
5 Dioxazine Purple
6 Pyrrole Red
7 Red Oxide
8 Raw Sienna
9 Yellow Ochre

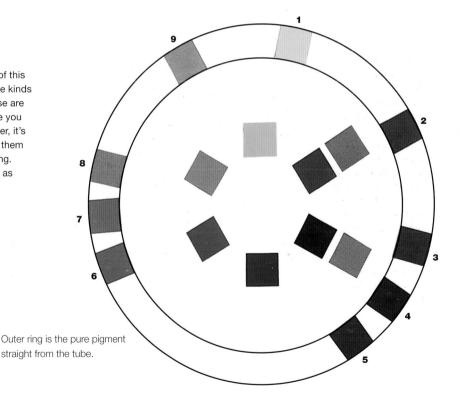

Outer ring is the pure pigment straight from the tube.

the full palette

A full palette includes all three of the primary hues—red, yellow and blue—in their full intensity. A full palette may be used to produce richly intense paintings as well as subtle grayer paintings.

creating intensity with your palette

Take advantage of a full-color palette by using vivid complementary colors. Complementary colors next to each other intensify one another. The effect will be greatest when the complements match in tone and strength.

the full-color palette

A full palette should represent the full intensity of the three primary colors. Two yellows, two reds, two blues, a green, a dark earth tone and white fill out the palette.

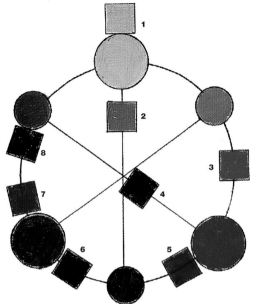

1 Cadmium Yellow Light
2 Yellow Ochre
3 Cadmium Red Light
4 Burnt Umber
5 Alizarin Crimson
6 Ultramarine Blue
7 Cerulean Blue
8 Viridian

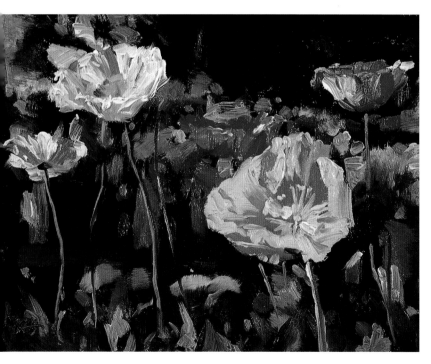

using the full palette

The color concept for this painting is basically "light and bright set off by dark and dull". This enables the strong colors of each flower to jump out at the viewer. Only a full-color palette could have achieved this.

Intense Statement
Craig Nelson · Oil
9" × 12" (23cm × 30cm)

the limited palette

For a wonderful limited palette, make a muted version of the color wheel by replacing red with Terra Rosa, yellow with Yellow Ochre and blue with gray (Ivory Black combined with Titanium White). The relationships between the colors will create a feeling of full color.

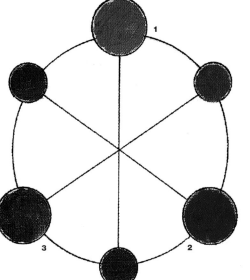

a limited palette
Using a limited palette will help you understand hue, value and intensity, especially if you are painting in acrylics or oils for the first time.

1 Yellow Ochre
2 Terra Rosa
3 Gray (Ivory Black and Titanium White)

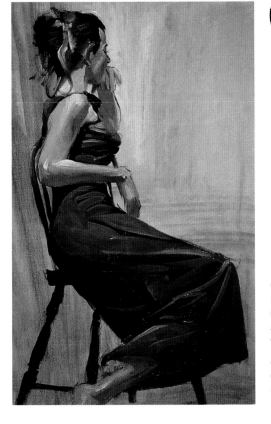

using the limited palette
Having only four colors to choose from made the unified, grayed color harmony of this painting easy to achieve. Value was the most important consideration, followed by hue and then intensity.

Classy Attitude
Craig Nelson · Oil
30" x 16" (76cm x 41cm)

variation: the analogous palette

One variation on the limited palette is the analogous palette. Analogous color schemes are colors that are related through one common color. For example, a lemon, an orange and a lime all have yellow in common; therefore, they are all in the same color family. Analogous colors can bring color harmony and unity to a painting while also working to establish a painting's mood.

planning the values

As with all paint mediums, building your acrylic or oil composition starts with a good value sketch. After you have selected a subject that you find engaging, begin sketching the design on paper with pencil, paint or even marker. Simplify the scene into masses of darks and lights.

Working with just black, white and a few grays will help you quickly identify the areas of light and dark. Without color, value is everything.

When you have determined the values for your composition with your sketch, you will be ready to translate those values into color.

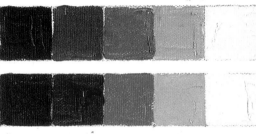

gray scale compared to a color

going from gray to color
With this chart, you can see how black and white values get translated into color. See the excercise on the following page to learn how to create these scales for each of your colors.

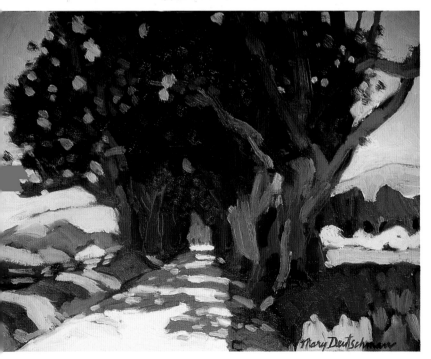

from value sketch to painting
In the finished painting, notice how the black and white values from the sketch above are translated into color values for the final composition.

Arbor in California Countryside
Mary Deutschman · Water-soluble oil
9" × 12" (23cm × 30cm)

mixing to change value

Making an acrylic or oil color lighter is easy—just add white. Making a color darker takes practice: you do it by adding some of a darker color. Get to know the colors on your palette by making a value scale for them as shown here.

create a value scale for each of your colors

Do this excercise with each of your colors. Draw five 1-inch (25mm) blocks across the top of a piece of canvas, canvas paper or canvas board. This will be your gray scale. Make the leftmost block black, the rightmost one a very light gray. Make the middle block a medium-value gray. Make the remaining two values medium dark and medium light so you have a gradual scale. You will judge the other colors by this gray scale, so try to be accurate.

 Squeeze a dab of five or six of your colors onto your palette. Place each of these under its corresponding gray value. Tube colors such as Ultramarine Blue and Phthalo Green are very dark and will be under the black column. Reds and oranges will probably be under the middle column, and some yellows will be very light. Once you have placed the tube colors there, you will have fun filling in the rest of the values for each color. The secret is in matching the values with the gray scale. Label each color on this chart and keep it for reference.

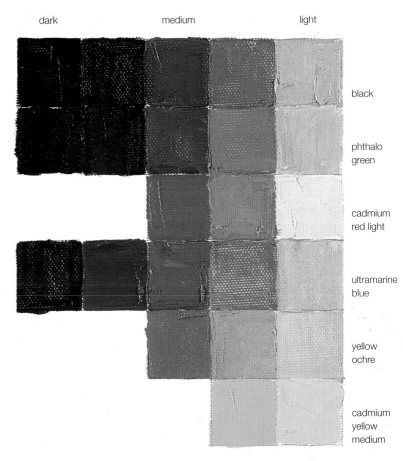

dark medium light

black

phthalo green

cadmium red light

ultramarine blue

yellow ochre

cadmium yellow medium

mix enough paint

Artists tend to put out minuscule amounts of paint on their palette, not wanting to waste paint. What gets wasted instead is time. When you want more of the same color you have already mixed, it will take much longer to match it and you might not end up with a perfect match. It's best to start out with more paint than you think you will need.

high-key color schemes

A painting in which light values dominate is called high key. Such paintings may have an airy feeling. They can contain a lot of beautiful color variation, since darks usually dull down intensity.

High-key paintings are extremely challenging: If you use too much white, they can become washed out. Look for the color variations between light and shadow, and be sure to capture colors that bounce from one surface onto another.

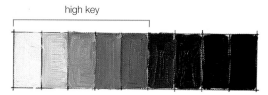

high-key values

This gray scale shows where the values for a high-key painting would fall on a full range of value. High-key paintings are represented by the light end of the gray scale.

maintain the high-key concept

Still lifes are excellent subjects for high-key paintings. Choose light-value objects of varying colors. You can exaggerate the color differences as long as nothing leans too dark. Maintaining the high-key concept is the challenge.

White, Light and Bright
Craig Nelson · Oil
12" × 16" (30cm × 41cm)

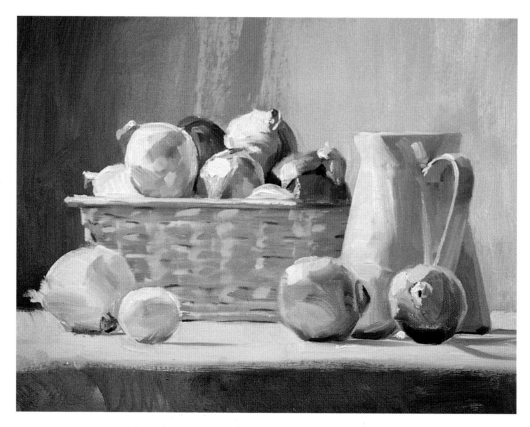

low-key color schemes

A painting that favors the darker half of the value range is called low key. Dim lighting and shadows can figure heavily into such a painting, creating a mood of mystery.

In low-key paintings, the light areas contain the most intense color. The shadows often dissolve into near blackness. Analogous or limited palette schemes can work well for a low-key painting but are not required.

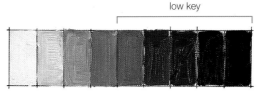

low key

low-key values

This gray scale shows where the values for a low-key painting would fall on a full range of value. Low-key paintings are represented by the dark end of the gray scale.

creating mood

When working with limited or subtle color schemes, you can use lighting to create mood for your piece. Mood created through lighting may be caused by deep dramatic shadows, contrasting backlighting or an interesting direction of a light source. Mood lighting often deals with a dull or unified color scheme, but a moody piece may also be colorful, its mood created by a unique angle of light. Although the mood of a painting may be created by the light, it is the concept of mood that a painter must concentrate on while working. This may include the elimination of detail, losing edges into shadow or a purely unified color effect.

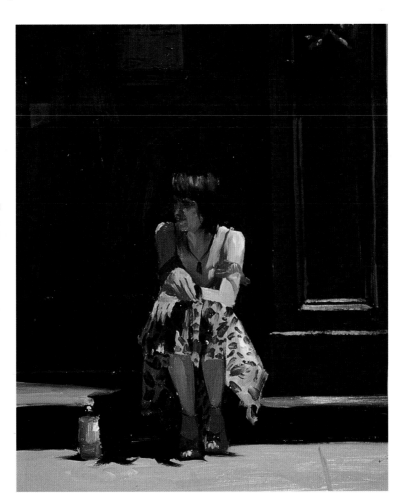

create a lost-and-found effect

This subject, a woman sitting in a shadowy doorway, lends itself to the low-key concept. The figure is almost swallowed by the shadow, creating a lost-and-found effect. The lights on the girl are so minimal that they do not overpower the low-key effect of the painting. The darks thoroughly dominate.

Soho Girl
Craig Nelson · Oil
16" × 12" (41cm × 30cm)

3

composition

composition basics

before
This drawing was done from a still life setup. The crock is sitting almost exactly in the center of the composition, violating the "rule of thirds" for placing focal points.

after
Here, the crock and cheese jar have been moved to the right, and the small jar on the left has been moved farther left so that the spacing between the jars would not be too even and repetitious. The result is a much more balanced and effective composition.

What exactly is composition? Simply, it's how the ingredients fit together to create your painting. Many painters struggle with composition. Some seem to have an innate sense for it, but most of us can benefit from some guidelines to follow.

elements of composition

Composition should bring the viewer's eye into and around the painting while creating harmony and balance. To create successful paintings, incorporate the following:

- **FOCAL POINT.** This is the center of interest, the first place your eye goes to when you look at the painting. You don't want it to be perfectly centered in the picture: Symmetry is dull. Use the *rule of thirds* (see illustration on this page) to place the focal point in a more pleasing spot.

tip

Tracing paper makes it easy to experiment with composition. Lay a piece of tracing paper over your sketch and trace the objects, simply moving the tracing paper as needed to change the relative positions of objects. You can do several quick variations this way in the time it would take to create one new sketch from scratch.

- **VALUE.** Using a full range of values from dark to light will make your painting stand out from the crowd.
- **HARMONY AND BALANCE.** Repeating shapes, colors and patterns in your painting will create a sense of harmony and balance. Add drama by introducing a little variety in these areas. Strive for balance between busy space and empty space. Empty space is an important ingredient in a well-balanced composition.
- **DEPTH.** Create depth in your painting with value and overlapping objects. Place objects in the foreground, midground and background.

rule of thirds
Imagine that there are lines dividing each side of the picture area into even thirds. The crosspoints on the grid are potential focal points for your painting.

composition: a real-life example

Get familiar with the elements of composition by following an example of how an actual painting was designed. In the series of photos on the next three pages, the artist tested several compositions and vantage points by photographing a still life setup.

photograph many arrangements to find balance and harmony

In the photo at top right, the arrangement of the fruit is too heavy on the right. The left side looks virtually empty. The middle photo's entire composition is too busy. The three plates and honeydew melon half are just too much. The bottom photo is getting close, but it's still not quite right. The stripe effect created by the stacked plates nicely mimics the stripes of the cloth, but the absence of the grapes with the additional green color and round shapes has left the setup a bit too sparse.

advantages of taking still-life photos

Working from photos of still-life setups allows you to paint perishable fruit without having to hurry. It also lets you try many different arrangements and light setups. One idea leads to another; you may end up with a terrific picture that you would not otherwise have considered.

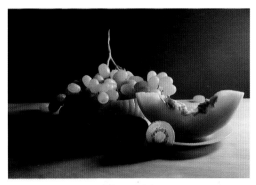
Imbalanced setup

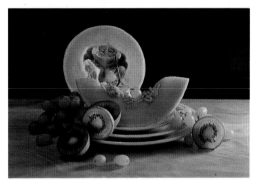
No empty space

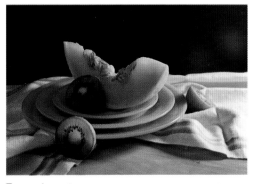
Too much empty space

experiment with lighting

The proper lighting of a subject can set a mood and help you tell your story. Light lets the viewer know if the sun is shining or if the only light is coming from a lamp. Beyond that, light creates shadows and highlights, which contour and shape objects.

Move your subjects and lights around, photographing many different setups, until you get the shadows and highlights that best show off the subject. The right lighting can add depth and drama, and can move the viewer's eye through the painting.

point of view

Another important influence on a composition is the angle from which the subject is depicted. In this example, the artist continued to explore different composition options by varying the point of view.

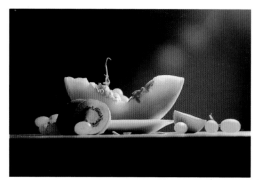

looking up from below
The objects dominate the picture. Shadows in this viewpoint tend to be unusual.

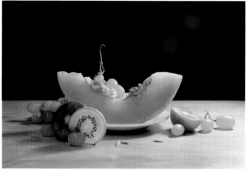

straight-ahead view
This view gives a still life an intimate feeling. Use strong lighting to overcome the lack of cast shadows.

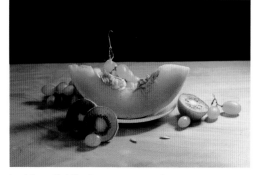

looking slightly down
Cast shadows are more evident than with the straight-ahead view. This creates instant depth.

overhead view
This viewpoint creates interesting, unusual compositions. Cast shadows become a very important part of the whole.

the final painting

Here's how the composition came together.

FOCAL POINT: The focal point is the area around where the seeds of the melon meet the grapes. This follows the "rule of thirds" principle described on page 66.

VALUE: The areas of strong value contrast attract attention and move the eye around the painting.

HARMONY AND BALANCE: The repetition of circular shapes brings harmony to this composition, while the grape stems and the pointed seeds balance the round shapes with linear ones. The various greens are in harmony with each other. The greens are balanced by the red (green's complement) in the seeds and tabletop.

POINT OF VIEW: A point of view looking slightly down shows off the backlit fruit better than any other perspective. The shadows add depth and help unify the objects.

DEPTH: The multiple overlapping of objects creates most of the depth in this painting, but the backlighting, shadows and value contrasts help too.

Shades of Green
Cecile Baird · Colored pencil
9" × 12" (23cm × 30cm)

using natural lighting

Sometimes nothing will create the lighting effect that you are after better than nature itself. Natural sunlight adds warmth to your still-life setups with color variations that shift depending on the time of day.

Try placing your setup in front of or beside a window, or do the entire setup outside. Also try different times of day for different shadows and lighting effects. Late-afteroon sun tends to produce the richest, most interesting shadows. Mid-day shadows are short and harsh.

a compositional theory for landscapes

Composing a landscape painting can be confusing due to the intricacy of the subject matter. Here is a principle to help you find the abstract patterns that tie a scene together.

the bar theory

The bar theory explains the primary breakup of space and tonal values in a landscape. The source of light, or sky, is the lightest area with a value from 0 to 30 percent. The ground, which receives the light, is the middle value of 30 to 60 percent. The vertical portions in shade—including vegetation, trees and buildings—are in the darkest area of 60 to 90 percent. With a snowy winter scene or bright sand on a beach, the bar theory sketch is turned upside down as the sky is usually darker than the ground in these settings.

This first step in designing the composition of your painting should be to emphasize the

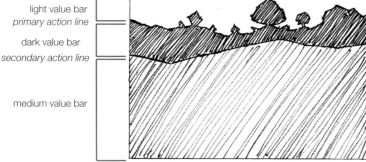

light value bar
primary action line

dark value bar
secondary action line

medium value bar

bar theory and action lines
The diagram above divided according to the bar theory. Space is divided into three zones or "bars" of value. The "action lines" are the divisions between the bars.

action lines at work
This painting shows the bar theory in its simplest form. The action lines clearly mark the value divisions of the painting. The sky is light value, the trees are dark value and the rocks are medium value.

One on the Rocks
Roland Roycraft · Watercolor
14" x 21" (36cm x 53cm)

unequal shapes and sizes of these various value areas so they are interesting to look at. Do several thumbnail sketches to find the pattern that satisfies you. A painting may include one, two or all three horizontal bars.

action lines

Because the horizon line used in one- or two-point perspective (page 91) is seldom seen, the silhouette of the foreground against the sky or background is important. Think of it as an "action line." It can involve the lacework of the painting as it includes all the little holes between the branches, foliage and sky. Try to get at least a small part of the action line in every painting because it helps to indicate a source of light.

A secondary action line, which is less important, may serve as a divider between the two lower value bars. If a reflective surface such as water is in the foreground, an upside-down action line may appear there in the sky and background reflections.

Do several thumbnail sketches to experiment with this preliminary division of space.

variation

There is no dark-value bar in this beach scene, as the only vertical object is the figure. The challenge in such a scene is to create enough foreground texture to lead the eye back in the composition.

Platte Bay
Roland Roycraft · Watercolor
14" x 29" (36cm x 74cm)

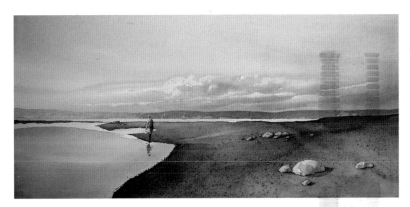

action lines add movement

Here the primary action line runs across the tops of the trees and includes the lacework of the trees. The secondary action line runs along the house and the overturned boat.

At Rest
Roland Roycraft · Watercolor
14" x 29" (36cm x 74cm)

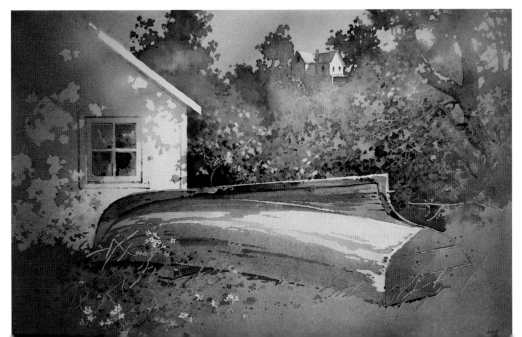

technique: composition chips

In a landscape painting, the largest value "bar" (page 70), the foreground, is broken up into smaller shapes of different colors and values to represent reality. If you merely follow what is shown in a photograph, you aren't assured of a good composition.

Try this technique: Cut up one of your small throw-away paintings into various little pieces and put them into an envelope. Sketch a rectangle onto a white piece of paper, and shake some of these "composition chips" onto the area. This forms a random pattern of small groupings of various shapes, sizes and colors. Reposition some of the pieces until you like the arrangement of colors and values. This random dropping is a way of imitating nature's way of dividing up space. The patterns you find in the dropped chips will inspire you; you'll begin to see painting possibilities in them. The chips could represent a cluster of leaves in the woods, a group of people in the mall or clouds in the sky. Rearranging them slightly brings your compositional judgment into play. Let the results lead you to a painting.

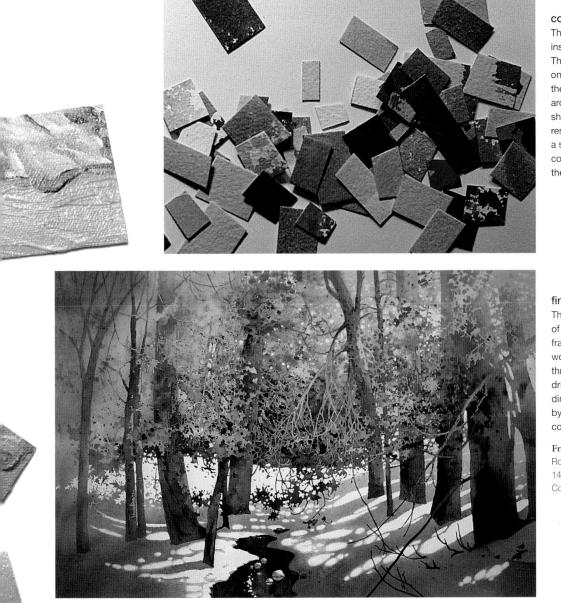

composition chips

These composition chips inspired the painting below. The artist dropped the chips onto a piece of mat board, then nudged some of them around to adjust the relationships of shape and color. The resulting pattern gave him a sense of the shapes and colors he wanted to use for the painting.

finished painting

The multicolored background of this painting illustrates the fragmentation of the winter woods as the light filters through the branches and dried vegetation. A three-dimensional effect is created by these small fragments of complementary colors.

Fragmented Light
Roland Roycraft · Watercolor
14" × 21" (36cm × 53cm)
Collection of William Jamnick

taking reference photos

Painting from life is a valuable experience, but working from photographs is undeniably convenient. Your still-life setup won't take up space in your studio, and you don't have to worry about perishable fruit spoiling. You can paint a dramatically lit subject without having to work in a darkened room.

Just be aware of the distortions that photos can create. Straight lines near the edges of a photo frequently appear to bow outward. Don't duplicate these distortions in your painting: Use a triangle and T-square to straighten lines in your drawing before you paint.

tripod
A tripod is very handy for still-life photography. Under low-light conditions, a tripod is essential. It takes a long exposure to photograph in low light, and it is impossible to hold the camera still for long enough to avoid blurring.

film camera
A 35mm SLR (single-lens reflect) camera is best for reference photography. An SLR camera allows you to frame your composition accurately because you are seeing your setup directly through the lens. On inexpensive point-and-shoot cameras, you are looking at your subject through a separate viewfinder, and your framing won't turn out quite the way you expected.

digital camera
With digital cameras you can see your photos immediately, and you can manipulate and print them on your computer. Find out how to turn off the flash on your digital camera, because a flash will completely destroy the shadows in your still-life setup.

print film
Fast (more light-sensitive) print film such as 800-speed works well for taking photos of setups in the studio. If you shoot outdoors, where light is plentiful, use 200-speed film for photos with great color and less grain.

take lots of photos

Don't skimp on film. Take lots and lots of photos. Try different arrangements, lighting and angles. Take close-ups of all the objects in your still life to see the texture and detail of each item. You will be glad you have them once you begin to draw. Alter the lighting to get pictures of objects in shadows. This enables you to see subtle detail in the shadow that you might want to show.

composition and reference photos

Photography is good for more than just recording images. It can be a part of your design process. Your camera, after all, is essentially a cropping device.

Start by scanning an area outdoors, just looking for anything that attracts your eye. Search for scenes in which light creates something magical out of something ordinary. Then use your camera to isolate this rectangle, this slice of reality.

Thinking about design at this point is critical. Cropping and composing in the photography stage doesn't have to be the final word on what you'll paint, but it's a wonderful first step. A zoom lens can help you try out different crops easily.

equipment for landscape photography
In addition to the equipment for still-life photography shown on page 74, the landscape photographer will benefit from:

SLIDE FILM: Slides capture the nuances of light and color better than prints.

ZOOM LENS: A zoom lens lets you stand in one spot to capture different crops of a landscape scene.

choose the best composition
Take many photos, then choose the one that best emphasizes what's important to you about the scene. The more distant shot of these boats (near right) includes too must background. The closer shot (far right) partially crops out the boats in the background, allowing the foreground boats to take center stage.

improve upon good design
Even if your photo was carefully thought out, look for compositional improvements and test them in thumbnail sketches. In this sketch of the boat scene, some shadows were removed from the foreground, and the shadow on the right was extended to balance the composition vertically. The image was cropped along the bottom and right edges for a tighter design.

designing thumbnail sketches

Once you have your photos in hand, move on to the next step: the thumbnail sketch. Using black, white and a few grays, indicate the masses and the major shapes of light and dark without trying to render a detailed image. Now evaluate this simplified version of the scene. Is it a clear, strong composition? How could you improve it? Look for movement, patterns and lines formed by masses of objects that will lead the eye.

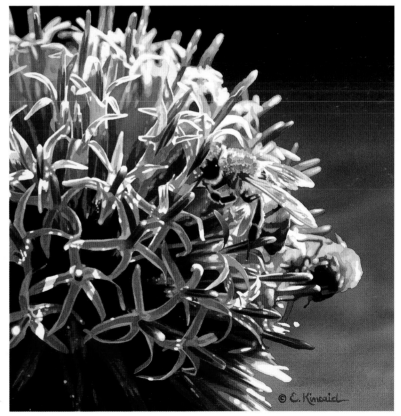

don't be afraid to get close
The interesting light effects in this flower demand a close-up view, but one lollipop-shaped flower would make a strange composition. A close crop does the trick. Notice the subtle value changes within the purple that really make this painting work.

Gift From Marv
Elizabeth Kincaid · Watercolor
13½" × 13½" (34cm × 34cm)

use photos wisely

Even if you fall in love with a certain photograph, never try to duplicate it. Treat photos as a source of ideas from which to build your paintings in combination with your knowlege of design principles. A photograph documents nature, but it does not necessarily make a good composition. Add yourself in to the mix by using your artistic judgment to combine, omit and exaggerate elements. This makes your artistic statement truly yours.

several views
These three photos were assembled to make the small color thumbnail shown on the opposite page.

photography tips

- Take lots of shots from different angles.
- Photograph your subject at three different exposures (called *bracketing*) to increase your chances of getting a good exposure.
- When combining reference photos, make sure the light sources are consistent. Otherwise you'll end up with impossible combinations of shadows in your painting.

get a head start on composition

When shooting reference photos, use the camera's viewfinder to find good painting compositions.

- For a composition with depth, look for objects that will lead the eye from the foreground toward the background. Be willing to move your tripod to get a more interesting perspective.
- Frame the scene so that strong verticals such as trees do not divide the picture in half vertically.
- Do not let the horizon divide your picture in half.

from color study to finished painting

The color thumbnail combines elements of the three photos on the facing page and is the basis for the final composition.

Sleeping Bear Pathway
Roland Roycraft · Watercolor
14" x 21" (36cm x 53cm)

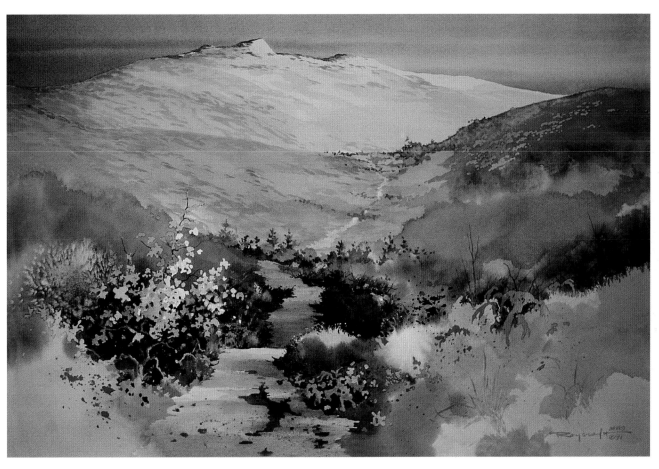

look for interesting shapes

A painting is two-dimensional. Designing a painting is like fitting together pieces of a jigsaw puzzle. These puzzle pieces are shapes that can be classified as round, square, triangular or some modification or combination of these. The shapes in a painting need to relate to one another and lead the viewer's eye through the artwork.

perfect symmetry
Circles, squares and equilateral triangles are the basic shapes. All are perfectly symmetrical. This perfect balance makes them uninteresting to look at.

dynamic shapes
Positioning a shape on an oblique angle suggests movement and makes a more dynamic statement.

distinctive shapes
Variety in edges—soft, hard, rough or smooth—gives the viewer additional information and makes a shape more interesting. A distinctive silhouette reveals the character, mass and function of the shape. Notice that simply trimming away at the edges of the circle, square and triangle can create these distinctive shapes.

finding motifs in nature

When you paint, it's easy to get sidetracked by all the confusing information and intricate details, especially if you are working in the great outdoors. There is much to see, and in the excitement sometimes an artist attempts to capture all this wonderful inspiration in one picture. It's little wonder that nature artwork can become overly complicated and lose focus.

When you find yourself in this situation, try looking for the simple shapes first. Concentrate on a small area and try to ignore all the non-essential details. See each object as a single shape. Next, explore the whole photograph. Search for shapes that are similar. Notice how a single shape is frequently repeated in nature. Each plant has its own unique shape and we commonly identify the type of plant by the shape of its leaves, flowers and stems.

A painting needs only a limited number of shapes to be successful. Variation keeps a repeated shape from becoming boring.

create variety in your shapes
The violet leaves curl and overlap. There is variety in size and direction in these numerous heart-shaped leaves.

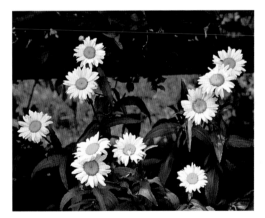

simplify recognizable shapes
The daisy's petals create an unmistakable, distinctive silhouette. It is not necessary to paint in veins, dew drops or ladybugs. Even without the yellow center, this shape with its serrated edge reads as a daisy.

making order out of natural chaos

Natural objects often fall in random, disorderly patterns, which can make for a painting with a casual, even chaotic feel. If that's not the statement you want to make, don't be afraid to eliminate some elements from the scene. For example, if a grouping of flowers scattered in a field looks too informal, choose just one flower upon which to focus your composition. The result will be almost like a formal studio portrait.

painting starts with seeing

Most of the time, every image we see is cloaked with labels we've been taught to attach to the world around us. In other words, you see a chair, not a conjunction of angles, parallelograms and triangles. You see a ball, not a sphere. To live successfully and practically, this habit is necessary.

However, this habit gets in the way of painting or drawing successfully. If you learned to draw a Christmas tree as a child, that stylized shape will intrude on your ability to really see the unique shape of an individual evergreen tree.

Seeing requires a total focus of your attention. Meditate upon a subject before you begin drawing or painting it in order to overcome your brain's habit of labeling objects and seeing stylized versions of them. At three different points in the painting process, fresh eyes are invaluable: when creating a strong design, when making an accurate drawing and when evaluating the almost-finished painting.

how to see a chair
This chair can be represented with simple geometric shapes, as the diagram shows. An artist sees not just "a chair," but shapes and angles.

Sally's Chair
Elizabeth Kincaid · Watercolor
9½" × 6½" (24cm × 17cm)

stylized shapes vs. reality
The average human would translate a tree to the kindergarten version of a Christmas tree. The artist needs to study the shapes and values particular to the tree he or she is drawing or painting.

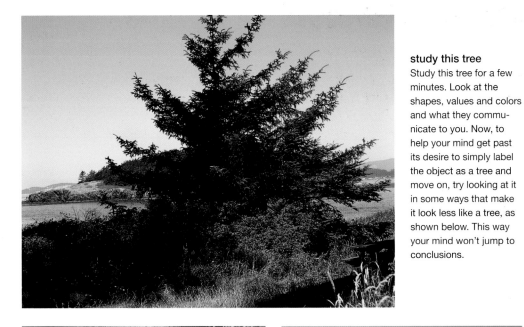

study this tree

Study this tree for a few minutes. Look at the shapes, values and colors and what they communicate to you. Now, to help your mind get past its desire to simply label the object as a tree and move on, try looking at it in some ways that make it look less like a tree, as shown below. This way your mind won't jump to conclusions.

negative space

positive space

turn it upside down

If you're working from a reference photo, turn it upside down. Now you can study value patterns, shape and the object's relation to its environment without any preconceived notion of how it should look.

look at negative space

Try drawing and shading in the negative space, or in other words, the shape of the air that contains the object. Drawing the shape of the air to create the shape of the object also helps you break away from the label your mind puts on an object. To really fool your mind, try drawing the negative space when the picture is upside down.

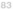

balance and the division of space

Shape, size, color, line, texture and edges work to influence the mood of your painting. Now you'll need to distribute these elements in an organized way to create a sense of balance and direct the eye along a visual pathway.

shift the balance
Dividing a painting's edges in half is uninteresting (3). A simple solution is to roughly divide the edges in a relationship of two-thirds to one-third (4). This establishes a more interesting sense of balance. Each shape thus created is a different size and proportion.

a distance to travel
A larger foreground (1) contributes to the impression of deep space, and can bestow a feeling of solitude and loneliness. A larger background (2) makes us feel closer to the subject.

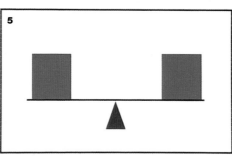

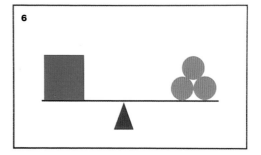

asymmetric equilibrium
Dividing a painting into equal spaces is uninteresting (5). A simple solution is to roughly divide the space into a relationship of two-thirds to one-third (6). This establishes a more interesting sense of balance. Each shape is a different size and proportion.

movement and direction

Just as a map leads a treasure seeker to the reward, you can direct the movement through your painting to the areas of interest. You guide the movement with lines (real or implied), edges and shapes.

provide a stop
The predominant use of horizontal movement or line (above, top) evokes a tranquil feeling. If the line is left unbroken, the eye travels quickly across the painting and out the side (and onto someone else's painting). Provide a few minor verticals (above, bottom) to slow or stop the eye.

make it swing
Curvilinear movement swings and flows. The red dotted line is a section of a circle that extends beyond the boundaries of the painting. To hold the viewer's eye in the painting you might want to counter the first arc with a secondary curve, the blue circle.

zig and zag
To evoke a dynamic and exciting sensation, create a path that darts back and forth. To soften the impact, use a slightly more curving S-shaped path. Be careful not to slice the painting into equal halves.

a heavenly feeling
Uninterrupted verticals yield a hopeful, spiritual sensation. Adding some horizontals stops prevents the eye from escaping the painting.

vertical suspense
A feeling of suspense can accompany vertical move-ment, for with only a slight adjustment the vertical becomes an oblique that threatens to fall.

develop a theme with shape and motion

square format
The square format is all too often overlooked. Perfectly balanced, it suggests intimacy—a quiet, captured moment.

When the focus of your painting is to establish a particular mood, it's natural to partner shape with movement. Combine one type of movement, either curvilinear, oblique or straight, with forms of the same type, based on the corresponding shape—the circle, triangle or square—and you will have a harmonious relationship. The eye moves around the perimeter of a shape in the same way it travels through the painting. The mood established is consistent with the individual personality of forms, lines and movement.

vertical format
Break away from tradition. Why not try a landscape using a vertical format? The feeling created is light and airy, but a sense of instability pervades as the tall vertical could easily topple. The picture plane appears flatter and shallower.

circular format
A circle fits into a square format. The feeling is similar, but softened by the rounded corners. This format provides a porthole or spyglass view of the artist's innermost feelings and vision.

horizontal format
Horizontal, or landscape, format feels peaceful and stable. The eye moves from side to side, back into the space. Movement from bottom to top is limited.

unity through shape and movement
In these three illustrations the shapes were randomly scattered within the space without giving attention to placement. Unity and harmony exist merely because of the association between shapes, line and movements.

the center of interest

In the theater when one actor appears on stage, all of our attention is drawn to that individual—the star. In the same manner, putting one shape anywhere on a piece of otherwise blank paper immediately draws the eye to that spot. While a talented actor is able to entertain us and hold our attention, you will most likely want more than just one shape in your painting. Adding even one additional actor, or shape, begins the competition for attention. If both characters are equally important your attention will bounce back and forth between the two, unsure of where to focus. On the other hand, filling the stage or picture plane with many actors or forms, all vying for attention, results in a lot of noise and confusion. The stage direction of your painting is up to you. What will be the main attraction and where will it be located?

Take your cue from a battle scene on stage represented in the images on this page. I have simplified the scene to a few basic shapes and values to illustrate the concept.

set the stage
When the triangular combatants and their swords are depicted with a high degree of value contrast, the eye is immediately attracted to them. Little attention is given to the nonaggressive, softly rounded forms that represent the crowd of bystanders.

change the focus
In the previous battle scene, the center of interest is clearly the dueling triangles. Rearrange only the values and notice how our attention is drawn away from the now gray rivals to the black and white bystanders. It follows that a wise painter will position highly contrasting elements in choice locations to determine areas of interest.

contrast of value
The battle scenes on this page depend on value contrast. Highly contrasting values (1) are a powerful visual draw when compared to a lesser shift in values (2). Lights appear lighter when surrounded by darks, and darks become increasingly dark when encompassed by light.

simultaneous contrast grabs attention

When opposites are placed side by side, they enhance and intensify each other. The two equally matched opponents compete for your attention in a phenomenon referred to as simultaneous contrast. The eye is captivated by strong contrasts of value, hue and intensity. The greater the contrast, the greater the visual attraction.

contrast of hue

Green is enhanced when surrounded with its complement, red (1). The same green surrounded by blue (2) is much less stimulating. In our battle scene, the yellow and orange antagonists stand out against the complementary blue background more than the green and violet spectators, who are closer to blue on the color wheel.

contrast of intensity

When encompassed by a neutral gray, the green appears clean and vibrant (3). Notice that the same green becomes lackluster when surrounded by a more intense version of green (4). In the fight scene, the vibrant pink and yellow seem to glow against the neutral backdrop. The muted bystanders seem to blend into the surroundings.

actions speak louder than words

Contrast isn't the only way to attract attention to a painting's focal point. The use of high activity and intricate details are other options. The eye hunts for interest—crisp edges, highly textured surfaces, patterns and intersecting lines—in preference over lost edges and quiet passive passages. The more you weave shapes and lines, create texture and enhance the surface, the more mesmerizing these areas become—up to a point. There can be too much of a good thing.

Where you position shapes and the centers of interest in your painting goes beyond simply making a pleasing arrangement. Frequently underestimated, placement is a powerful design tool. Placement affects the sense of balance and directs the viewer through the work. If the shapes and areas of interest are placed haphazardly or in conflict with each other, or if the artist has not provided a satisfying balance of elements, the results will leave the viewer unsatisfied.

select your design tactic

Here's a list of ways to attract attention to your painting's center of interest:

- simultaneous contrast of hue (complementary or temperature)
- value and intensity
- textures
- intersecting lines
- hard edges
- vibrant color
- intricate detailing

Select one type of simultaneous contrast as the major player in your painting. A minor supportive role can be taken by one or two of the remaining tactics. Cramming too many of these tactics into one painting would cause chaos and defeat your purpose.

color stands alone
There is no doubt about it: the eye loves color and actively seeks it out. If you want to attract attention, wave a brightly colored flag. A dull, or lightly tinted one just won't have the same effect. Pure color is captivating and electrifying. Position your cleanest, most vibrant color with the knowledge that you will be announcing "Look here!" Notice how the flags of pure color are the most eye-catching.

mass confusion
Whether it's a stage full of battling actors or a painting filled will too many equally demanding elements, the overall effect is clutter and confusion.

linear perspective

Linear perspective is the system of applied geometry by which we depict three-dimensional objects on a two-dimensional surface. Linear perspective makes objects appear larger when they are closer to you and smaller as they recede into the distance. A few simple rules will enable you to draw in linear perspective accurately and easily.

the vanishing point

With linear perspective you can create the illusion of parallel lines in a three-dimensional space. Parallel lines are drawn on a flat surface at an angle, so that they appear to be parallel in space as they recede into the distance, converging at specific points called vanishing points.

Vanishing points almost always occur on the horizon line, so establish this line first. Occasionally it is easy to actually see the horizon line, as when you are looking out across the ocean. But in many instances you cannot see it because your view is blocked by trees or buildings. Eliminate this problem—regardless of your view or position—by always drawing the horizon line at your own eye level.

the picture plane

The picture plane is an imaginary flat plane through which the actual three-dimensional objects in life are viewed. You may think of the picture plane as the surface of your paper up to and including the outer edges of your drawing. The artist draws on the paper, varying the size of the objects according to how near or far those objects are from view.

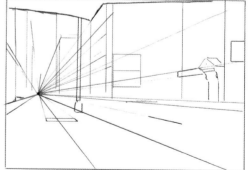

realism through linear perspective
This simple schematic clearly depicts one-point linear perspective as it applies to this painting. Linear perspective creates the illusion of distance, regardless of the subject.

Arch Street
James Toogood · Watercolor
14" × 20" (36cm × 51cm)
Collection of the Woodmere Art Museum

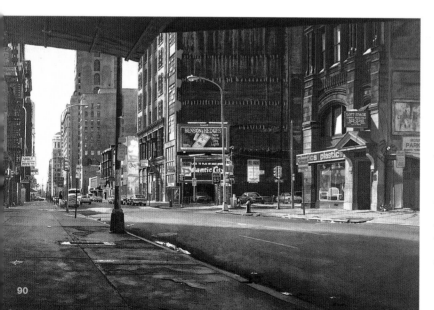

one-, two- and three-point perspective

Linear perspective is drawn in either one-point, two-point, or occasionally three-point perspective. The names refer to the number of vanishing points.

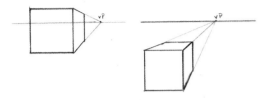

one-point perspective

One of the visible planes is parallel to the picture plane. Horizontals and verticals on this plane are parallel to the edges of your painting and do not recede. The other visible plane or planes recede to a vanishing point along the horizon line.

using a viewfinder

When working from nature, to help you imagine the two-dimensional world of your drawing, close one eye and look through a rectangular hole cut in a piece of wood or matboard. This device is called a viewfinder. It will help you determine your picture plane. You can attach a grid of wires or threads to the frame and transfer a corresponding grid to your canvas or paper to aid in your drawing.

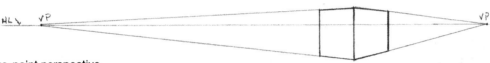

two-point perspective

All the visible planes recede to two separate vanishing points. Usually only the vertical lines are parallel to the picture plane.

three-point perspective

None of the planes or lines depicted is parallel to the picture plane. All planes vanish to three separate points, two of which occur on the horizon line, but one of which does not.

using format to emphasize a composition

compositional conventions

Even though artists may no longer feel quite as constrained by the conventional use of proportion and format, there are still certain intrinsic qualities about the shape of your painting that should be taken into account. A horizontal shape is considered more pleasing to the eye than a vertical. Horizontal shapes are somewhat more passive, and vertical shapes tend to be strong and dominant.

When approaching a new subject, among the first things to consider are the size and shape of the painting.

The shape of your painting is determined by its proportion and its format. Proportion refers to the ratio of height to width in your painting. Format refers to whether the shape of the painting is horizontal or vertical. The mere shape of a painting enables the artist to subtly imply a lot about the nature of the subject. For example, the narrow feeling of an alley can be reinforced with a vertical format. You can increase the sense of expansiveness in a landscape with an exaggerated horizontal format.

In the past, certain subjects had specific formats and proportions that were considered the norm. Traditionally, the format of a landscape is horizontal. In this format the implied view is from side to side. Today artists do not feel quite as constrained by the use of such strict conventions. A vertical format (which is a bit less conventional) can also be successfully employed for landscape painting. In a vertical format the implied view is frequently up and down. Because there is less of a peripheral view, a vertical format can also invite the viewer to look deeper into the painting.

horizontal format

The feeling of expansiveness in this painting is reinforced because of the elongated horizontal proportion of the painting. The directional lines of the bogs carry the eye deep into the distance. Even the clouds imply depth and movement.

Cranberry Harvest
James Toogood · Watercolor
16" × 30" (41cm × 76cm)

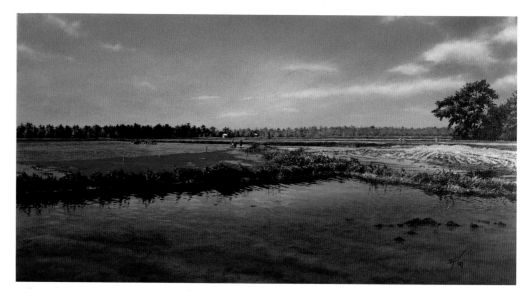

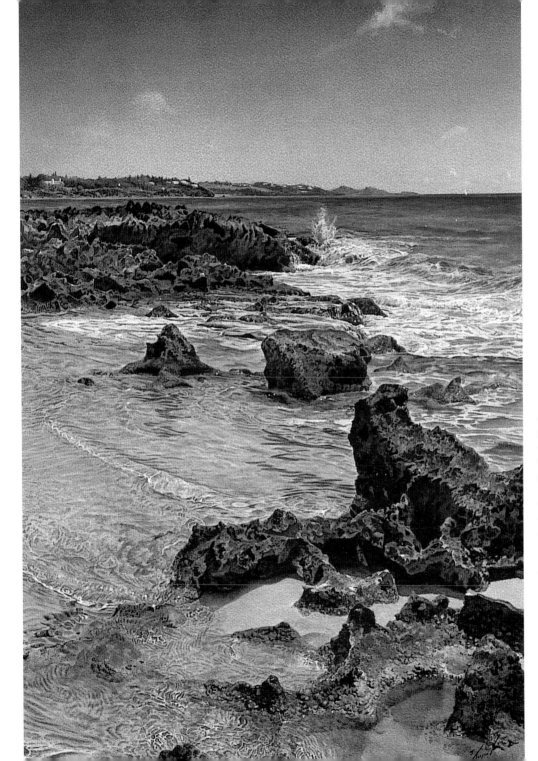

vertical format

In this painting, the vertical format helps to carry the eye from the foreground to the action of the waves crashing in the middle ground and finally to the shoreline in the distance. Emphasizing this are the implied directional lines formed by the arrangement of the rocks as well as the movement of the water.

Tidal Pool
James Toogood · Watercolor
20" × 15" (51cm × 38cm)

color and texture contrast at work

Color and texture, light and dark, and man-made and natural are all contrasted in this painting. The bright red car is contrasted with the greenish color of the lake. Other reds are repeated here and there. Green is repeated by darker greens on the distant shores and elsewhere. A violet is delicately applied throughout the water itself. The needles of the trees, made up of a heavy and directly applied green-violet mixture, are such a dark green against the pale gray sky that their texture is reduced to nothing but a spiky silhouette. This, along with the rough texture of the tree's bark, contrasts with the soft texture of the misty background and with the smooth shiny texture on the surface of the car. The choice of the violet throughout the painting, though not obvious, is there to contrast with the complementary yellow color of the sand and the yellow underpainting in the water, keeping all the colors in harmony.

The Last Moments of Summer
James Toogood · Watercolor
14" × 20" (36cm × 51cm)

breaking the rules

Because design is so important, artists have come up with rules to make this process simpler. Some of the more common rules include:

1 Never place the focal point of a painting in the center or on the edge of the rectangle.
2 Always vary the sizes of the major components.
3 Never lead the eye off the image by running strong diagonals into a corner.
4 Never place a person facing the edge of the paper.

Rules, however, are only guides; they are not sacred. Understanding the reasons the rules exist is far more important than following the rules. If a rule doesn't work for you, simply address its reason in some other way. You can successfully break any rule if you solve the problem that rule addresses.

Cat Watch
Elizabeth Kincaid · Watercolor
13½" × 21" (34cm × 53cm)

use value to link main elements
In this thumbnail for *Cat Watch*, the gradation of value from black at the top to white at the bottom links the cat and the chicken, creating a cohesive image. The choice of background values also sets up the play of light against dark (the cat) and dark against light (the chicken). When you play with these value relationships, you create a more dynamic image.

use visual tension to link elements in a painting
You could consider the cat or the chicken, or both, to be the focal point of this painting. Both the cat and the chicken are on the extreme edges of the painting, a location where one isn't normally supposed to place a focal point. What holds them together is the tension that exists in the space between. This "empty" space has only seeds, but they are attracting the chicken. Cats and chickens are natural adversaries. This painting asks, "Who is in charge here? What is going to happen?"

creating a path of focus

using contrast to move the eye

Contrast can be a matter of color, such as using colors at their most intense or placing complementary colors next to one another. Contrast can also be a matter of value, such as black and white next to each other or two colors with very little difference in value side by side. In representational painting, contrast is an important tool to create the illusion of real space. Low-contrast areas tend to recede, while high-contrast areas advance.

A path of focus is like a path through a forest. If you want an animal to follow that path, you must place treats all along the way. A painting contains a similar path with visual jewels placed along the way, leading the eye from one to another, weaving around the picture plane.

lines create movement

Lines induce the eye to move, whether the lines are formed by the edges of shapes or created directly with calligraphic strokes. Movement can be rapid, with straight lines and sharp angles, or slow, with soft, flowing lines and gradual transitions.

lead the eye on a visual dance
The eye follows the path marked by the bright centers of these Matilija poppies. The eye is attracted to what is most rare in any painting. In this case, dark greens, blues and violets dominate the painting, so the hot spots—the yellow centers and white petals—stand out.

Ladies Dance
Elizabeth Kincaid · Watercolor
22" × 29½" (56cm × 75cm)

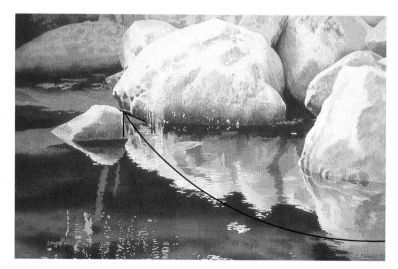

follow a direct path
The simple underlying structure of this painting of a cove in Nova Scotia leads the eye right to the group of rocks. Complex textures and reflections in the water give the viewer more to contemplate.

Rocks at Aspetogan
Elizabeth Kincaid ·
Watercolor
14½" × 22" (37cm × 56cm)

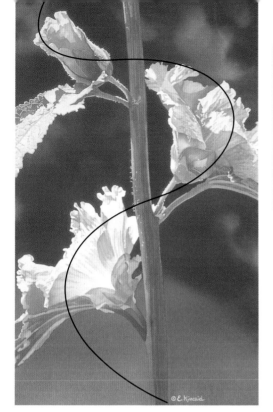

imbalance

Imbalance in a painting creates movement. You can't take a step forward unless you first place yourself in a state of imbalance. Consider a painting that has elements with high contrast on only one side and the center of interest in the middle. This arrangement creates an off-balance dynamic tension that is an antidote to the anchor at the center.

Well Centered
Elizabeth Kincaid · Watercolor
13½" × 21 (34cm × 53cm)

the curving path

The strong vertical line running down the center dominates this painting, but the flowers on either side create movement by leading the eye back and forth through the rectangle.

Mallow in the Pharmacy Garden
Elizabeth Kincaid · Watercolor
21" × 13½" (53cm × 34cm)

the cross format

The crack in the rock wall of this quarry and its reflection provide for the vertical axis of this cross design. The junction of the crack with the waterline creates a focal point for the eye. Placing that focal point to the left of the center of the painting gives that side more visual weight.

Afternoon With Leo
Elizabeth Kincaid · Watercolor
22" × 29½" (56cm × 75cm)

strengthen your design

These substructures can be helpful guides when you design a painting. They are commonly used to aid with design decisions.

nine equal rectangles

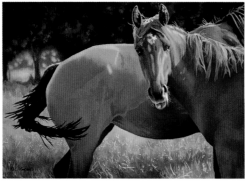

divide into ninths

With this structure, you place the center of interest at one intersection of lines and any secondary centers of interest at other intersections. Where the grid lines exit the rectangle is a good place to have major lines exit the painting; this avoids dividing the painting symmetrically.

Sugar?
Elizabeth Kincaid · Watercolor
10½" × 14½" (27cm × 37cm)

four equal rectangles

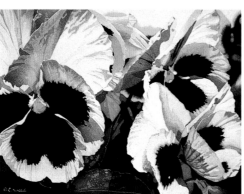

divide into fourths

With this structure, place the center of interest within one of the quadrants. All the quadrants should have something of interest, but one should dominate. Three quadrants might contain all the details in a painting, but the fourth could provide interest through graded washes or soft-edged calligraphic strokes. Most of the contrast and interest in this painting falls in the bottom and right-side quadrants, while the upper left is relatively quiet but not totally empty.

Pansies at Home
Elizabeth Kincaid · Watercolor
11" × 14½" (28cm × 37cm)

take a risk

Creating a strong diagonal that runs to a corner may lead the viewer's eye out of a painting. This painting succeeds because there is something else to pull the eye back in: the high contrast between the dark background and the pink flowers.

First Orchid
Elizabeth Kincaid · Watercolor
10½" × 14½" (27cm × 37cm)

subdividing à la mondrian

Piet Mondrian, a Dutch painter in the early twentieth century, used horizontal and vertical black bands to create unequal-size boxes filled with white or primary colors. In a Mondrian, certain spots attract the viewer because of their intensity relative to the surrounding field of white and black.

The representational painter can learn useful lessons from the way Mondrian painted:

- The greater the intensity of a color, the greater its weight. Red has more weight than blue and yellow, but certain blues can be quite intense and weighty.
- The size of a colored shape will increase or decrease its weight.
- Vary your shapes and the spaces between them to help move the eye.

a mondrian-like design in watercolor

Many of Mondrian's paintings have just a few lines and are much simpler than this painting. Try creating your own Mondrian-like painting. First divide a square into rectangles of different sizes and proportions. Do this by drawing vertical and horizontal lines that divide the space unequally. Then choose three shapes to fill with red, yellow and blue. The challenge is to create visual balance despite the unequal color weights and rectangle sizes.

testing a composition

One way to evaluate the impact of your composition is to turn it upside down. This should be an important part of your working process. Sometimes at the thumbnail stage, you have a question about your concept or how your composition is working visually. Turn the thumbnail sketch and reference photo upside down and evaluate them from this perspective.

It is also a good idea to invert your painting frequently while in the process of painting. Be sure to stand far enough away so that you can easily evaluate it. Facing the painting toward a mirror is another way of getting a fresh view. Look at the design, but don't label the objects in it; just see shapes.

These practices allow you to evaluate the design as an abstract and to see it with fresh eyes.

sketching

A great painting usually begins with a strong sketch. A sketch generally depicts its subject in a linear fashion showing basic linear breakdown and contour. Some sketches include a bit of tone achieved by linear hatching, scribbling or smudging. A sketch lets you plan subject placement, basic shapes, perspective (if necessary), proportions and gesture before committing paint to paper or canvas. Complete each planning sketch in two to five minutes; too tight a drawing may inhibit you from painting boldly and freely.

dare to deviate from your sketch

As your drawing skills improve, you may find that your sketch is merely a beginning rather than a diagram of your finished painting. As you paint, you will increasingly be able to look and make decisions, then build layers or scrape away in order to make your painting what you want it to be.

sketching organic forms

When sketching organic forms, it is best to look for angles and lengths. Angles will give gesture, and lengths will give proportion. These will, in turn, create the basic shapes of the subject. This sketch was done in about three minutes using a no. 2 bristle filbert.

the study

The sketch at top was the basis for this study. The background tone at the top helps to establish the figure contour. The basic goal is to create masses where there are lines. Finish by adding light and shadow to give form to the masses.

Girl at Rest
Craig Nelson · Oil
11" × 14" (28cm × 36cm)

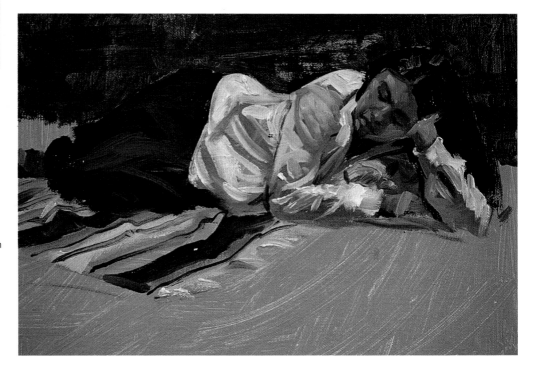

sketching geometric forms

Sketching architecture requires a more geometric approach than figurative subjects. Straight horizontal, vertical and angular lines work best. Proportion and perspective play an important role in most architectural subjects.

check your work

As you paint, periodically check the proportions in the painting against your original sketch. As you face your painting, hold the sketch by its edges and move it closer and farther away until the sketch and your painting seem to be the same size. Take a hard look at the canvas. If it doesn't look right, re-work the basic elements until they have the correct proportions. Remember that all the paint in the world will not cover up a bad design.

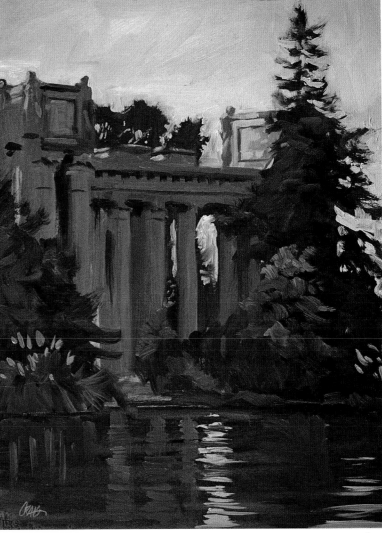

the study

All elements were painted in their basic shapes with attention to the edges: firm, crisp edges for the architecture and wispy, soft edges for the tree forms. This transforms the basic linear sketch into masses, which is how we see. Form can then be developed with value and color variation.

Palace in Shadow
Craig Nelson · Oil
12" x 9" (30cm x 23cm)

compositional clues

Think of the elements in your painting as simplified shapes. Then refer to these diagrams for help with troubleshooting your compositions.

worm's-eye view
Try a worm's eye view to create an intriguing breakup of space that deals with angles, perspective and the interesting overlap of elements.

bird's-eye view
Experiment with a bird's-eye view to give your piece more flow and to direct the viewer's eye around the composition.

No

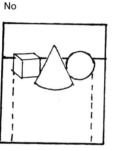

Static; no flow

Yes

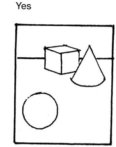

Interesting movement

No

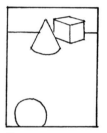

Closed corner creates tension

Yes

Near corner eliminates tension

No

Too centered; boring

Yes

Off-center creates eye flow

No

Alignment directly above flattens space

Yes

Alignment to the side creates flow and depth

avoid the bull's-eye

How a composition breaks up the space of the picture plane is important. Placing something in the center of a painting creates a bullseye composition that lacks interest and complexity. For a more dynamic composition, try an uneven spatial breakup by using the "rule of thirds" (page 66) or a grid of fourths or ninths (page 98).

No

Empty bottom; dead space

Yes

Empty bottom has meaning

No

Tangencies flatten space

Yes

Overlapping creates depth

No

Bad cropping; object cut in half

Yes

Good cropping

No

Light

Dull, flat lighting

Yes

Light

Interesting lighting describes form

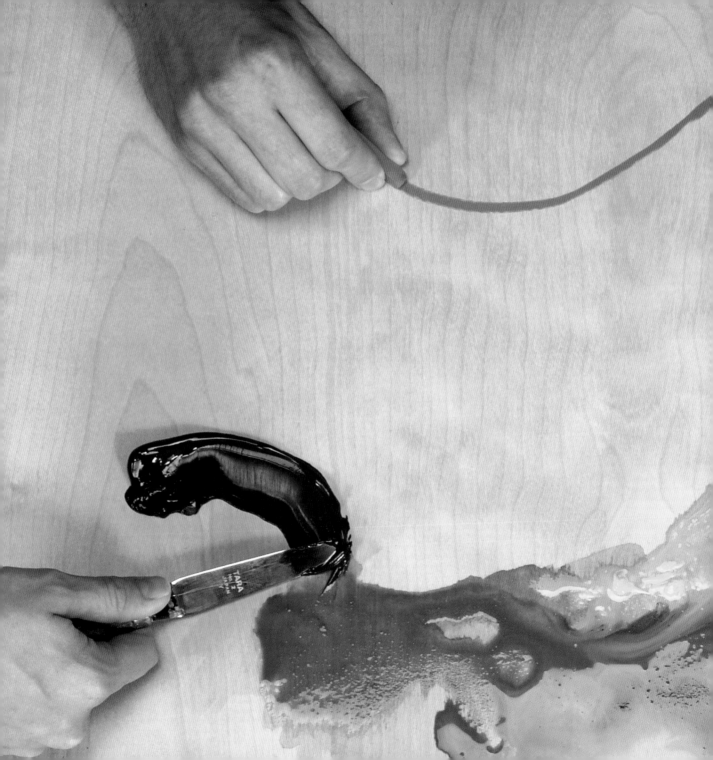

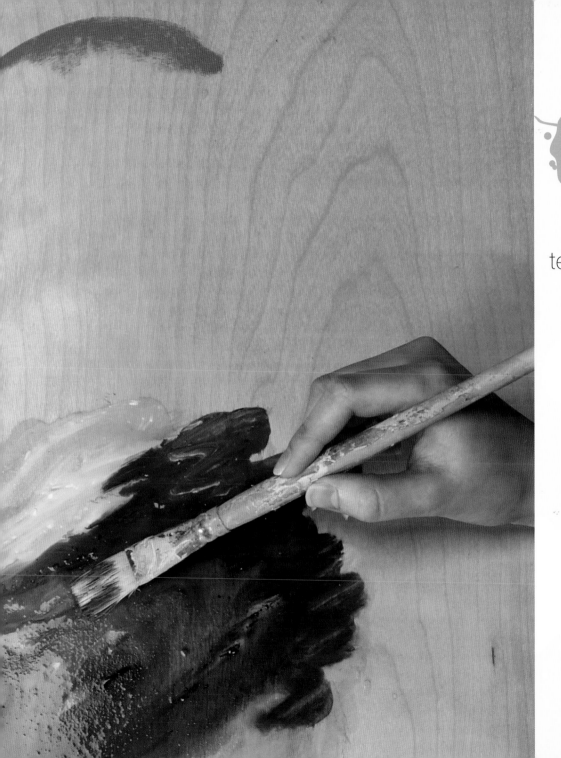

4

techniques

value studies and line drawings

value studies

Value contrast directs the viewer's eye around the painting; it also helps emphasize the painting's focal point or center of interest. So it's vital to plan carefully where the lights and darks will go. You should do this even before deciding which colors to use. Do your value sketches with soft graphite pencil in a pad or notebook.

simplify the values

For stronger paintings, learn to simplify what you see into about five values: white, medium light, middle gray, medium dark and dark.

the literal path

Think of the value study as a map for where you want the viewer's eye to go. In this study and painting, the placement of lighter values amid dark grays leads the eye from the lower right to the left and then diagonally to the upper right. At the top of the stairs, black is next to white, creating the area of maximum contrast which becomes the painting's focal point.

Fern Canyon Steps
Elizabeth Kincaid · Watercolor
21" × 13½" (53cm × 34cm)

line drawings

If a value sketch lets you plan major shapes, a line drawing is where you put the plan into action. It's accurate enough that you could paint on top of it. Therefore, the medium of choice is probably something fine and easily erasable, such as graphite pencil.

Begin a line drawing by holding the pencil loosely. Draw lightly as you rough in the shapes, then darker as your eye finds the right lines. When you're satisfied with the shapes and proportions, you can erase the unwanted lines and be left with a drawing that is ready to be transferred to paper or canvas (see page 108).

determining value

If you are having trouble determining the tonal value of your subject, try squinting your eyes. When you squint your eyes you slightly darken what you are looking at. You also increase visible contrast and eliminate superfluous detail. Squinting at your painting or drawing as you work will also help you determine if the values are correct or if they need adjustment.

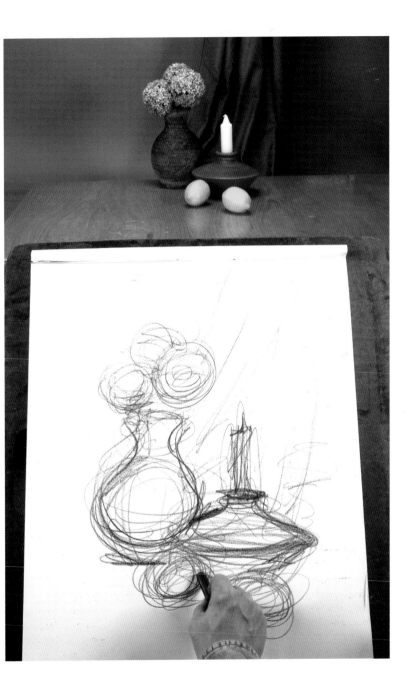

transferring a drawing

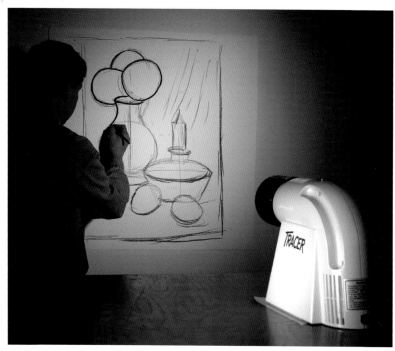

projector method
Projectors for flat artwork are available at art supply stores. Even inexpensive models are very serviceable. Place a drawing under the projector, then direct its beam at a wall on which you have taped your canvas or drawing paper. Then trace.

avoid distorting your image

When using the projector method, make sure that your slide or photo is perfectly parallel to the drawing surface. It is easy to distort your image with any kind of projection.

When using the photocopier method, an inexpensive tool called a proportion wheel is handy. On the inner wheel, select the size of your original; then select the desired size of your enlargement on the outer wheel. Line the two up and the scale will tell you the percentage of enlargement.

Once you have a satisfactory line drawing (page 107), you can transfer it to your painting surface. Here are three ways to do it.

projector method
Place your sketch on an opaque projector. Tape the painting surface to a wall and project the drawing onto it. Then trace.

grid method
With a ruler and pencil, draw a grid of squares on your sketch. Lightly draw an identical grid (with the same same number of squares across and down) onto the painting surface. Make the squares larger to enlarge the drawing, or smaller to reduce it. Now copy the drawing one square at a time. When the drawing is accurate, erase the grid lines. See the full demonstration of this process on the next page.

photocopy method
Photocopy your sketch, enlarging or reducing to the desired size. Lay a piece of transfer paper on top of your painting surface, then place the photocopy over that. Retrace the lines with a pencil to transfer the drawing onto the painting surface.

the grid method of transferring a drawing

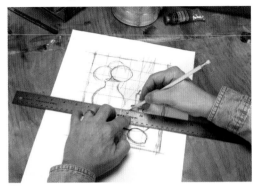

1 draw a grid on a sketch
Using a straightedge and a pencil, draw a grid of uniform squares over a sketch. (To preserve the original sketch, you can draw the lines on a piece of acetate laid over the sketch.)

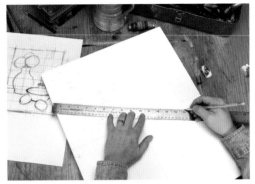

2 draw a matching grid on painting surface
On the painting surface, lightly draw a grid with the same number and arrangement of squares as the one on your sketch. To enlarge the drawing, make the squares larger.

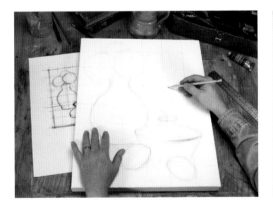

3 copy the drawing
Copy the drawing. The grid lines make this easy: Simply copy what you see in each square, and the entire drawing will fall into place.

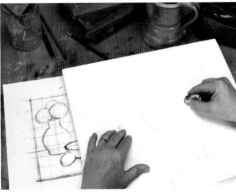

4 erase the grid lines
Erase the grid lines from the painting surface.

the ruler trick

Here's a trick that makes it easy to divide a painting surface into a grid of specific dimensions.

Let's say you need to draw a grid six squares wide on a canvas.

1 Find a multiple of 6 on your ruler: Let's use 12 (2 times 6) for this example.

2 Hold the 0 marker of the ruler at the left edge of the canvas, then swing the other end of the ruler until its 12-inch marker lines up with the right edge of the canvas.

3 Mark a dot every 2 inches along the ruler—2 being the multiple of 6 that we used in step 1.

4 Use a triangle to draw vertical lines through these points. Your paper's width is now divided into six equal segments.

hardness, pressure & points

Learn how to use the properties of colored pencil in concert with the roughness or smoothness of your paper to produce just the kind of finish you want.

pencil points

BURNISHING POINT: This blunt point is used with heavy pressure to build layers of color.

DULL POINT: A dull point is too wide to get into the valleys of the paper's roughness. The valleys stay white for a textured finish.

SHARP POINT: Used to apply layers of colors. The small point goes down into the valleys of the paper texture for complete coverage.

more pressure = more coverage
Stroke up and down, moving your hand from left to right as you increase pressure. Practice this until you can increase the coverage smoothly from light to heavy.

dull point = light coverage
When the pencil point is dull, its rounded tip can't get inside the recesses of the paper texture. It hits the peaks only, resulting in light coverage.

Burnishing point

Dull point

Sharp point

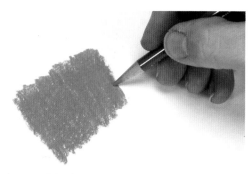

verithin vs. prismacolor
The smaller, harder lead of a Verithin pencil (below, top) makes a finer line than the thicker, softer lead of a Prismacolor pencil (below, bottom). Try Verithins for detail work.

sharp point = heavy coverage
When the pencil point is sharp, its tiny tip is able to reach to the bottom of the paper texture's recesses. This allows for heavy, dark coverage.

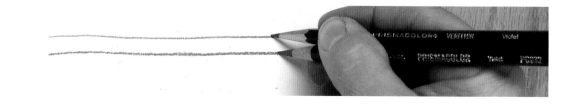

strokes

You can apply colored pencil to paper any way you want, but it helps to learn names for the most common methods.

technique for even coverage

Applying layers of colored pencil at different angles will help you achieve even coverage. Apply one layer of vertical strokes, then turn your paper and apply another layer at a different angle. Turning your paper like this is easy if you tape your paper to a drawing board rather than directly to your drawing table.

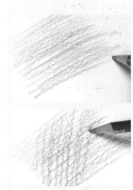

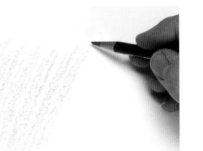

long, vertical strokes

Stroke upward with long, parallel lines, lifting the pencil after each stroke, while moving your hand smoothly from left to right.

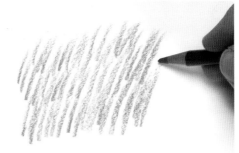

short, choppy strokes

Stroke upward with short parallel lines, lifting the pencil after each stroke, while moving your hand smoothly from left to right. Begin each new row of strokes slightly overlapping the previous row.

scumbling

Move your pencil in a random scribbling manner. At the same time, move your hand slowly around the area. The longer you scribble over the same area, the denser the coverage will be.

circular stroke

Move your pencil in tight circles as you move your hand slowly around an area. You can work in overlapping rows as shown here, or go over the same area repeatedly as with the scribble stroke to get gradually denser coverage.

smoothing out colored pencil

burnishing with white
Burnishing with a white (shown) or light-colored pencil lightens the base color as well as smoothing it.

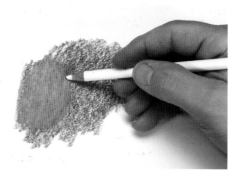

solvent: odorless turpentine
Turpenoid, or odorless turpentine, applied with a swab smooths and spreads the pigment.

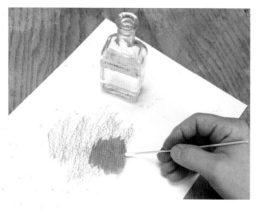

colorless blender

Colorless blenders are essentially colored pencils with no pigment, just binder. Use colorless blender to burnish (smooth) an area without lightening the color. Colorless blenders can be either wax- or oil-based; either type can be used with any brand of colored pencil.

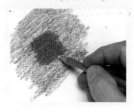

There's more than one way to smooth out colored-pencil pigment after it's applied. Try each of these methods to learn the particular look they create.

burnishing
To burnish colored pencil means to go over an area of applied color with heavy pressure. The result is a smooth, lustrous finish.

solvent
Dissolving colored-pencil pigment with a solvent creates a smooth look and can make the work go faster. Since colored pencil pigment is bound together with wax or oil, dissolving the pigment requires a solvent such as odorless turpentine or alcohol. Apply with a brush, rag, swab or tortillion. It doesn't take much. Let the solvent dry thoroughly before going over the area again. And, of course, follow the manufacturer's precautions when handling solvent.

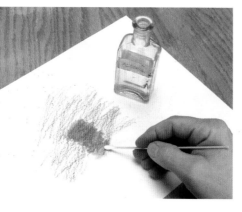

solvent: alcohol
Alcohol can be used in the same manner as odorless turpentine as a colored-pencil solvent. The results are not quite as smooth as with odorless turpentine.

burnishing and solvents

Burnishing will accomplish the rich, soft petal colors of this orchid, and solvents will help create an impressionistic background which will contrast beautifully with the crisp flower.

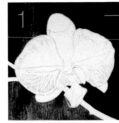

blended with solvent

1 begin the background
Draw the flower with Lavender. Apply dark red, blue and green heavily to the background. Blend the background with a small flat brush and a very small amount of solvent.

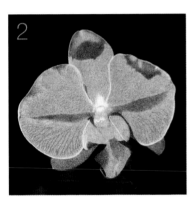

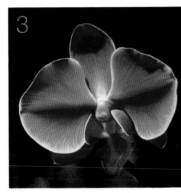

2 finish the background and begin the flower
Reapply the background colors. Add Sand, Bronze and Clay Rose to the lower background. Layer Indigo Blue and Dark Umber on the stem. Define petal shadows with Grass Green. Add the Sunburst Yellow area. Draw veins with Lavender, then layer the petals with Hot Pink and Lavender.

3 continue
Burnish Process Red on the lower three petals and on the green areas of the main petals. Go over the veins with Process Red. Layer the red areas with Hot Pink, then burnish with White. Go around the petal edges with a sharp White, then bring the White into the pink. On the yellow area, layer Sunburst Yellow, then Process Red and White as shown.

use tape to define the picture's edges

Since the background will be blended with solvent, you might find it helpful to define the outer edge of the picture frame with white artist's tape as many watercolor artists do. Then you can brush the solvent right over the edge of the tape and still keep a nice crisp edge when the tape is removed.

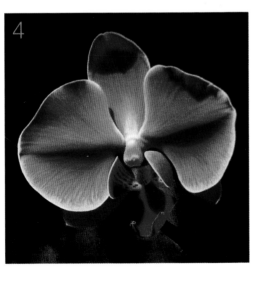

4 add shadows and finish
Layer the shadows on the main petals lightly with Black Grape, then burnish with Mulberry. Layer Tuscan Red on the lower petals and burnish with Mulberry. Cover the yellow area with Mulberry and Process Red, then burnish with Cream. Do the shadows on the lower petals just like you did on the main ones. Add the spots with Black Grape covered with Tuscan Red.

color mixing

Use the colored pencil strokes and smoothing methods you've learned to combine colors.

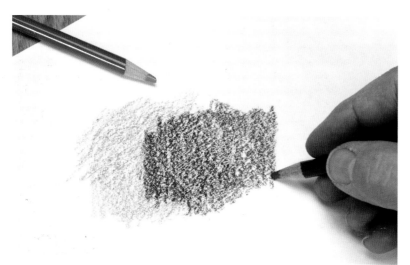

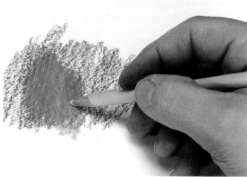

burnishing to blend
Try burnishing a darker color with a lighter one for a blended result.

layering to blend
Blend two colors with smooth, overlapping applications of each color.

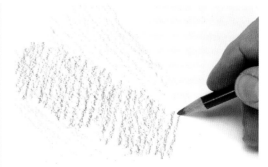

scumbling to blend
When you scumble one color over another one, the result is textured, and the colors blend optically for an almost sparkling look.

crosshatching to blend
Lay linear strokes of one color, then apply another color with linear strokes at a different angle. The colors will appear blended, yet textural.

layering complementary colors to create neutrals

Complementary colors (colors opposite each other on the color wheel) combine to create neutrals. The resulting grays and blacks are richer than if you simply used a gray or black pencil. Use complementary pairs to your advantage by doing an initial contouring layer with the darker complement, then adding the lighter one in a second layer.

1 contour with dark purples
Contour the petals with Greyed Lavender and the center with Black Grape.

2 layer on orange for neutrals
Add Goldenrod over the Greyed Lavender and Dark Brown over the Black Grape.

3 finish details and shadows
Finish the daisy with Sunburst Yellow, Canary Yellow and White on the petals. Deepen the shadows on the petals with more Goldenrod. Add the red around the center with Crimson Red and Crimson Lake. Cover the center with Terra Cotta and then deepen the shading there with Black Grape, Indigo Blue, Dark Brown and even a little Black in the darkest areas.

a simple sphere with layering

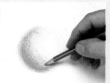

1 Contour with blue

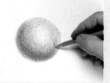

2 Add orange, blue's complement

hardness

hard vs. soft pastels

Use hard pastels for finer work such as making the initial sketch lines or adding fine details near the end of a pastel painting.

Use soft pastels for broad areas and blending. Usually most of a pastel painting is done with soft pastel. Use hard pastels first, then soft, because hard ones won't fill up the paper's tooth.

hard pastels

soft pastels

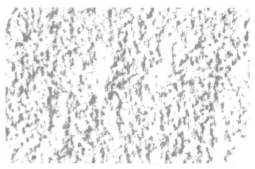

hard pastel on rough paper
There is a lot of tooth in this rough paper, and the hard pastel doesn't fill it very fast, resulting in light coverage.

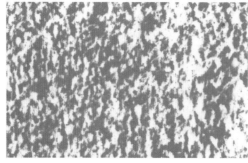

hard pastel on smooth paper
Hard pastel doesn't fill up the paper tooth very fast, but since this is smooth paper, the coverage is fairly dense.

soft pastel on rough paper
On rough, toothy paper, soft pastel fills the paper tooth more quickly than hard pastel does.

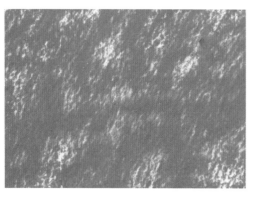

soft pastel on smooth paper
Soft pastel covers smooth paper densely in a hurry.

strokes

With pastel, the stroke depends not only on how you move the stick, but upon the angle at which you hold it to the paper.

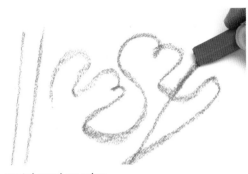

pastel used on edge
Pastel held with an edge against the paper lets you create wavy lines that vary in thickness like strokes of a calligraphy pen.

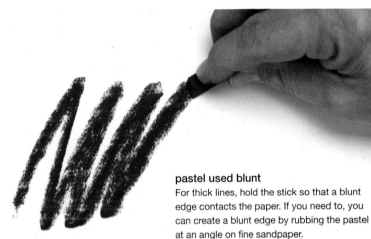

pastel used blunt
For thick lines, hold the stick so that a blunt edge contacts the paper. If you need to, you can create a blunt edge by rubbing the pastel at an angle on fine sandpaper.

pastel used on its side
Rubbing the broad side of a pastel stick on the paper creates a large area of coverage.

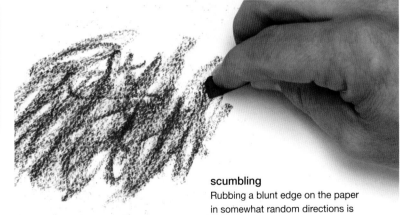

scumbling
Rubbing a blunt edge on the paper in somewhat random directions is called scumbling.

smoothing out pastel

The powdery nature of pastel requires smoothing techniques slightly different from those used with colored pencil.

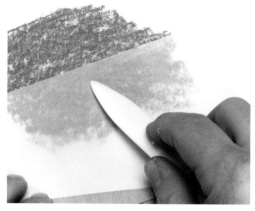

finger-blending pastel
Blend pastel with a finger, swab or tortillion. For large areas, you can use a rag.

burnishing pastel
To really help pastel adhere to the paper, you can burnish it. Lay newsprint or tracing paper over a pastel painting, then rub with a bone folder (shown) or the back of a spoon. Pastel is too soft to burnish with the pastel itself, the way it's done with colored pencil.

mixing pastel and watercolor

For interesting blends of color, try brushing soft pastel not merely with water, but with diluted watercolor. Combine watercolor with oil pastel for a "resist" effect.

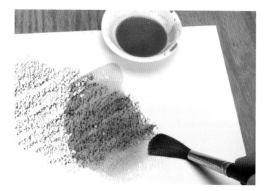

watercolor over soft pastel

watercolor over oil pastel

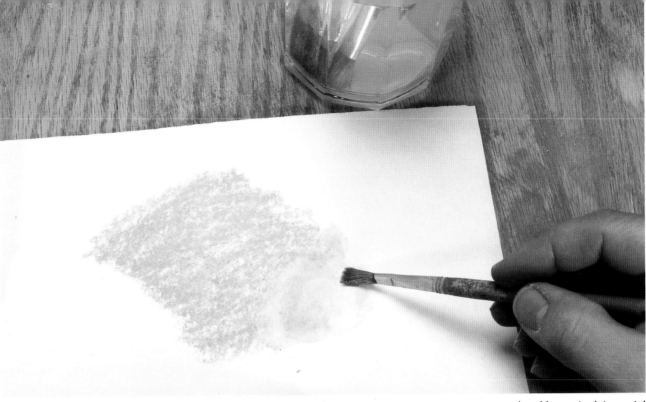

brushing water into pastel

With soft pastels, you can use water on a brush to smooth out a layer (above).

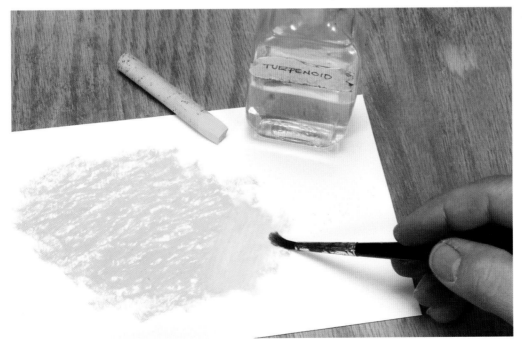

odorless turpentine brushed into oil pastel

Oil pastels are oil-based; for them, the solvent of choice is odorless turpentine. Apply with a swab or brush (left).

color mixing

Optical blending figures heavily among color blending techniques for pastel. Powdery pastels can't mix together on a nearly molecular level the way liquid paints or oil-based pencils can, so side-by-side color becomes an important way to blend.

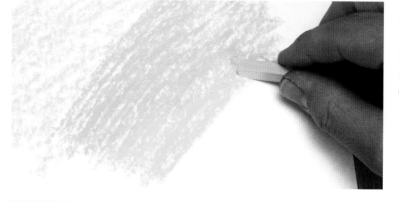

layering for optical blending
Layer one color of pastel atop another using a broken application that lets some of the base color show through.

optical blending with pointillism
Pointillism, pioneered by Georges Seurat (1859–1891), means painting closely spaced dots of different colors whose colors do not physically blend, but which appear to blend when seen from a distance. Pointillism creates a sparkling effect. This can be done with any medium but is especially common with dry mediums; this is because it is easy with dry mediums to keep the dots separate.

layer, then blend
Layer one color of pastel atop another, then blend the pigments together with a swab or your finger.

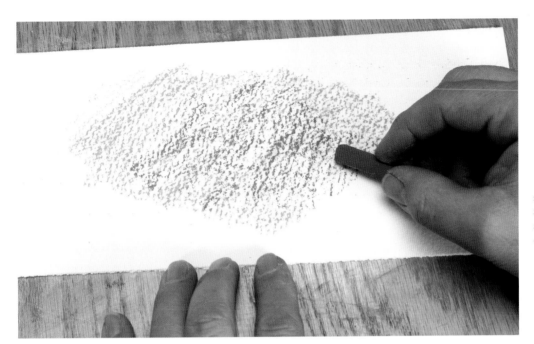

scumbling to blend
Scumble one color, then another color for a sparkling optical blend.

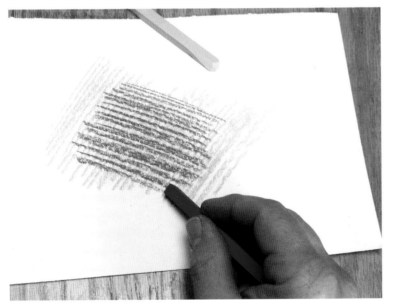

crosshatching to blend
Apply one color with linear strokes, then a second color with linear strokes at a different angle for a textured blend.

smooth blending

When you are blending colors, try squinting or leaning back from your work to see if the colors and values transition smoothly. Go over uneven spots until you achieve an even and gradual color change.

stretching watercolor paper

All but the heaviest weights of watercolor paper need to be stretched if you plan to use a lot of watery paint on them. Otherwise, wet washes will cause the paper to buckle. To stretch paper, you wet it, stretch it and force it to dry flat.

1 tear the paper

Using a T-square and a board, tear your watercolor paper into the size sheet you need.

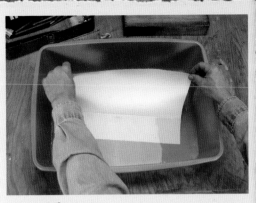

2 wet the paper

Place the sheet into a tub or sink of clean water. Hold it in the water until it becomes pliant. Lift it out and let the excess water drip off.

3 lay the paper on a board

Lay the wet sheet flat on a piece of plywood. Smooth it and remove excess water with a sponge.

4 staple, then let dry

Staple the paper to the board around the edges of the sheet. Begin stapling in the center of each edge, then work your way toward the corners with staples about 1 inch (25mm) apart. Let the paper dry flat, then remove the staples with a staple remover.

tearing watercolor sheets

Watercolor paper is available as loose sheets or in pads, in different sizes. It's economical to buy large sheets and tear them down to sizes you need. For example, you can tear a large 22" × 30" (56cm × 76cm) sheet into four 11" × 15" (28cm × 38cm) sheets.

the flat wash

The flat wash is the most basic means of filling an area with watercolor. It is a smooth area of even color.

1 prepare color and wet the paper with water

Dilute watercolor paint in a dish. With a 1½-inch (38mm) flat brush, stroke clear water horizontally along the top edge. Working downward, apply overlapping strokes of clear water, re-wetting the brush for each stroke. The goal is to wet the paper evenly.

2 wait for the right moment, then add color

Wait and watch as the water evaporates and is absorbed by the paper. When the paper has just lost its shine, use a ¾-inch (19mm) flat brush to make overlapping strokes of color starting from the top. Each stroke should overlap the wet edge of the previous stroke for a smooth wash. Use a clean, damp brush to pick up any excess paint at the bottom of the last stroke.

flat washes for an underpainting

The first wash of Cadmium Yellow Lemon was applied over all the sunlit areas with a no. 5 round kolinsky sable. Cerulean Blue was applied to the shadow areas. A second, lighter wash of Cerulean Blue was then applied over the yellow to the sunlit areas that are in slightly less direct sunlight. These three flat washes differentiate all of the primary visible planes.

underpainting for impact

An *underpainting* is the initial layer of color on a painting's surface. This technique is especially useful in watercolor. Because watercolor is essentially a transparent medium, the underpainting in a watercolor is seen through the subsequent layers of paint and influences the finished painting.

A yellow underpainting will brighten and enliven subsequent layers of paint, giving them a warm sunlit feeling, while a blue underpainting will cool and slightly dull subsequent colors to help impart a feeling of shadow.

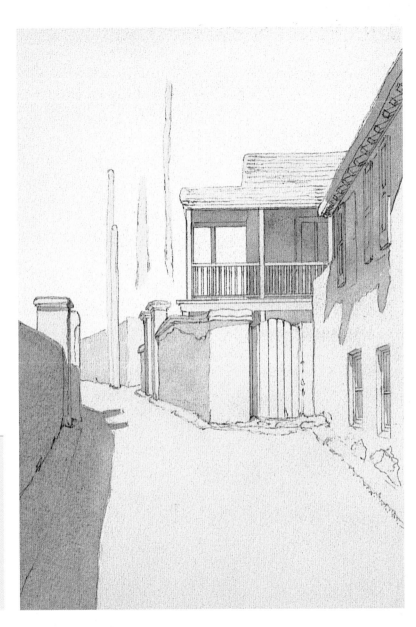

the graded wash

The graded wash creates an area of color that transitions smoothly from dark to light.

1 start at the top

Tilt your board. Apply a stroke of color across the top edge of the paper, then over that a stroke of clear water. Work your way down the paper with overlapping strokes of clear water.

2 work down

Continue working downward with overlapping strokes of clear water. The farther you go, the more the pigment is diluted. If your strokes are smooth and overlapping, you'll get a smoothly graded wash.

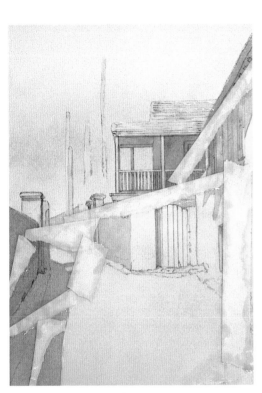

graded washes for a sky

To paint this sky, the artist turned the board upside down and applied a graded wash of Cadmium Yellow Lemon starting at the horizon, quickly blending to clear water. After that was dry, a second graded wash of Permanent Rose was added just above the yellow and blended once again to clear water. Mid- and foreground areas are masked (see pages 142–143) to keep the gradated washes off of them.

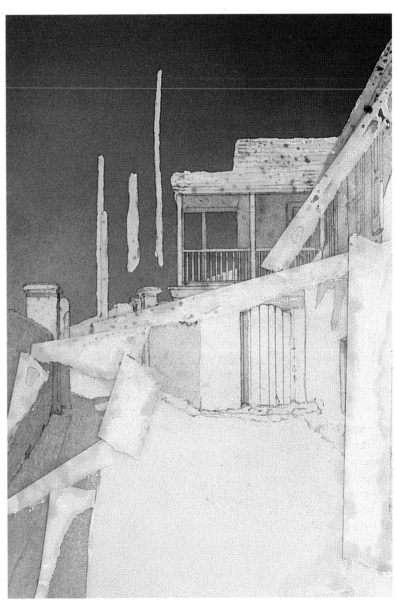

building layers of color

Next, the artist enhanced this sky with several gradated washes of Cerulean Blue and other colors, working each wash from the top down.

glazing to build color

Glazing means applying layers of transparent paint wet-on-dry. The base color shows through the transparent layer on top of it, creating a stained-glass effect. The best results are achieved with a soft round or flat brush. A stiff brush may disturb the underlying pigment.

tip

For crisp edges and no mixing of color, each layer must be completely dry before you apply the next glaze. If the layers are not completely dry and a previously painted surface is disturbed by a subsequent layer of paint, the pigments mix both optically and physically at the same time. This could quickly result in your colors going from brilliant to muddy.

creating brilliant colors with layers

American painter Maxfield Parrish (1870–1966) has long been admired for the luminous colors in his oil paintings. This effect is due in large part to his technique of using multiple layers of transparent glazes.

controlled glazes
These colors and edges are clean and crisp. Each layer of paint was allowed to dry completely before the next layer was painted. New colors have been created by layering rather than by mixing.

uncontrolled glazes
Ragged edges, dull color and backruns indicate layers were painted before the previously painted ones were absolutely dry.

variation on glazing

To increase the depth and complexity of your water-color painting, experiment with scumbling. Usually associated with oil painting, a *scumble* is a thin layer of opaque paint rubbed or scrubbed over a previously painted surface. Even though the paint is opaque, be-cause it is applied thinly, it does not completely cover the surface below. The result is a gauzy effect.

A scumbled passage is applied in a more random and casual way than the more careful and controlled application of a glaze. In watercolor, this more random application of paint, regardless of whether the pig-ment used is or is not opaque, is also referred to as a *scumble*.

applying glazing techniques

Hooker's Green was applied to the porch and right under the blue underpainting beneath the porch. A wash was applied to the gate with a more saturated mixture of Burnt Umber and Cerulean Blue than was used on the road. The under part of the porch roof was glazed with Dioxazine Violet and Quinacridone Gold. To intensify the color, more Quinacridone Burnt Orange was carefully glazed under the porch roof in and around the doorway and between the balusters. The texture of the orange wall was developed with a series of glazes using Quinacridone Burnt Orange.

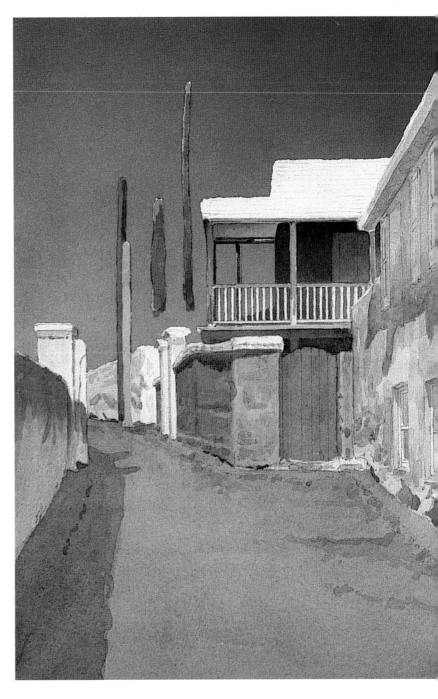

painting wet-on-dry

Painting *wet-on-dry* means about what it sounds like: wet pigment on dry paper. With no water on the paper, the pigment stays where you put it.

drybrush
If you load your brush with only a little pigment and paint on dry paper, the result is partial coverage with a lot of texture. For textured subjects such as rocks or wood, try adding some dry-brushed texture over the base color.

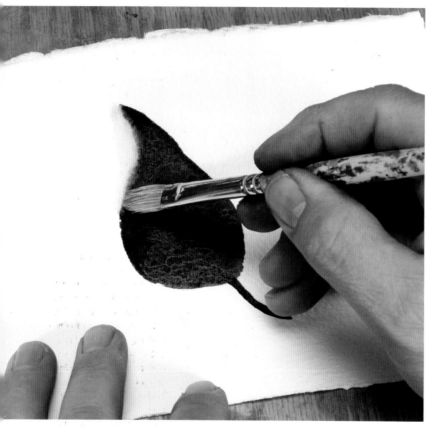

wet-on-dry yields hard edges
Painting wet-on-dry results in hard-edged shapes. If you find you need to soften an edge slightly, wet a brush with water, then pull the brush into the edge you want to soften.

getting the most out of drybrush painting

The drybrush technique is best done on paper that has a little surface texture of its own, such as cold-pressed or rough. This technique can be very hard on your brushes; keep a few older brushes around for drybrush painting. Synthetic brushes and bristle brushes can both work well for this technique. Typically drybrush is applied toward the end of the painting process.

details

textural effects with drybrush

Different degrees of dryness are needed to produce different textural effects. For example, on the roof of the building and the wooden gate, the flat side of the bristles was dragged along the surface of the paper, but slightly more water was used in the paint mixture for the roof than for the gate. Drybrush is also randomly applied to the wall of the building on the right to enhance its rough texture.

Stockdale
James Toogood · Watercolor
11" × 7" (28cm × 18cm)

painting wet-into-wet

Painting *wet-into-wet* means applying wet pigment to wet paper. The wetter the paper is, the more the paint will move. This feature of watercolors is sometimes tricky, sometimes frustrating, but it is part of watercolor's spontaneity and charm.

watch those drips!

One stray drip of water can ruin your perfect wash. Keep paper towels handy to dry your hands and brush handles.

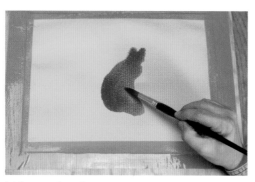

just enough water
When the paper is wet but not too wet, a shape will be soft-edged yet defined.

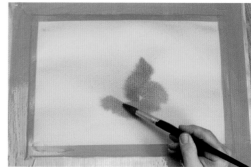

more water means softer edges
If the paper is very wet, shapes will blur quickly. If this isn't the effect you're going for, the paper is too wet.

bloom
If you touch water onto wet pigment, the water chases the pigment away, leaving a bloom or lightened area.

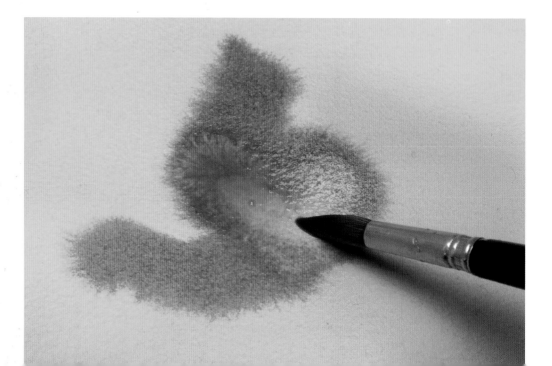

a wet-into-wet underpainting

Here are several ways to use wet-into-wet techniques for an underpainting that seems to blossom almost effortlessly into a finished piece.

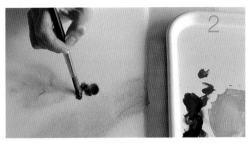

1 paint sky tones
Thoroughly wet your paper all over. When the shine has disappeared, stroke on a blue sky color.

2 drop in berry shapes
Double-dip a wet round brush into paint and touch it to the surface of the saturated paper.

3 make the color flow
Lift and tilt the paper to encourage the movement of color.

4 spatter
Spatter on texture by flicking the bristles of a stiff brush or toothbrush that has been dipped in paint.

5 add a branch
Double-dip the end of a brush handle into paint and scribe a branch onto the wet paper. Hesitate and change directions to vary the line.

6 spray on water
To speed the flow of paint, spray the paper with water. Lift and tilt the paper to encourage the colors to mingle.

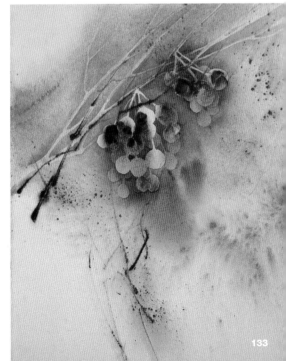

the finished painting
After the underpainting was dry, the artist created branch and berry shapes by painting negatively around the shapes with blue and violet washes.

Painting the Flavor of Berries, Cherries and Grapes
Linda Kemp · Watercolor

the variegated wash

Painting wet-into-wet is all about how colors mingle. When this is done over a large area, it's called a variegated wash. This kind of wash could be done in as an underpainting, as a background, or in one area of a painting for texture.

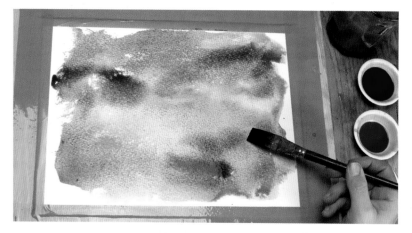

1 apply water and pigments

Choose two colors (here, a red and a green) and premix them with water. Apply each color in different areas and encourage them to blend by occasionally brushing on some clear water.

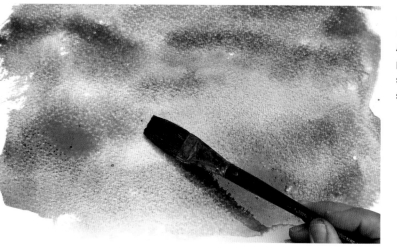

2 introduce another color

If you like, add another color to the wash (here, blue). A variegated wash can become the base wash for a painting. Look for shapes in the wash and let them suggest painting subjects, the way you would look for shapes in clouds.

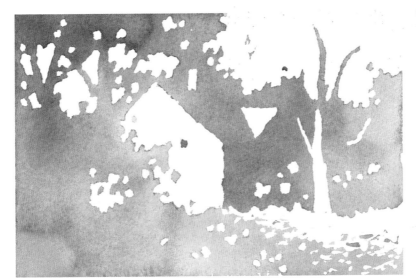

variegated wash plus masking

The artist masked out the light areas and loosely painted in an atmospheric underpainting. The influence of the initial variegated wash is apparent in the finished painting.

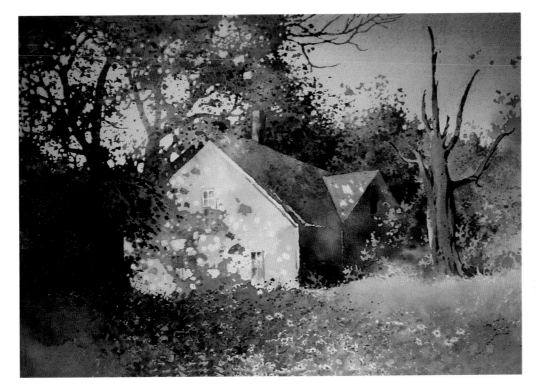

House on 669
Roland Roycraft · Watercolor
14" × 21" (36cm × 53cm)

line and wash

Watercolor combines beautifully with ink line-work. Draw a subject with pen and permanent ink, let it dry, then add watercolor washes.

ruling with watercolor

If you need to "draw" straight lines with water-color, use a small round or liner brush and steady your strokes by running your painting hand along the edge of a ruler.

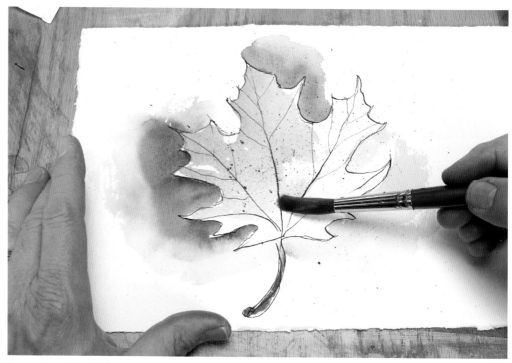

line and wash technique

handling excess water

Controlling the amount of water on the painting surface is of paramount importance with watercolors. If wet paint pools in an area, a dark ring of color will form around the circumference of the pool as the water evaporates. Usually this is not desirable. To remove excess water, try wicking it away by touching it with either the corner of a tissue or a damp, blotted brush (also called a "thirsty" brush). You can also prevent pooling before it occurs by touching your loaded brush to a pad of folded paper towels before each new paint application.

diverse textures with watercolor

Try these techniques to create textures with watercolor.

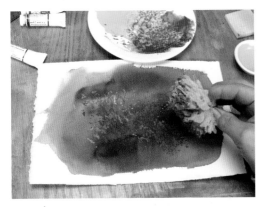

sponging
Dampen a sea sponge with watercolor and press it on your paper. Vary the angle to avoid repeated patterns.

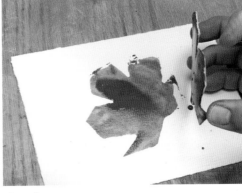

stamping
Cut a shape from stiff board and use it like a rubber stamp to print the shape.

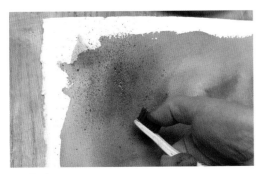

spattering
Pick up some watercolor on an old toothbrush, then drag your thumbnail across the bristles to throw fine dots of watercolor over the paper.

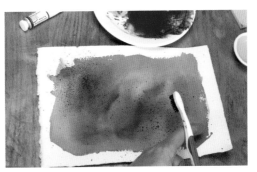

throwing
Pick up some watercolor on an old toothbrush or on a watercolor brush. Strike the brush handle against your finger so that drops of pigment are thrown off.

stamp with found objects

Try stamping watercolor with found objects to add texture or create a mood. Some ideas:

- Coins
- Feathers
- Leaves
- Air-cushioned packing material
- Plastic wrap
- Burlap
- Beads

For the best impression, place the painted object on the surface, then let the paint dry before removing the object.

hint

It may be tough to control where spattered or thrown pigment goes, so use a piece of scrap paper to cover any areas of your painting that you don't want textured.

pouring

Watercolor pigments go where gravity takes them. Use this to your advantage. Hold your watercolor paper over a tub or sink and pour on diluted pigments.

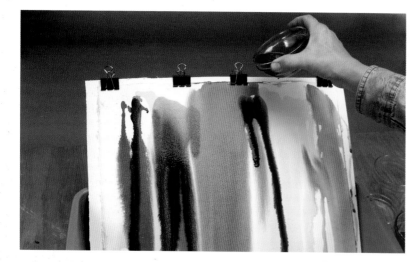

1 pour it on

Clip your watercolor paper to a piece of foamboard to give it rigidity. Dampen it with a brush and clear water. Set the paper in a tub or sink, then pour diluted pigments from a cup. Let the excess run off, as shown here, or lift the board and tilt it to encourage the paint to run in different directions.

try this

A poured background could become the toned ground for a painting.

2 let it dry

When the paint dries, it will be lighter. If the paper was wet before pouring, the colors will blend together, creating soft-edged shapes.

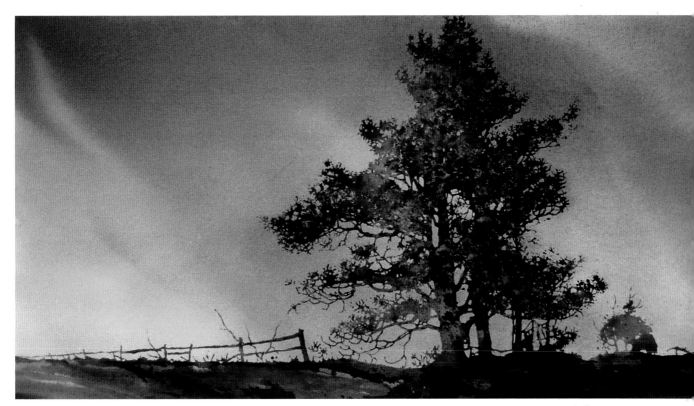

tips for painting a brilliant sky

Whether you use the pouring technique or paint
directly with your brush, take your color cues from
the sky itself. If you take time to observe a clear blue
sky, you will notice that it is lighter and sometimes a
different hue of blue toward the horizon. You may also
notice that higher in the sky, as the color deepens,
it appears lighter on one side or the other. This is
because one side is closer to the sun. This effect is
more apparent in the morning and afternoon than it is
at midday. Incorporating these two observations into
your work will give even a clear blue cloudless sky
greater authenticity.

lifting out color

Watercolorists do not have the luxury of white paint; they must use the white of the paper as their white. There are a few different ways to preserve or create whites:

PAINT AROUND: If you want a hard-edged white shape, the paper has to be dry.

MASK: Use a liquid latex mask product to paint a temporary protective film over an area (page 142).

WIPE: Use a paper towel to wipe away pigment.

LIFT OUT: Use a wet brush to wet a painted area, then blot the pigment away with a paper towel. "Staining" pigments will tend to leave some of their color behind.

wiping out
A paper towel or tissue can be a perfectly good way of removing some color. While the paint is still wet, simply wipe the surface with the pointed end of a paper towel to lift out shapes.

lifting out through a stencil

If you want to lift out a well-defined shape, gather a piece of acetate and a scrubber brush (a brush with short, stiff bristles). Cut a stencil from the acetate, lay the stencil on your dry painting, and use the damp scrubber brush to scrub out paint through the stencil.

1 apply water with a brush
To an area of dried watercolor, apply clear water with a clean brush.

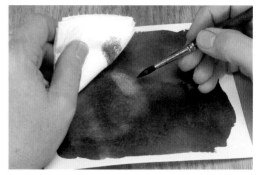

2 blot away pigment
Quickly blot the wetted area to lift some of the pigment.

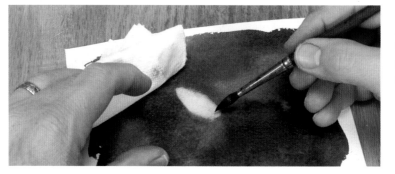

3 repeat
Repeat as needed until the area is as light as you want.

flower shapes lifted out
The artist did a variegated wash and tilted the paper so the colors would run freely. Shapes were then lifted out with natural-hair brushes. Very wet areas were blotted with a tissue.

reference photo

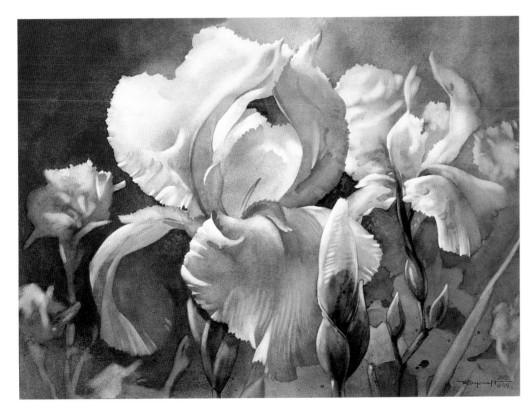

finished painting

Grand Opening
Roland Roycraft · Watercolor
21" × 29" (53cm × 74cm)
Collection of Karl and Eileen Rauschert

using liquid mask

frisket film

Sticky-backed frisket film is a handy way to mask off large areas of a painting. It's visible in steps 2 and 3 on this page. See the demonstration on the facing page for more on using frisket film.

Liquid mask protects the paper so that you can paint smoothly across areas that are interrupted by other shapes. Flip back to pages 28–29 to review the basics of choosing, storing and using masking products, then practice your skills with this demonstration.

2 apply mask
Mask the foreground and the whitest part of the cloud. Let dry thoroughly.

softening hard, masked edges

To soften a hard edge created by masking, dampen a scrubber brush with water and gently agitate the edge, then blot with a tissue.

1 do the underpainting
Apply washes of color to the clouds, the water and the beach.

3 add washes
Paint washes on the sky. Let them dry thoroughly, then remove the mask from the cloud with a rubber cement pickup.

4 finish
Finish developing the sky, remove the remaining mask and paint the land and water.

Elbow Beach
James Toogood · Watercolor
10" × 14" (25cm × 36cm)

using frisket film

Sticky-backed frisket film is great for masking large areas. Here's how to do it.

1 prepare masking film
Attach a sheet of film (with its backing on) to the drawing with drafting tape. Trace the shape you want to protect, drawing about 1/16 inch (2mm) inside its edge.

2 apply masking film and fluid
Cut the shape out of the film, peel off the backing and position the film on the drawing. With a small brush handle, apply masking fluid to fill in the gap between the film's edge and the outline on the drawing. Seal the edge by overlapping the fluid onto the film.

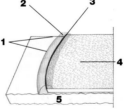

3 create texture with masking fluid
Spatter masking fluid onto the ground area to create texture. To suggest hay, draw lines of masking fluid with a fine-tipped tool.

4 work the background and do more masking
Paint the background. Once it's dry, peel up the masking materials. Now use masking fluid to mask light hairs and white spots on the goats. Let dry.

diagram of paper, film and masking fluid

1 Pencil outline of subject on watercolor paper
2 Band of masking fluid
3 Marker line on film edge
4 Masking film
5 Watercolor paper

5 finish
Paint dark spots and light washes over the goats. Let dry, then mask more hairs. Alternate between washes and masking hairs until the fur texture is convincing. Remove all masking fluid with a rubber cement pickup.

Kids and Moms
Elizabeth Kincaid · Watercolor
10½" × 14½" (27cm × 37cm)

scratching

Try scratching to create shapes in paint that is still wet. You can scratch with a brush handle or any pointed stick.

You can even use a knife to scratch or pick out small highlights from dried paint. Do this with caution and primarily for fine lines or specks, since you're really lifting off some of the paper surface as well as the paint.

terminology

Scratching is also called *sgraffito*.

scraping

Scraping is the same as scratching except with a broader implement to achieve a wider scraped line. A palette knife is a good scraping tool. There are also "aquarelle" watercolor brushes with blunt-tipped scraper handles designed especially for the purpose.

1 scratch lines from wet watercolor
Paint an area with watercolor. While it is still wet, use the pointed end of a brush handle or other stick to scratch out lines.

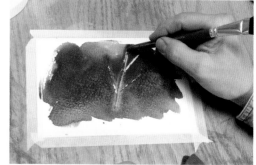

2 watch it flow
You can see here that pigment has begun to flow back into the line that was scratched out in step one.

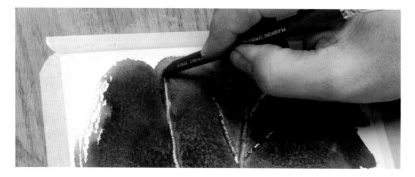

3 scratch on
As the pigment soaks into the paper, the lines become softer-edged.

spraying

Since diluted watercolors are liquid, they are readily sprayed. Purchase or recycle spray and mist bottles for this purpose. Experiment with the organic look of sprayed drops of paint.

spraying ideas for landscapes

If you are painting a landscape, spraying can be a good way to represent snowfall, stars or a light rain. Practice your chosen spraying method on scrap paper to perfect your technique before spraying on a painting.

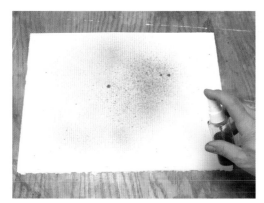

misting bottle
A misting bottle produces a fine spray.

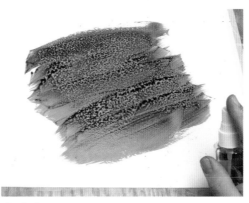

alcohol spray
For a light-on-dark spray effect, try spraying rubbing alcohol onto a still-wet area of watercolor. The alcohol pushes the watercolor pigment away, making light dots.

the mouth atomizer in action

mouth atomizer
A mouth atomizer is an inexpensive tool that uses the force of your breath to propel droplets of pigment up the tube and out as a fine spray.

important tip
Adjust the atomizer's larger tube until its end extends halfway over the opening of the smaller tube, as shown in this close-up photo.

preparing canvas

1 assemble the stretcher bars

Purchase stretcher bars from any art supply store. These ready-to-assemble strips of wood come in different widths; choose wider ones if you are making a support for a canvas wider than 4 feet (1 ⅕ m). Connect the mitered corners of the bars.

2 check for squareness

Use a T-square to make certain that the sides of your frame are perfectly perpendicular.

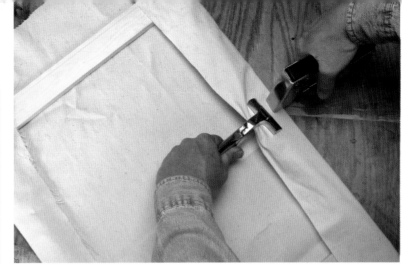

3 cut the canvas and begin stapling

Cut your cotton or linen canvas, leaving yourself 2 inches (5cm) of extra fabric on all four sides. Center the frame on the reverse side of the canvas, wrap one side around to the back and place the first staple at the center of one edge with a staple gun.

4 stretch and staple

Use canvas pliers to hold the canvas as you work. Put a staple in the center of each side about ¼ inch (1cm) from the outer edge, then work your way toward the corners, spacing the staples about 1 inch (3cm) apart. As you work, make sure the canvas is wrinkle-free.

priming the canvas

If you don't purchase pre-primed canvas, prime your stretched canvas with a smooth, even coat of acrylic gesso to protect it.

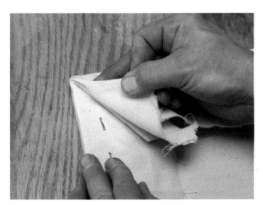

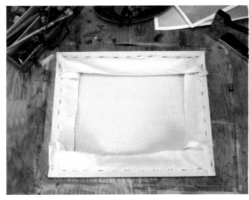

5 staple the corners last

At the corners, you'll have excess canvas. Fold it neatly and staple it down.

6 the finished job

You're done. Since you have all of your tools and materials out, it makes sense to prepare several canvases at a time. It's a good activity for days when you don't feel like painting.

brush pressure

clean and reshape the brush between strokes

Cleaning your brush between strokes not only removes unwanted paint, it also keeps your brush shaped to a fine point or chisel edge for careful and crisp brushwork.

For quick cleaning between strokes, try holding a rag in your palette hand and pulling the brush straight through it, or hang a rag from your belt and firmly pull the brush across it.

You can also use a palette knife to clean a brush. Hold the brush at a low brush-to-palette angle, press its rear edge against the base of the brush hairs, and pull it toward the tip. This technique also removes loose hairs from the brush.

When it comes to pushing on the brush, there are a few things to know. Downward pressure flattens and spreads the paint as it spreads out the brush hairs. Light pressure, in which only the paint contacts the canvas, keeps the brush hairs close together and the stroke narrow.

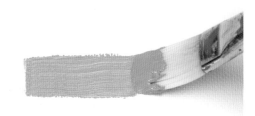

light pressure
Exerting light pressure allows the brush hairs to stay together for a thinner stroke, and it flattens the paint less than heavy pressure does.

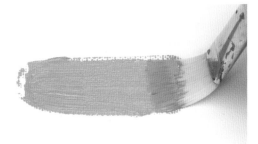

heavy pressure
Heavy pressure spreads out the bristles much farther for a wider stroke, and it flattens the paint more than light pressure does.

increase pressure during stroke
Change a stroke from narrow to wide by increasing pressure on the brush during the stroke.

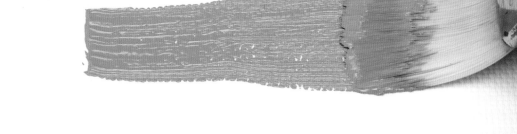

brush motions

Pull the brush, don't push it. This applies whether you are stroking, brush mixing, glazing, applying impasto strokes or cleaning the brush between strokes. Pulling lines up the hairs for better control and reduces wear on the brush tip. Pushing splays the bristles out of alignment and wears out brushes quickly.

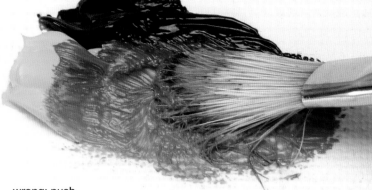

wrong: push
Pushing the brush to apply paint reduces control by splaying the bristles, and it greatly increases wear.

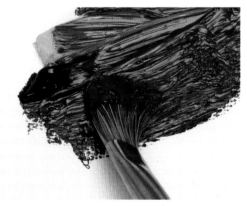

pull from side to side
In addition to pulling toward you, you can also pull from side to side. Lean the brush handle in the direction of the stroke to avoid pushing the bristles.

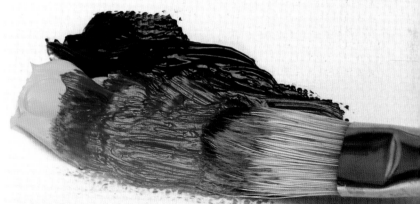

right: pull
Pulling keeps the hairs lined up for better control and minimizes wear.

blending with side-to-side pulling

It's often not necessary to mix intermediate colors to blend areas of oil or acrylic. Practice the mechanics of blending with side-to-side pulling, shown here.

1 before blending

Lay down the two colors you intend to blend. For the sake of demonstration, the boundary between the two colors is very distinct and straight, but in practice it isn't necessary for it to be so clearly defined.

2 pull from side to side

Start in one area of color just inside the boundary. Pull side to side with strokes more or less parallel to the boundary, advancing into the second color. At the same time your brush picks up more of the color you're advancing into, it also deposits the original color. Repeat until you are satisfied with the degree of blending. If you must repeat several times, clean your brush at intervals.

3 after blending

This blending was done using only side-to-side strokes—no cheating with intermediate colors or a fan brush.

other blending methods

When you need to blend more smoothly and gradually than is possible with side-to-side pulling, try one of these methods.

brushes for smooth blending

Most of the time, soft flats and brights are the best brushes for smooth blending. Their softness means they won't pull up paint, and their straight tips let you exert even pressure. Soft filberts also work well for blending if you use just the tip; avoid trying to use the whole curve of the brush, which would create uneven pressure.

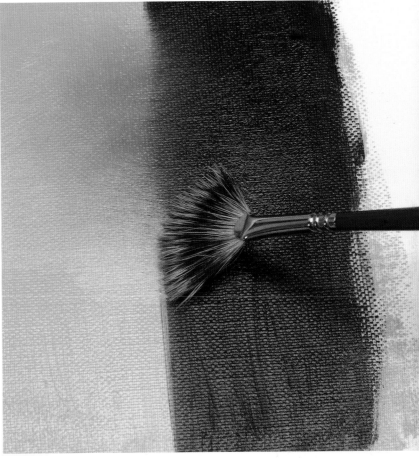

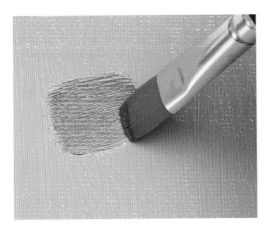

smooth blending

For refined blending, use a soft brush. Hold the brush perpendicular to the surface, and touch the paint as lightly as possible. Here, a red mixes with a cream color to produce a coral hue.

about fan brushes

Soft-haired fans provide a gentle touch for smoothing out brush marks. Bristle fans have the stiffness to blend thicker paint, but they will also leave brush marks (which can be desirable if you want that texture). Have both types in your brush collection.

fan brush blending

For the smoothest possible blending, try a fan brush. Hold the brush perpendicular to the surface and touch the paint with only the tips of the hairs. Using a finger or wrist motion, gently sweep the fan in an arc back and forth.

using a script liner

The script liner or rigger brush is specially designed for painting long, thin lines such as branches, fence wire and ship rigging. Its elongated, flimsy body can soak up a large amount of very thin-consistency paint, then dispense it in long flowing strokes through the fine point. Load it using the body fill-up method (page 159). The script liner's long hairs make it unsuitable for moving thick paint.

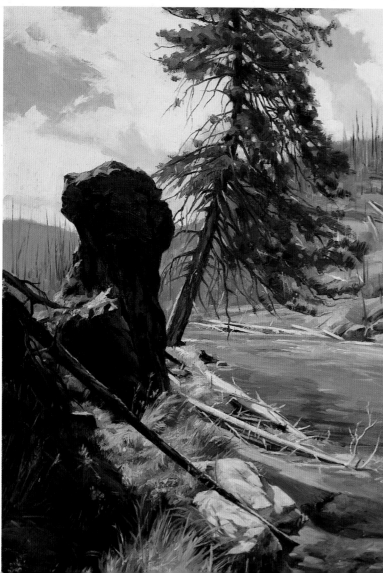

painting with a script liner

Use the body fill-up method (page 159) to soak up thin-consistency paint with your script liner. Then, using just the point of the brush, paint long, thin lines.

using a script liner

All of these branches were painted using a script liner.

Riverside—Yellowstone
Mark Christopher Weber · Oil on linen
18" × 12" (46cm × 30cm)

point-loading a round

Often in detail painting, it's necessary to paint very small highlights. A round brush is the perfect tool for this.

point-loading a round

Shape a round brush to a fine point, then dip only the tip into the paint pile. Touch only the paint; do not push through to the palette surface because you will force the hairs apart and blunt the point. Load only as much pigment as you need for the highlight you're about to paint.

using a point-loaded round

The trees, grass and highlights on the rock formations required a good deal of careful work with point-loaded rounds to render the fine detail.

Cathedral Rock—Head in the Clouds
Mark Christopher Weber · Oil on panel
14" × 14" (36cm × 36cm)

tip loading methods

chisel-shaping brushes

Before loading a brush using the chisel-tip method, it may be necessary to reshape the tip to the sharpest, straightest edge possible, especially if you are doing fine brushwork or careful lines. After cleaning and reshaping the brush with a rag, hold the handle at about a 45-degree brush-to-palette angle. Push down and then very slightly forward. Load your brush, then paint away.

shovel loading

Shovel loading involves placing the brush tip on the palette, holding the handle at a medium to low angle, and pushing lightly down and forward into the paint pile. The deeper you push into the paint pile, the larger the load of paint you pick up. In this way you load an easily controlled package of paint anywhere from a razor-thin line to a medium amount for a nice clear stroke that will mirror the shape of the brush you're using.

chisel tip loading

Chisel tip loading is another method for loading a very thin line of paint just on the brush tip. It uses a side-to-side motion rather than a pushing motion.

shovel loading

Place the tip of the brush on the palette, holding the handle at a medium to low angle, and lightly push the tip down and foward into the paint pile. To apply the paint, turn the brush over.

chisel tip loading

Smooth the paint at the pile's edge to a thin depth. Draw the brush tip in a slight arc across the edge of the paint pile to pick up paint only on the tip.

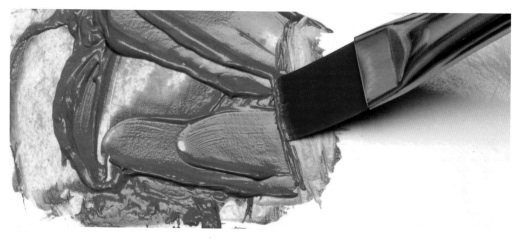

tip load application

The branches, prominent grasses and branch highlights in this painting were done with tip-loaded strokes.

shovel loaded brushstrokes
Flat and bright brushes that have been shovel loaded can produce controlled, precise strokes like a calligraphy pen.

painting a fine line with a chisel tip loaded brush
Load a precise bead of paint on a chisel tip. Barely touching the paint to the surface, pull the brush in line with the chisel tip.

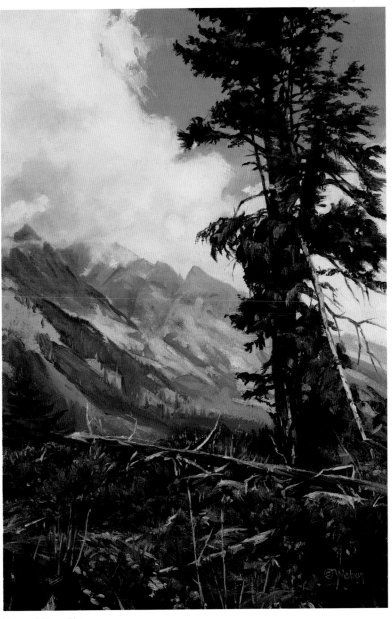

Battered Pine—Tetons
Mark Christopher Weber · Oil on linen
15" × 10" (38cm × 25cm)

tip pull loading

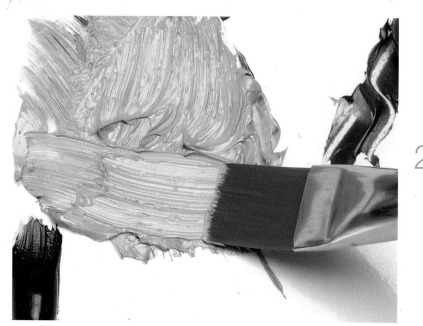

2 ready to go
The brush tip holds a nice load of paint.

1 tip pull loading
Hold your brush at a medium to steep angle and pull the tip through the top or edge of the paint pile.

3 application
With the paint side down and using a medium brush-to-canvas angle, simply pull across. You get a much less precise stroke with this loading method than with shovel loading (page 154).

tip-pull-loaded brushstrokes

choosing a brush loading method

You may not have thought much about brush loading before, but the loading method you use will heavily impact your strokes and your painting. As a general guide, use:

- tip pull loading (above) when it's necessary to pick up a very large amount of paint and precision is not the focus.

- body loading (page 158) when you want to pick up a large amount of paint for impasto strokes.
- body fill-up loading (page 159) to soak thin-consistency paint into the brush body for more precise applications.
- multicolor loading (page 160) to create optical blending with streaks of color.

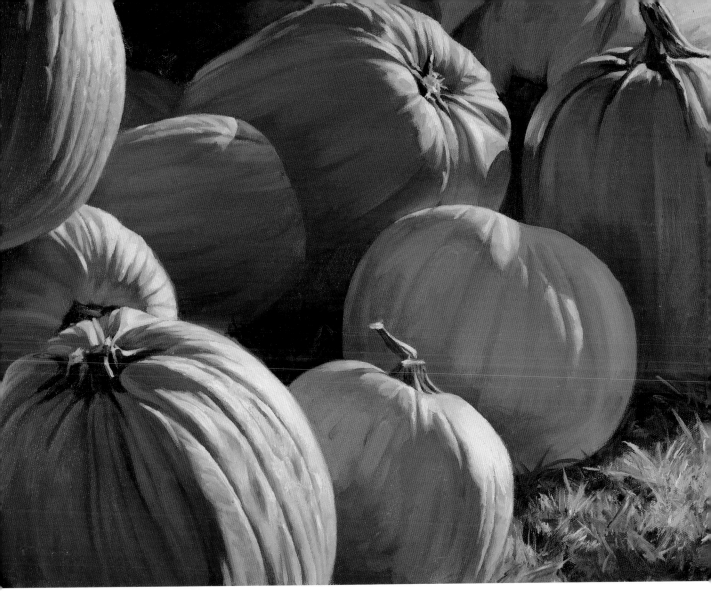

tip-pull loaded strokes
All the highlights on these pumpkins were painted using
tip-pull loaded strokes.

Pumpkins
Mark Christopher Weber · Oil on canvas
14" × 18" (36cm × 46cm)

body loading

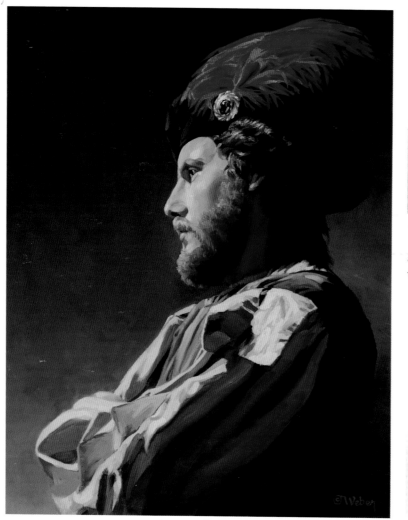

1 body loading
Hold the brush at a shallow brush-to-palette angle, then pull the body of the brush over the top of the paint pile.

2 ready to go
Notice how body loading, unlike tip pull loading, distributes paint along the brush's body.

Red Feather
Mark Christopher Weber ·
Oil on canvas
20" × 16" (51cm × 41cm)

body-loaded strokes
The body-loaded strokes show up especially well in the yellow highlights on the sleeves. The feathers have a few thick, impasto body-loaded strokes to enhance texture.

body fill-up

If your paint is extremely fluid, you may need to exercise extra care in getting your brush to the canvas without dripping. Try holding the brush tip upward. If you see a drip developing on the bottom of the brush, rotate it top to bottom.

1 body fill-up

Thin your paint with medium or solvent so that it can soak into the brush body. Work the brush around in the thinned paint until it soaks up as much paint as you'll need.

2 body fill-up stroke

Create a long, washy stroke. This type of loading and stroke can give an impression of breezy spontaneity.

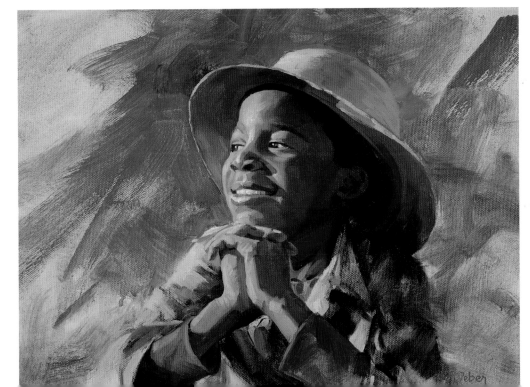

body fill-up strokes

The background strokes were painted with a thinned blue-green mixture and a no. 12 bristle bright loaded with the body fill-up method.

Straw Hat
Mark Christopher Weber
Oil on canvas
11" × 14" (28cm × 36cm)

multicolor loading

1 **load the first color**
Using a wide flat, load the first color onto one corner of the brush.

2 **load the second color**
Load paint from the second paint pile on the brush's other corner.

4 **apply**
Pull the brush in one smooth motion. If you change directions, the colors obediently trail along in formation.

3 **add a third color**
Touch just the corner of the brush into a third pile of pigment.

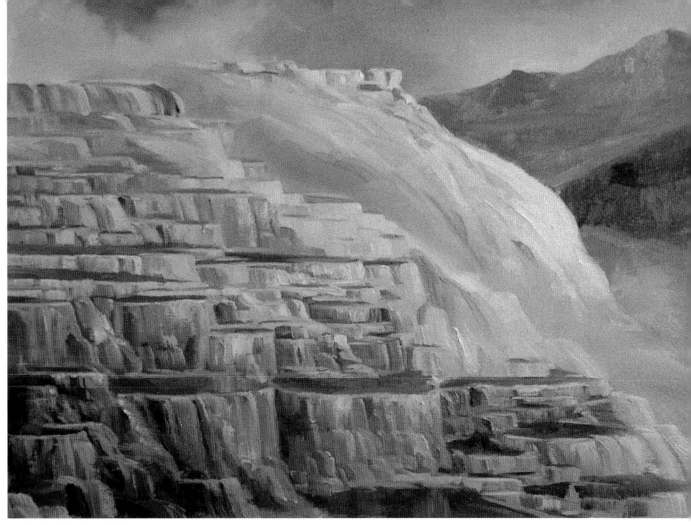

multicolor-loaded strokes

Many of the varicolored streaks on the amazing travertine in this Yellowstone National Park scene were painted with multicolor-loaded strokes.

Minerva Terrace
Mark Christopher Weber · Oil on canvas
12" × 16" (30cm × 41cm)

tip

The multicolor loading technique is very useful because it blends the colors as you apply the paint to the canvas, creating a marblelike effect. It helps to use thinner consistency paint so that the pigments blend together during the pull and are fluid enough to give you a long, flowing stroke.

knife painting

Your palette knife doesn't have to be just for mixing. Use it to create texture or hard-edged angular forms.

painting with a knife
To cover an area with knife texture, use thick paint and trowel the paint around with your knife. Thicker paint will hold the texture created by the knife's edge (see Impasto, next page).

With thinner paint, you can use single strokes of the knife to get hard-edged shapes (see below).

palette knife strokes
The hard-edged cliffs in this scene were perfect candidates for palette-knife painting.

Frosted Canyon
Mark Christopher Weber
Oil on panel
20" × 30" (51cm × 76cm)
Collection of Carl Ruggins

impasto

Thick paint lends itself to wonderful impasto passages that can energize a canvas. Paint thinned with little or no medium retains more body, which is needed for impasto work.

detail

impasto texture
The detail view of this painting shows impasto brush-strokes that can be created with thick paint.

Yosemite Falls—Morning
Mark Christopher Weber · Oil on canvas
24" × 18" (61cm × 46cm)

skimming

Skimming is similar to drybrushing, except that the paint need not be thinned. Skimming means applying a color over another one so that much of the base color shows through. It's a way of blending colors optically.

Skimming has applications beyond blending. It can be used to create irregular patterns in foliage, rippling water, fabric, splotchy complexions (not recommended for commissioned portraits) and abstract painting.

skimming mechanics
The brush, when held at a very low brush-to-canvas angle, skims lightly over the exaggerated weave, depositing paint only on the peaks. The green basecoat in the valleys shows through.

how to skim one color over another
Quickly wash in a base color. Make sure you work the paint into all the valleys of the surface tooth. Using the tip-pull loading method on page 156 with a bristle flat, pick up a load of thin to medium-thick paint. Then, using a very shallow brush-to-canvas angle, lightly pull the brush over the canvas. Paint will land on the peaks of the weave but will leave much of the color in the low spots showing.

skimmed strokes

Even though the artist worked over the yellow grasses with several yellows and greens, the original red underpainting still shows through because the yellow was skimmed over the red. From a distance the skimmed areas look orange.

detail

more techniques for broken color

- Mix paints incompletely on the palette, then apply this broken, varied color to the canvas.
- Mix paints with a brush directly on the canvas.
- Paint small flecks of color side by side on the canvas.

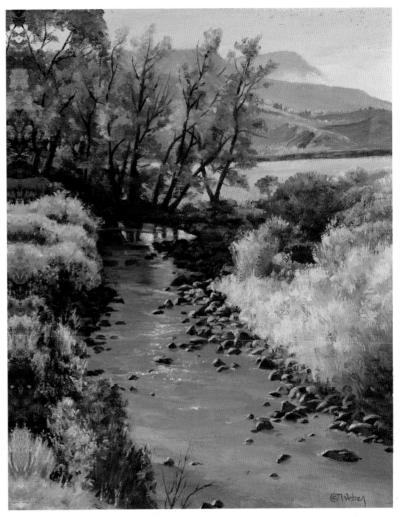

Colorado Gold
Mark Christopher Weber · Oil on textured canvas
18" × 14" (46cm × 36cm)

partial wet-into-wet

When you need to paint an area that shifts smoothly from one color or value to another (such as a sky that transitions from medium blue at the top to powder blue at the horizon), the simplest approach is to lay down bands of paint that change in value and color. Then you blend the wet color bands where they meet. This is called *partial wet-into-wet* because the blending occurs only where the colors meet. It's easier than painting an entire area one color, then laboriously blending pigment into the basecoat to change its color.

extending working time for acrylics

Paints with a slow drying time, such as oils, have a decided advantage over most acrylics when it comes to working wet into wet. Mediums are available that will extend the "open" or workable time of acrylic paint. Follow the instructions on the label and don't use too high a proportion of medium to paint, or the paint film may be compromised.

1 paint the lower sky
After blocking in the buildings, paint the lighter bottom color of the sky.

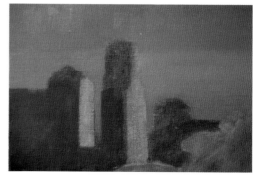

2 paint the upper sky
Mix a darker and grayer color for the top portion of the sky and paint it right up to the border of the first color.

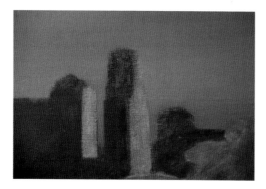

3 blend
Use a side-to-side motion moving parallel to the meeting of the colors. Blend the two bodies of paint together, working only as far in to each as needed to get the degree of smooth transition desired.

thorough wet-into-wet

As the name implies, in the *thorough wet-into-wet* method, you apply one color to an area, then blend other colors into that still-wet paint to create the shifts in color and value you need.

This is an excellent technique for areas with lots of subtle color variations. As you blend, you pick up the wet basecolor and it dilutes the new color.

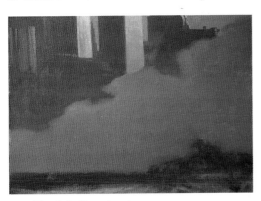

1 block in the cloud
Start by blocking in the entire cloud with a medium-light slightly orangy color.

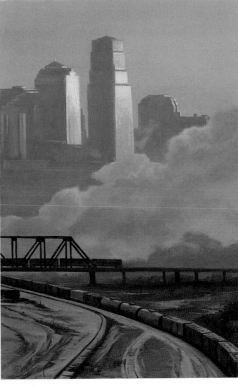

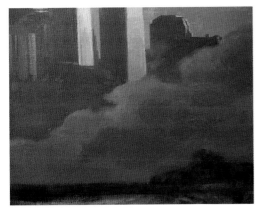

2 blend the dark areas
Blend in the largest darker areas without worrying about the variations within them.

3 blend
Blend in the smallest areas of light and dark and add the darkest darks and lightest lights.

Downtown Morning
Mark Christopher Weber
Oil on canvas
18" × 12" (46cm × 30cm)

toned ground

Painting a base color or *toned ground* on your canvas is a common and classic technique. A toned ground can literally set the tone for an entire painting, since bits of the tone can show through. It also makes it easier to cover the canvas.

1 prepare the canvas
Start with a stretched, primed canvas (pages 146–147).

2 tone the canvas
Apply thinned acrylic or oil paint to the entire canvas. You can use a brush or, if you are working with oils, a rag.

This canvas was toned with a thinned Burnt Sienna color, but any color can be used—light or dark—depending on what serves the needs of the painting.

hint

Some oil painters like to use a toned ground but find the drying time to be too long, especially if the humidity is high. A time-saving solution is to underpaint with acrylics, which dry much faster.

3 let dry, then begin to paint
Let the toned ground dry, then begin the initial sketching in of your painting.

4 add shading

Use the same paint color as in step 3 to shade the objects, This is also called "modeling" because shadows suggest the forms of the objects.

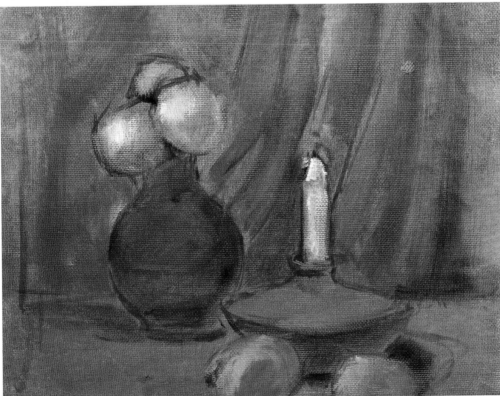

5 add color

Begin to add more colors. The toned ground may end up being more or less of the final painting, depending on how much of it you cover up, but you won't have to worry about white canvas peeking through because it's all covered.

glazing to build color

Translucent colors, such as Ultramarine Blue, Rose Madder and the Phthalo colors, are more suitable for glazing than earth colors. Glazes can be brushed on in thicker or thinner layers, or they can be rubbed on with a rag. Make sure the base colors are perfectly dry before glazing; otherwise the base color will lift up and muddy the glaze you're trying to apply over it.

1 before glazing
Originally this painting was grayer overall than the artist wanted.

2 glazing the rocks
A cream-colored glaze warms the rocks.

3 scumbling in haze
Scumbled bluish-gray patches of mist break up the shapes of the mountains.

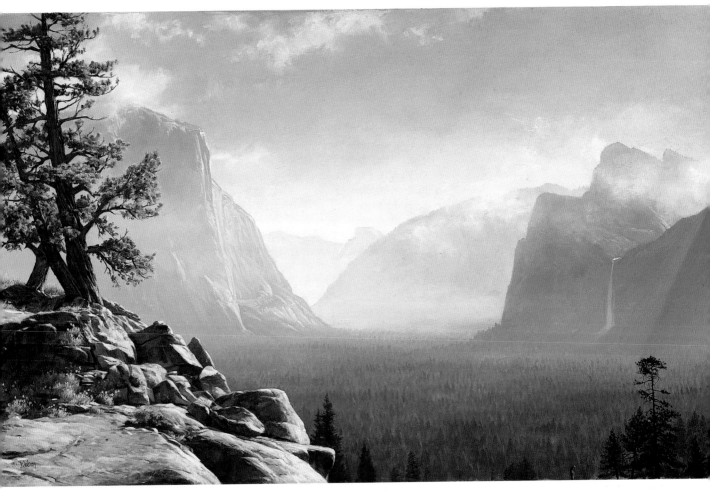

4 final glaze
A bluish white glaze over the sky intensifies the blue.

Granite Vista
Mark Christopher Weber · Oil on canvas
24" × 40" (61cm × 102cm)

tip
Watercolorists can also glaze and scumble. See page 129.

acrylic texture mediums

An amazing array of texturizing mediums is available for acrylic paints. These can be used for traditional realistic paintings, abstract work or even crafts. Mix texturing medium with acrylic paint on your palette, then apply the textured paint with a knife or brush. Unlike white paint, mediums do not dilute the intensity of the color you mix with them—it almost seems like magic.

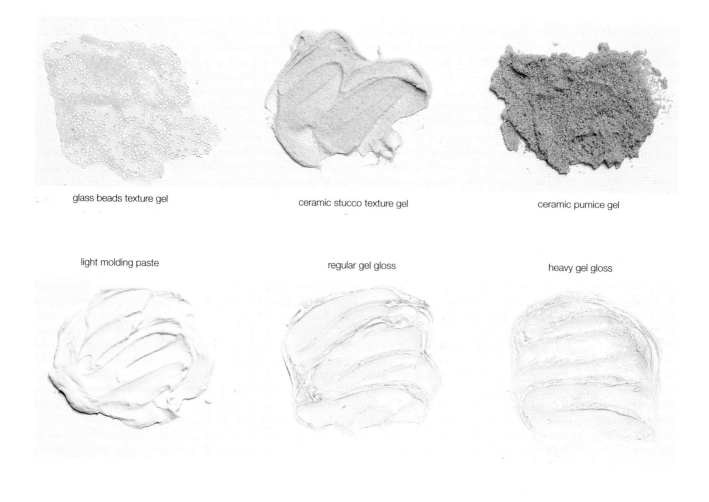

glass beads texture gel

ceramic stucco texture gel

ceramic pumice gel

light molding paste

regular gel gloss

heavy gel gloss

texturing mediums
straight from the jar

texturing mediums mixed
with acrylic paint

5

painting
demonstrations

choosing a subject

start simple

Paint simple subjects (such as the peppers at right) until you start to feel comfortable with the brush and pleased with your results. Then add props to your still lifes (as in the painting below) to increase the challenge and to create additional interest for the viewer.

What to paint? Don't agonize. Subjects for still lifes are easy to find. Go through your house and select everyday, familiar objects that you like: dishes, colored napkins, glasses, fruit, wine bottles, gardening tools, potted plants. Bring some of your selections to your painting area and arrange just three or four together. You are more likely to want to paint a subject when it is not overwhelming.

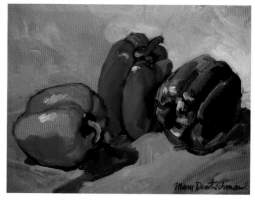

simple subjects
Peppers are shapely and colorful vegetables to paint. For variety, cut one of them in half or place them in a bowl.

The Color of Peppers
Mary Deutschman · Water-soluble oil
9" × 12" (23cm × 30cm)
Collection of Sally Nagele and Jon Schurmeier

incorporating color
A colorful ceramic piece inspired the focal point of this setup. The fruit and fabric continued the colorful theme, and the strong lighting added the feeling of sunshine.

Covered Pot From Portugal With Fruit
Mary Deutschman ·
Water-soluble oil
9" × 12" (23cm × 30cm)

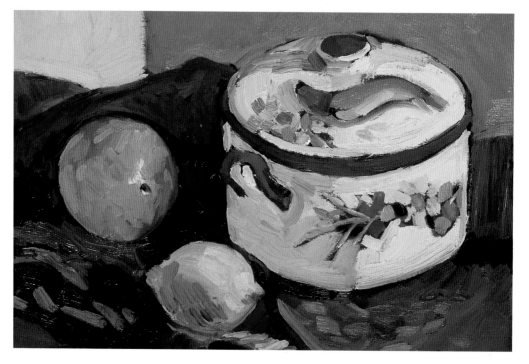

creating a background

Not sure what to put in the background of your still life? Backgrounds can be light or dark, and made up of smooth tones or heavy strokes. They can be part of the room that is actually behind the still life, something you make up, or an arrangement that you set up. You will have far less difficulty deciding if you give it some thought in the sketch stage.

composing a still life

When arranging a still life, pay attention to:

- Balance. A small, brightly colored object can carry the same visual weight as a large, plain one.
- Negative space, meaning the spaces between objects. These spaces should contribute to the overall balance of the composition.
- Shadow shapes. Stick to a single light source, and move it around until the shadow shapes are pleasing.
- Overlapping. If two shapes "kiss" (that is, just touch without overlapping), move one of the objects so that the overlap is definite. Clear overlapping of shapes helps create depth.

1 Geometric shapes in colors that repeat or complement those of the subject
2 Heavy strokes
3 One-color background
4 The scene behind the setup

simple pear

materials list

SURFACE
Canvas paper

BRUSHES
No. 6 round • Nos. 4 and 6 flats

WATER-SOLUBLE OILS
Alizarin Crimson • Cadmium Red Light • Cadmium Yellow Light • Phthalo Green • Titanium White • Ultramarine Blue • Yellow Ochre

OTHER
Pear

Fruit has been the subject for many still-life painters. Fruit is colorfully appealing, and its roundness and subtle tones make painting fruit rather like painting people. Put two pieces of fruit in a still-life setup, and it's as if they are hanging out together and chatting.

how to get textured brushstrokes

If you want your brushstrokes to show the texture of your brush, use either no medium (i.e., linseed oil or water) or very little. Apply your paint on the canvas with very little pressure.

study real shadows

To learn to paint deep and convincing shadows, you must observe and study them. Put a bottle on a table and make the room dark. Shine a flashlight on one side of the bottle and move the light around the way the sun moves through the sky. Observe what happens to the shadow. Change the color of the surface beneath the bottle and see how it changes the shadow color.

1 paint the outline
With a no. 6 round, paint the simple shape of the pear, including its shadow, with Ultramarine Blue diluted with water.

2 paint the darkest values
Squint to determine where the dark values are. On the pear, paint first the dark (Phthalo Green + Yellow Ochre + Cadmium Red Light), then the medium values (same mixture + more Yellow Ochre).

3 paint the areas facing the light

Paint the shadow of the pear (Alizarin Crimson + Ultramarine Blue + Titanium White) with a no. 4 flat. With a no. 6 flat, paint the light areas (Cadmium Yellow Light + Phthalo Green) and the background (Yellow Ochre + Titanium White). Then paint the stem (Ultramarine Blue + Yellow Ochre).

paint quickly

Don't spend a lot of time painting details. Paint quickly. Let the direction of your strokes describe the shape of the fruit.

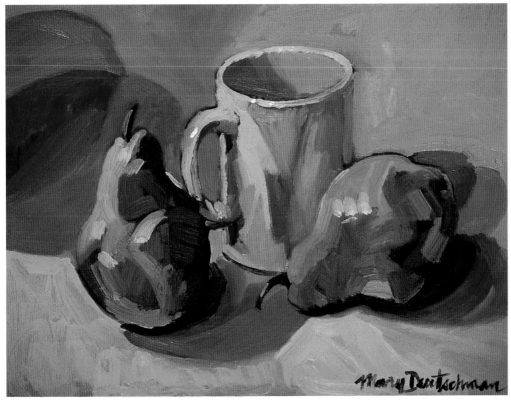

4 final painting

Now that you have learned to paint a pear, set it up with two other objects. Using odd numbers, for design purposes, often results in a more interesting composition.

Two Pears With a Yellow Cup
Mary Deutschman
Water-soluble oils
9" × 12" (23cm × 30cm)

apple with crock

materials list

SURFACE
Stonehenge paper, Pearl Gray

PRISMACOLOR PENCILS
Clay Rose • Cool Grey (30%, 50%, 70% and 90%) • Cream • Crimson Red • Dark Umber • French Grey (10%, 20%, 30% and 50%) • Indigo Blue • Light Umber • Olive Green • Poppy Red • Sand • Scarlet Lake • Spanish Orange • Tuscan Red • Ultramarine • White • Yellowed Orange

VERITHIN PENCILS
Carmine Red • Indigo Blue • Scarlet Red • Tuscan Red

OTHER
Flat brush • Solvent

This demonstration deals with two different shiny surfaces. The apple is very smooth and slick. The crock shines with glaze, but it has a pitted surface. The light creates a beautiful reflection of the apple on the side of the crock. Contrast that uses a full range of values creates drama in this simple image.

reference photo
The position of the stem in the photo is kissing the edge of the apple and crock. For your painting, move the stem above the apple and onto the crock to improve the composition.

1 begin the crock
Use a sharp point, medium pressure and vertical stroke on the right side of the crock with Cool Grey 90%, gradually lightening the pressure as you move left. With Cool Grey 70%, overlap the 90%, then fade out as you go left. Repeat with Cool Grey 50%. This takes you almost to the middle of the crock. Now continue the overlapping technique with French Grey 50%, 30%, 20% and 10%. Fade the grays into the apple's reflection area. Leave the white highlight on the top of the inside of the crock.

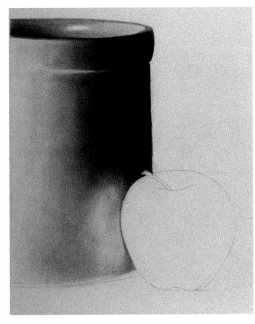

2 blend with solvent

Solvent will blend the color for the undercoat. Use a soft flat brush with medium pressure and vertical and circular strokes to apply the solvent over the colored pencil. Use just a little solvent and you won't have to worry about it bleeding.

tip

Because some pigments (such as the cadmiums) are toxic, it's a good idea to wash your hands frequently, keep your fingers and your pencils out of your mouth and avoid eating while working.

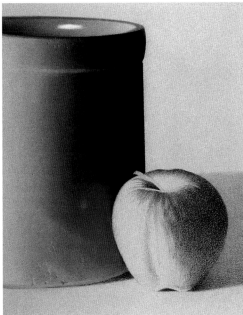

3 finish the crock; begin the apple

Burnish with the same grays used in step 1, using a multidirectional stroke and working from left to right. Finger-blend the grays into the apple reflection area. Cover the dark side of the rim with Cool Grey 50%, then Ultramarine. Soften with Cool Grey 90%. Cover the highlight with White.

Lightly apply Scarlet Lake and a bit of Spanish Orange over the grays for the apple reflection. Burnish with French Grey 30%. Bring the surrounding grays into the burnished area. Add a highlight to the apple's reflection with White and tone it down with French Grey 30%.

Define the crock's bottom rim with Sand, Cream, Light Umber and French Grey 30% and 50%. With a very sharp pencil, add dots and imperfections with Cool Grey 90%, 70% and 50%. With French Grey 10%, draw half moons on the right side of the dots for depth.

Use a sharp point, light pressure and a linear stroke to contour the apple with Indigo Blue. Define the cast shadows with Indigo Blue, fading into Cool Grey 50%, then 30%.

tip

After blending colored pencils with your finger, wash your hands so that you don't transfer unwanted color to another area of the drawing.

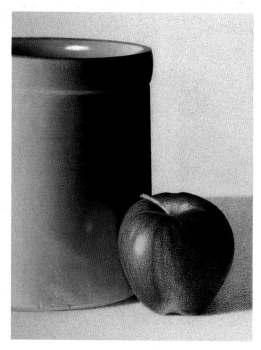

4 continue the apple

Using the same points, strokes and pressure as in step 3, layer Tuscan Red over the apple. Define some of the apple's stripes with Tuscan Red. Apply Spanish Orange to the bottom center with Yellowed Orange extending up into the middle and on the left side. Around the stem use Cream, Sand and a little Olive Green. Apply Poppy Red to the rest of the apple, going over the yellows but not the white areas or highlights. Let the Poppy Red overlap the Tuscan Red. Layer Crimson Red over the Tuscan Red. On the cast shadows cover the Indigo Blue with a very light layer of Tuscan Red fading into Clay Rose.

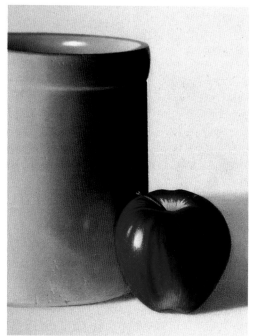

5 burnish the apple with color

Burnishing with color, rather than colorless blender or White, will create intense color more quickly. Burnish with Yellowed Orange using a linear stroke over the areas of Spanish Orange and Yellowed Orange. Then burnish these areas and the entire left side of the apple with Poppy Red. Fade the Poppy Red into the Yellowed Orange at the bottom of the apple. Burnish the dark shaded Tuscan Red areas with Crimson Red. Cover the highlights with White beginning in the middle and fading out into the red.

Apply another layer of Clay Rose before burnishing the cast shadows with Cool Grey 50% in the darker areas and Cool Grey 30% in the lighter areas. Use French Grey 10% to soften the shadows' upper and lower edges.

With your finger, rub a little of the red from the apple onto the shadow. Begin the stem with Dark Umber over Indigo Blue on the dark side and Sand with a little Olive Green on the light side. Use a very sharp point for this tiny area.

6 add the details

Reapply a heavy layer of Indigo Blue and Tuscan Red under the crock and apple, fading as you go up the shadow. Burnish these with Cool Grey 90% in the dark areas, then French Grey 50%, 30%, 20% and 10% over the rest.

Add stripes to the apple. Stripe Yellowed Orange around the area of the highlights, then add more stripes with Crimson Red and Tuscan Red. Darken the shaded side of the apple with a heavy layer of Indigo Blue, letting it fade out lighter as you go left. Go over this with Tuscan Red. Apply some stripes with Cream on the left side of the dark area. Cover those with Crimson Red. With sharp Verithin Carmine Red, Scarlet Red, Tuscan Red and Indigo Blue, go over the edges of the apple.

remember to brush your work

Brush your colored pencil work frequently with a drafting brush or other soft brush to remove pencil dust that could cause smudges. Brushing crumbs away with your hand invites smudges; blowing on your work is a bad idea because sooner or later, you'll accidentally blow drops of saliva onto your paper.

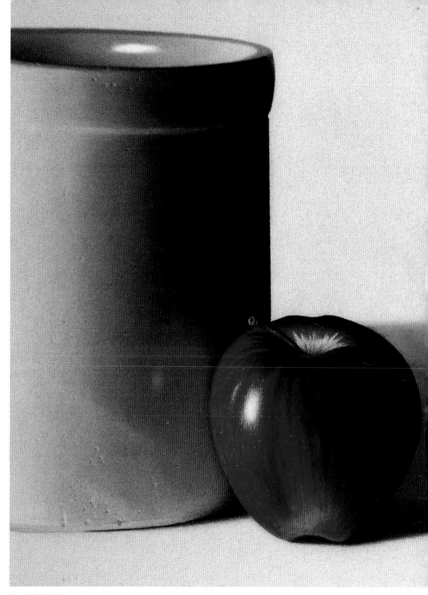

Apple With Crock
Cecile Baird · Colored pencil

cantaloupe

materials list

SURFACE
Stonehenge paper, Natural

BRUYNZEEL PENCILS
Indian Yellow • Light Ochre

PRISMACOLOR PENCILS
Beige • Bronze • Cool Grey (10%, 30%, 50%, 70% and 90%) • Cream • Dark Umber • Deco Orange • Goldenrod • Grass Green • Indigo Blue • Light Ochre • Lime Peel • Marine Green • Orange • Pale Vermilion • Poppy Red • Sand • Scarlet Lake • Slate Grey • Tuscan Red • White •Yellow Ochre • Yellowed Orange

VERITHIN PENCILS
Tuscan Red • Indigo Blue

OTHER
Colorless blender • Craft knife

This demonstration will show you how to capture the juiciness and texture created by the light and the juice on the side of freshly sliced fruit, as well as all the subtle color variations within the cantaloupe's mostly monochromatic (single) color.

reference photo

1 lay down the base color and define the seeds

Using a very sharp Bruynzeel Light Ochre pencil and light pressure, outline and fill in around the seeds. Fill in the seeds with Goldenrod, leaving the white highlights. Leaving only the white highlights, fill in the rest of the melon with a light layer of Beige, covering the rind area at the bottom and the remaining pulp area at the top. Use a sharp pencil, light pressure and a multidirectional stroke. Apply a light layer of Slate Grey to begin the shadow. Soften the outer edges of the shadow, but keep the edges crisp under the melon.

tip

Tape your work to a drawing board, rather than directly to your tabletop, so that you can turn the paper as you work. Your hand naturally draws in one direction better than in others, and if you try to force your hand to draw in the wrong direction, you sacrifice some control of the stroke.

2 define the texture

Begin with Deco Orange and a hit-and-skip circular stroke on the side of the cantaloupe. Use a sharp point to go around highlights, then let your point go a little dull. Define the darker areas on the side of the melon first, then work around them. Apply a light layer of Sand over the Deco Orange. Define the rind with a wide strip of Sand and a narrower strip of Lime Peel in the middle of that.

Outline the seeds with a light layer of Deco Orange and Bruynzeel Light Ochre, extending this color down into the drip areas. Fill in the seeds with Sand. Apply a light layer of Bruynzeel Indian Yellow over the dark areas on the side.

Apply a light layer of Tuscan Red on the dark shadow under the melon. Cover this with a light layer of Indigo Blue letting it extend beyond the Tuscan Red and fading out on the left side of the shadow. Apply the shadow colors with a sharp point, light pressure and a multidirectional stroke.

3 burnish with a colorless blender

Burnish the entire melon and shadow, except for the white highlights, with a colorless blender. Apply heavy pressure using a blunt burnishing point and a multidirectional stroke. Because light colors have been used, you may not see a great change after the burnishing, but you have filled in the grain of the paper and blended the colors together.

using a colorless blender

When using a colorless blender pencil, keep its point clean and work from light areas to dark ones. This way you will avoid dragging darks where you don't want them.

4 finish the seeds and the shadow

Fill in the seeds with Goldenrod and heavy pressure, leaving the white highlights. Contour with Cool Grey 30% on the lighter seeds and Cool Grey 50% on the darker seeds. Add a little Pale Vermilion and Orange. Burnish the seeds with Cream and Sand. Hit the highlights with White.

Reapply Bruynzeel Light Ochre with heavy pressure to the pulp around the seeds. Make the dark areas with Cool Grey 30%, 50% and 70%, then Scarlet Lake and Poppy Red. Cover the rest of the pulp with Pale Vermilion.

Define the bottom edge of the melon slice with the dark of the shadow. Use a blunt point, heavy pressure and a multidirectional stroke to go over the shadow with Cool Greys: 90% in the darkest area, then 70% and 50%. Add a little Tuscan Red over the gray under the melon. Use sharp Verithin Tuscan Red and Indigo Blue to sharpen the edge of the shadow at the melon. To soften the outer edge on the left side go over it with Cool Grey 10%. Go over the right edge with Light Ochre and Sand, then Cream to soften.

create fruit and flowers that glow

The beauty and variety of fruits and flowers are limitless. Add light to a fruit or floral setup, and your paintings will jump off the paper. To see for yourself, shine a light through a slice of kiwi fruit or a bunch of grapes.

5 finish the side of the melon

Apply a heavy layer of Yellow Ochre over the rind area at the bottom of the cantaloupe. Use a linear stroke from outside to inside to bring the Yellow Ochre up into the orange of the melon. Apply Lime Peel over the Yellow Ochre with the same stroke, letting it go up into the melon. Add a little Grass Green for the darker green areas. Go over the side of the melon with Yellowed Orange and Orange, applying the color more densely in the darker areas. Finish the rind on the left with a little Bronze and Marine Green over the Yellow Ochre. Complete the darkest area of the rind on the right side with Yellow Ochre, Bronze, Marine Green and Dark Umber.

With a sharp craft knife scrape out the tiny highlights and cover them with White. Touch up the highlights with White as the last step.

Cantaloupe
Cecile Baird · Colored pencil

cobalt blue glass

materials list

SURFACE
Stonehenge paper, White

PRISMACOLOR PENCILS
Aquamarine • Black • Blue Slate • Deco Blue • Indigo Blue • Light Cerulean Blue • Mediterranean Blue • True Blue • Ultramarine • Violet Blue • White

VERITHIN PENCILS
Ultramarine

OTHER
Colorless blender

The bright afternoon sun shining through and backlighting the cobalt blue glass creates an amazing variety of brilliant blues in the glass as well as a very sharp intense shadow. Colored pencil is the perfect medium to capture this brilliance. This demonstration will help you to overcome any fears you might have of incorporating glass into your paintings.

reference photo

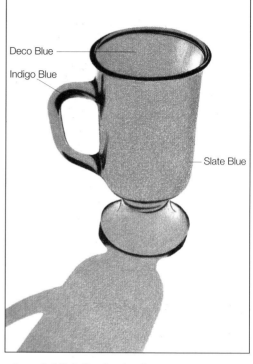

Deco Blue

Indigo Blue

Slate Blue

1 establish the basic shape

Apply all the colors in this step with a sharp pencil, light pressure and a multidirectional stroke. Keep applying the color with light pressure until you have a dense area of color.

Fill in the shape of the glass and the shadow with a layer of Deco Blue, leaving the white highlights. Use Blue Slate on the left and right side where the reflected light will be. Define the darkest areas with Indigo Blue over the Deco Blue.

2 define the highlights and reflections

Use the same stroke, light pressure and a sharp point throughout this step.

Apply Light Cerulean Blue over the glass and shadow, softly blending out the edges to form the light blue highlights. Lightly indicate the pattern in the base of the glass with Indigo Blue. Layer Violet Blue over the glass, shadow and dark Indigo Blue shapes. Apply lightly where needed and more densely to form the darker shapes. Leave the inside and the light blue highlights.

3 burnish with white

Always burnish white highlights with a White pencil. Begin in the center of the highlight and fade the white into the color for a soft edge. Burnish the rest of the glass and shadow with a colorless blender using the multidirectional stroke.

finding references

Looking for inspiration for your next painting? You needn't travel far. There is a wealth of material inside and around your home. Some ideas:

- Paint an object you wouldn't usually consider worthy of painting, such as a kitchen implement or a single leaf from a potted plant.
- Paint an object larger than life size.
- Paint something with lots of texture, such as a moss-covered rock or a draped piece of silk or velvet.

4 finish the glass

Applying color over burnishing requires medium to heavy pressure and the same stroke used before. If needed, touch up the white highlights to finish the glass.

Enhance the color on the inside of the top of the glass with Mediterranean Blue. Start heavier at the left and lightly blend out before reaching the white highlights on the right. Cover the light blue highlights softly with Aquamarine, then True Blue. Blend and lighten with White. Cover the dark shapes with Black, then Ultramarine. Cover most of the glass with Violet Blue; apply it heaviest over the intense blue shapes and softer over the lighter blue in the body of the glass. Burnish the lighter blue areas with Mediterranean Blue.

watch that pencil dust

The heavy pressure used to burnish darks can create quite a bit of pencil dust, so brush often! Specks of Indigo Blue and Violet Blue can be very staining.

5 finish the shadow

Apply a heavy layer of Black over the darkest areas in the shadow then burnish over the Black with a layer of Ultramarine. Cover the highlights with a soft layer of Aquamarine, then burnish with True Blue. Cover the remainder of the shadow with a light layer of Black and burnish that with Ultramarine.

If needed, the edges of the glass and shadow can be sharpened with a colorless blender or a Verithin Ultramarine pencil.

more challenges

The "paint what you see" principle (page 189) that is so helpful for painting this cobalt blue glass also works for other challenging subjects. Try some of these:

- Cut glass
- Spilled or moving water
- Shiny metal

Cobalt Blue Glass
Cecile Baird · Colored pencil

tulip

materials list

SURFACE
Canvas paper

BRUSHES
No. 4 filbert • Nos. 2 and 4 rounds

WATER-SOLUBLE OILS
Alizarin Crimson • Cadmium Red Light • Cadmium Yellow Medium • Phthalo Green • Titanium White • Ultramarine Blue • Yellow Ochre

OTHER
Fresh tulip

You can approach flowers in many ways. When you paint them as they grow outdoors, they become part of a landscape painting. Those flowers are usually painted without a lot of detail. Paint flowers in a vase with the same approach. Use minimal details, and make the painting about shapes and color. When you paint a single blossom, you may want to use detail to make the flower look like a specific type.

1 paint the outline
Using Ultramarine Blue and a no. 4 round, paint the flower's outline.

2 paint contrasting reds
Paint the petal in shadow (Ultramarine Blue + Titanium White + Alizarin Crimson). Then paint the petal that faces the light (Cadmium Red Light + Cadmium Yellow Medium). Paint the background (Phthalo Green + Yellow Ochre) using a no. 4 filbert. When this step is completed, you could stop because you have enough detail for a flower in a bouquet.

3 add detail

Add Titanium White to the Cadmium Red Light and Cadmium Yellow Medium mixture for the lighter petals. Add more Cadmium Yellow Medium to the red and white mixture. Paint the light edge of the shadowed petal with your no. 2 round. Add more Phthalo Green to the green and ochre mixture to darken the bottom of the background. Paint the stem dark green (Phthalo Green + Yellow Ochre) on the shadowed side and less Phthalo Green mixed with Yellow Ochre for the light side.

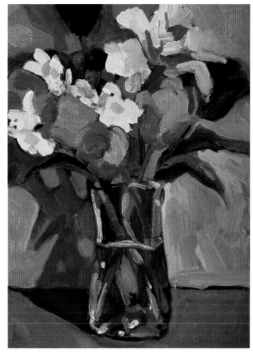

4 final painting

The bouquet of tulips and narcissus is painted its true colors: purple, pink and white. Proportion is important in flower presentation. A medium-sized vase was used for this arrangement. The artist placed cardboard close behind the flowers so that the shadow cast from the lamp would show clearly. When you are painting a bouquet, focus on a few flowers in the foreground and suggest the rest with minimal strokes.

Spring Bouquet With Tulips
Mary Deutschman · Water-soluble oils
12" × 9" (30cm × 23cm)

deciding if your painting is finished

Knowing when a painting is finished can be difficult. Two things can help: experience, and knowing your desired result. Before you decide, take a step back from your work and consider the following:

- Your initial impression of the painting
- Objects or areas that may stand out as unfinished
- Brushstrokes or other textures that work or do not work for the piece
- Details that may need to be added or eliminated
- Overall impact from a distance
- Details at close range.

DEMONSTRATION

layered fern fronds

materials list

SURFACE

140-lb. (300gsm) cold-pressed watercolor paper

BRUSHES

1½ -inch (38mm) flat • Nos. 4 and 8 round

WATERCOLORS

Cerulean Blue • Cobalt Blue • Phthalo Blue • Raw Sienna

OTHER

Eraser • Paper towels • Pencil

Here you'll paint multiple leaves suspended on a common stem such as you might find in most species of trees, low-growing bushes, ferns and the greenery of floral bouquets. The cluster of leaves becomes a complex shape, but remember that it is still just a shape.

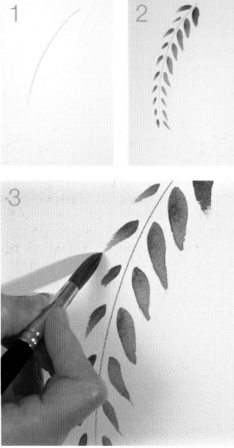

1 start with a pencil guideline

Indicate the curve of the branch with a single flowing pencil line.

2 paint the negative spaces

Without overmixing, combine freshly squeezed Raw Sienna and Cerulean Blue with water. Place the tip of your no. 4 round near, not on, the pencil line and pull the stroke down and away. The brushstroke should look like a teardrop.

Repeat the stroke, decreasing its size, along both sides of your pencil line to the tip of the branch. Although these strokes may resemble tiny leaves, they are actually the negative spaces between the leaves.

3 carve around the leaves

Load a large round brush with the same combination of Raw Sienna and Cerulean Blue. Position the tip of your no. 8 round at the narrowest end of a previous brush mark. Now pull your brushstroke down and out at an angle similar to the captured negative spaces previously created. This line forms the lower edge of one leaf and the top edge of another.

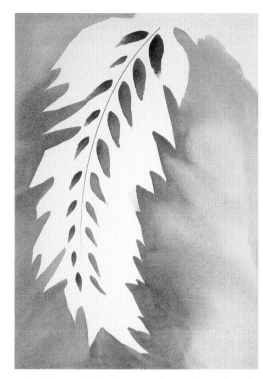

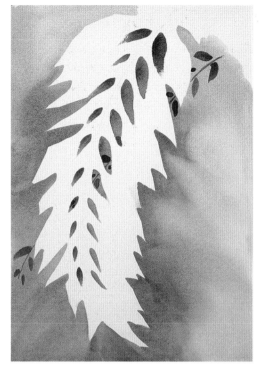

4 delineate the leaves

Continue to carve around your leaves. The shape you paint may look something like a saw blade. Use a 1½-inch (38mm) flat and plenty of water to dilute the color as you pull it away from the leaves. Work quickly. After the shapes are formed but before the paint has dried, use a no. 8 round to cut notches for serrated or wavy edges, typical in ferns and many other plants. Dry your paper thoroughly and erase the pencil line.

5 weave a second guideline

The second layer of leaves will be partially hidden under the first. Weave a second pencil line through the spaces between the leaves. Once again paint the air holes (captured negatives) along your guideline. Using less water, dilute your paint to create a darker value.

imitate nature

To establish natural movement when painting a tree or plant, make your brush follow the direction of growth. Generally stems and leaves become progressively finer and smaller as you move from the heart of the plant toward the tip. When painting a hanging cluster of leaves, start at the top and glide the pencil line in a downward sweep. Alternatively, to simulate the upward growth of ferns or saplings, begin at the bottom and quickly draw the line up.

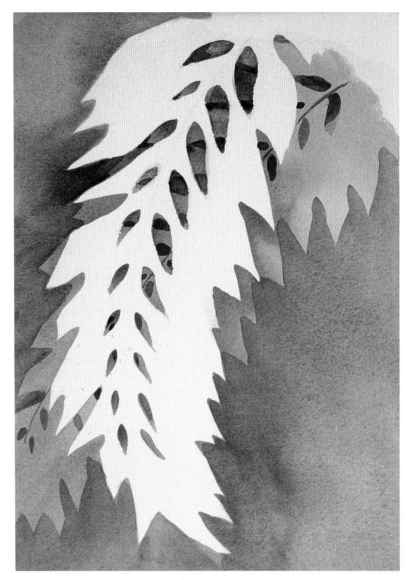

6 paint a second layer of negative leaves

Using your guideline and the little air holes that you made as reference points, glaze around the second set of leaves. Be sure not to paint over the existing leaves and branches. Working on dry paper is the secret to maintaining clean, crisp edges.

7 add more layers of foliage

Continue adding foliage to your painting, further enhancing the value range and creating a more dramatic final layer. Add a touch of Phthalo Blue or Cobalt Blue to the Raw Sienna and Cerulean Blue to create darker values.

create layers

In some areas of this painting, you will want to create numerous levels of foliage. In other areas, establishing only one or two layers will allow for calmer and less intricate areas where the viewer's eye can rest.

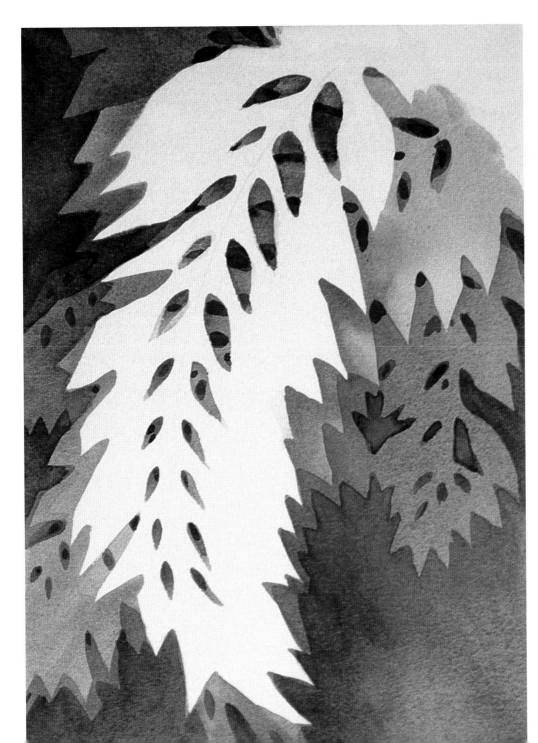

Fern Fronds
Linda Kemp · Watercolor

a note about copying

Many artists paint from reference photos. This is fine as long as the photo is one you took. Copying someone else's photograph (even by painting it) infringes upon the photographer's copyright of his or her work. If you want to practice by using photos from a magazine or book, keep the results in your studio.

Likewise, if you copy another artist's painting for practice, do not display or sell the results.

layered floral shapes

materials list

SURFACE
22" × 8" (56cm × 20cm) sheet of 140-lb. (300gsm) or heavier cold-pressed water-color paper

BRUSHES
1-inch (25mm) and 1½-inch (38mm) soft flats • No. 10 round sable or sable mix

WATERCOLORS
Cadmium Orange • Cerulean Blue • Cobalt Blue • Leaf Green (yellow-green) • Quinacridone Violet

The exact flower shapes you paint aren't important in this painting; the goal is to paint an expression of joy. This painting uses contrasts of complementary hue as well as value change.

1 establish the underpainting with bright colors and big strokes

Saturate the front and back of the paper with water. Do a wet-into-wet underpainting with upward, energetic strokes of pure blue and green mixtures and a 1½-inch (38mm) soft flat. Brush beyond the edges of the paper. With a no. 10 round, drop juicy Cadmium Orange and Quinacridone Violet into the main and secondary areas of interest. Splatter this combination lightly in the remaining point of balance. Lift and tilt the paper to encourage the color to flow. Spatter clean blue and green up the surface.

As the paper begins to lose its shine, you will notice that the paint no longer disperses wildly. Now you can work with more control. Use the 1½-inch (38mm) soft flat brush and undiluted combinations of blue and green paint to carve around long, angular, negative leaf forms. To suggest twigs, apply calligraphic marks with thick paint applied with the pointed wooden end of the round brush. These are the only positive forms. Place the completed damp foundation on a board to dry completely.

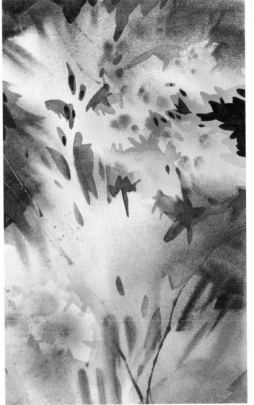

<div style="float:right">

tip

When painting this project, you won't go wrong using pure color, angular shapes and upward movement.

</div>

2 create simple shapes with vibrant color

In the main and secondary areas of interest, begin to carve around the first layer of flowers with rich glazes of orange. Use a 1-inch (25mm) flat on dry paper to keep the edges crisp. Begin to negatively delineate large leaves and main branches with transparent glazes of blues and greens. Allow the painting to dry.

3 repeat the shapes to build floral forms

Carve around a second layer of blossoms in the main area with rich Cobalt Blue. If the blue is thinned with too much water, it will be neutralized by the underlying orange. In the secondary area of interest, apply a third glaze of diluted orange to build additional layers of floral shapes. Continue to mold leaves in the upper two-thirds of the painting using progressively darker values of green and blue. Add the small negative shapes of air holes between the branches and leaves with a no. 10 round.

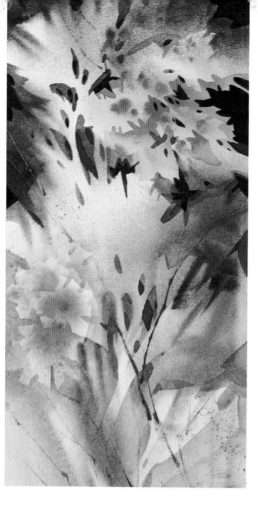

4 continue to build layers

Continue to sculpt the clusters of flowers in the upper area of interest using pure orange and red. Dry these hot colors completely before laying in more deep blue to ensure sharp edges and to avoid sullying the color. Work around the painting to develop multiple layers of leaves and stems. Follow the main line of stems to ensure a natural connection. Make sure the stems line up.

emphasize the focal point with contrast

In the past you may have been advised to always place your lightest lights and your darkest darks at the center of interest. While this is a powerful and dramatic way to attract the viewer's attention, there are other, less widely used options. Contrast in intensity is elegant, but contrasting complementary colors can be wildly exciting.

5 develop the minor area of interest

Develop smaller, less intricate blossoms with little change in value or hue in the areas of the orange splatters. Move down the paper and begin to develop a few overlapping leaves. Keep the changes of hue and value subtle by glazing with delicate tints, or washing excess color away. While the wedgelike shapes are repetitive, slightly softer edges and more gradual transitions of color and value provide variety.

6 balance the design

Stand back from the work to evaluate the overall balance and movement of the painting. Make final adjustments of awkward shapes, distracting lines and out-of-tune elements. Lift any areas of dull color with a soft wet brush and a tissue, then repaint with clean hues.

underpaintings as inspiration

Try dropping and splattering watercolor on wet paper in a freeform manner, then looking at the resulting shapes to see if they suggest a subject—rather like hunting for shapes in clouds.

tip

Place clean, dark blue against light or white areas to provide contrast of value. Create contrast of hue by abutting bright blue with its complement, orange.

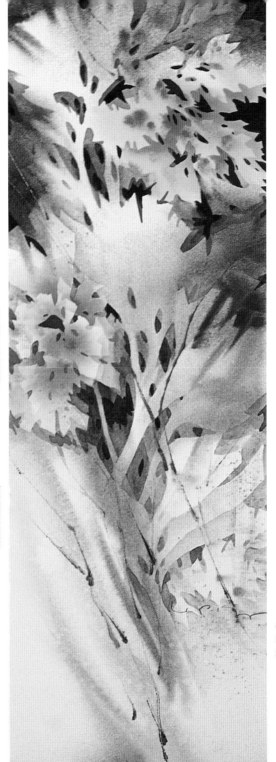

Celebrate an Expression of Joy
Linda Kemp · Watercolor
22" × 8" (56cm × 20cm)

using bold brushwork

materials list

SURFACE
12" × 16" (30cm × 41cm) neutral-toned Masonite or canvas

BRUSHES
Nos. 1 and 8 hog bristle filberts • No. 12 hog bristle flat • Large sable flat for oils • Large 2- to 3-inch (51mm–76mm) flat for acrylics

PAINTS
Alizarin Crimson • Burnt Umber • Cadmium Red Light • Cadmium Yellow Light • Cerulean Blue • Sap Green (Acrylics: Hooker's Green) • Terra Rosa (Acrylics: Red Oxide) • Titanium White • Ultramarine Blue • Viridian • Yellow Ochre

OTHER
Liquin (medium for oil paint) • Palette knife

A snowy scene can be a great opportunity to showcase bold, powerful strokes. This is particularly so when using a strong, graphical, somewhat abstract composition. The basic concept is to work from larger simpler areas to smaller more intricate ones.

use light to establish time of day

When you are painting a landscape, the light indicates the time of day and helps set a mood. The angle of the sun and the length of shadows are the main indications of the time of day. Morning light tends to be cool, since moisture in the air has not yet burned off. Late-afternoon light is warmer, sometimes even fiery in color.

1 sketch the basic shapes
Use a no. 1 bristle filbert to quickly sketch the basic shapes. Use a no. 12 bristle flat to create the various drab olives by using a little Liquin combined with blues, ochres and browns, which are similar in the pond and the trees at the top. Accentuate the top left with a dark brown tree trunk.

2 paint shadows, then rocks
Paint the blue-violet shadows on the snow using a no. 8 bristle filbert and a mixture of Titanium White, Ultramarine Blue and a touch of Alizarin Crimson. Lay in rock forms and reflections next with the same brush and warmer tones of ochres, earth tones and white.

3 paint the snow

Use a palette knife to mix a large amount of Titanium White with a little Yellow Ochre for warmth and some Liquin for fluidity. Boldly apply this to the snow areas with a no. 8 bristle filbert. Add a bit of darker edge control in the trees, some snow on branches and rocks, and a few refinements in the reflections with the no. 8 bristle filbert.

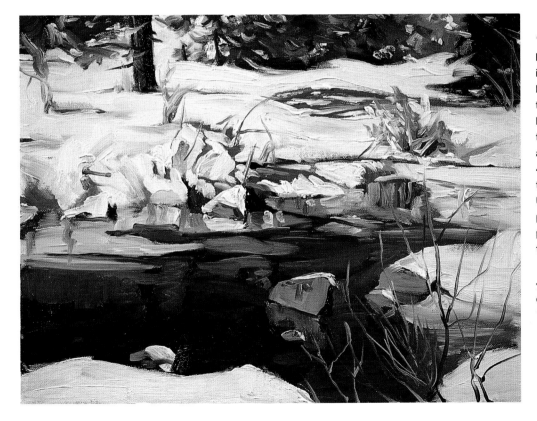

4 finish

Use the nos. 1 and 8 bristle filberts to begin adding in the warmer, more calligraphic weeds, brush and their reflections. Add tree branches, a background, trunks and linear weed forms and branches with the no. 4 round sable using neutral tones of very wet paint. Use a very light touch when painting through the wet paint, and constantly clean the brush.

The Snowy Truckee
Craig Nelson · Oil
12" x 16" (30cm x 41cm)

painting trees with a small script

materials list

SURFACE
Crescent Illustration
board no. 1, 8" × 10"
(20cm × 25cm)

BRUSHES
Nos. 1 and 2 script • ⅛-inch
(3mm), ¼-inch (6mm),
½-inch (13mm), ¾-inch
(19mm), 1-inch (25mm) and
1½-inch (38mm) one-stroke
or flat brushes

ACRYLIC PAINTS
Anthraquinone Blue •
Diarylide Yellow • Jenkins
Green • Quinacridone
Magenta • Titanium White

OTHER
Drafting or masking tape •
Masking fluid • Paper towels
• Spray bottle

You can create form and shape using cross-hatching. Use a small script brush, either no. 1 or no. 2, to paint the trees in this demonstration.

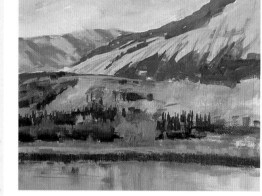

1 paint a low-value landscape
Using the colors in the materials list, paint a basic landscape keeping most of the mixtures low in value.

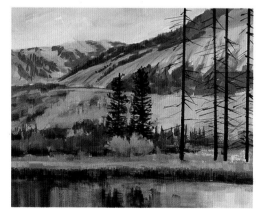

2 add tree trunks
Mix Jenkins Green, Anthraquinone Blue and Quinacridone Magenta to create a very dark green. Use a ⅛-inch (3mm) one-stroke and a no. 1 or 2 script brush to paint in the pine tree skeletons. Because of their dark nature, you can place the pine trees over the background color.

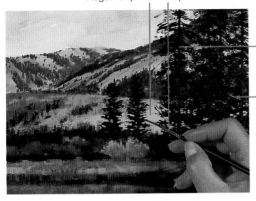

Negative space — No. 1 or 2 script brush

Splatters

Use an orange-white mixture to highlight the tree trunks

3 develop the trees

Add some pine foliage with a no. 1 or 2 script brush and some splatters using the same dark green. To highlight the foliage, mix Diarylide Yellow, Anthraquinone Blue and a touch of both Quinacridone Magenta and Titanium White. This highlight color will also be dark. To highlight the tree trunks, mix Quinacridone Magenta, Anthraquinone Blue, Diarylide Yellow and a touch of Titanium White.

Paint in the negative space to create a bright spot just beyond the twin trees in the midground. This will help create the center of interest.

4 finish

Use the same colors you used in step 3 as a wash for the pond reflections. Soften the area vertically with a paper towel. A light-spray bottle is handy here to keep the surface wet while you work it. Paint some highlights with a no. 1 or 2 script brush. Add some brushwork.

Blanco Basin Pond
Hugh Greer · Acrylic on Crescent Illustration board no. 1
8" × 10" (20cm × 25cm)

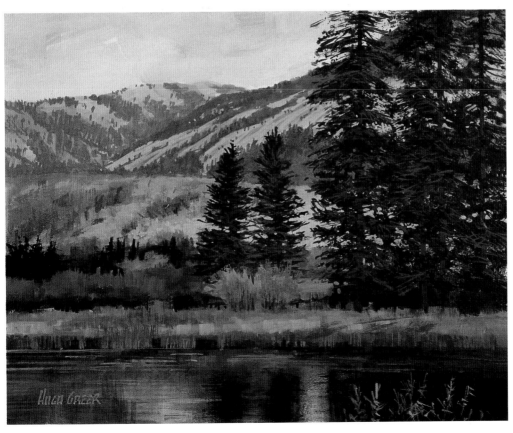

painting aspens with a wide brush

materials list

SURFACE
Gessoed Masonite 12" × 16" (30cm x 41cm)

BRUSHES
Nos. 1 and 2 scripts • ⅛-inch (3mm), ¼-inch (6mm), ½-inch (13mm), ¾-inch (19mm), 1-inch (25mm) and 1½-inch (38mm) one-stroke or flat brushes

ACRYLIC PAINTS
Anthraquinone Blue • Cerulean Blue • Diarylide Yellow • Dioxazine Purple • Jenkins Green • Quinacridone Magenta • Titanium White • Yellow Ochre

OTHER
Drafting or masking tape • Masking fluid • Palette knife • Rubber cement pickup • Ruling pen • Saral paper or pastel stick • Scissors • Spray bottle

Aspen trees are loved for their tall, straight, pristine appearance. They color up beautifully in the autumn and are a knockout to see. Most artists who see them have to paint them. Here's your chance.

1 sketch and mask
Start by sketching onto your board. Mask out the tree trunk areas with masking fluid.

2 paint the aspens and pine trees
Brush in the background aspens using Yellow Ochre, Diarylide Yellow and Titanium White, graying it slightly with a touch of Dioxazine Purple. Gray the green areas slightly with a touch of Dioxazine Purple and brush and blend them into the yellow with a ¾-inch (19mm) one-stroke while they are still wet. Work quickly and use a medium-spray bottle to extend your drying time.

Brush in the pine trees behind the barn using the edge of a ½-inch (13mm) one-stroke. Use a mix of Dioxazine Purple and Jenkins Green with a touch of Anthraquinone Blue. The same green is used for the foreground. Let all of this dry and remove the masking fluid with a rubber cement pickup.

tips for painting trees

- Different species of trees have different skeletal structures. Study deciduous trees in winter, when their branches are easy to see, to get a feel for the structures that support the summer foliage.

- You may find unusual tree specimens in your travels (leaning or curling trunks, for example), but the most unusual trees may not always translate into a believable painting.

3 develop the trees

The aspen tree trunks are a slightly greened gray. Mix a black using the base palette, but go heavier on the blue and yellow. Now add a little bit of this mix to your Titanium White and see if you get a greened gray. You may need to adjust your proportions to get a good aspen tree trunk color. Brush this color in vertically with the one-stroke brushes depending on the trunk width. Splatter the foreground and work in sticks, leaves and foliage using a no. 2 script and a ruling pen. Let dry.

4 finish

The sunlit leaves in the foreground trees are a mix of Diarylide Yellow with touches of Quinacridone Magenta and Titanium White. The darker leaves are a color mixed from Diarylide Yellow and Dioxazine Purple. Splatter these leaves in and refine them with a no. 1 script. Use a ⅛-inch (3mm) or ¼-inch (6mm) brush for the highlights on the aspen trunks, mixing a color of mostly white with a little yellow for the sunny side of the aspens. There is some reflected light on the trunks. The reflected light is put in with the greened gray color you used for the aspens, plus a little Cerulean Blue and Titanium White added to cool the color for the shaded side of the trees. Add more splatters and use your palette knife, brushes and other tools to create the illusion of detail.

Create the center of interest by contrasting the bright roof and bright golden aspen with the dark of the pine trees.

Ranch in Blanco Basin
Hugh Greer · Acrylic on Gessoed Masonite
12" × 16" (30cm × 41cm)

cumulus clouds

materials list

SURFACE
Crescent Illustration board no. 1, 9" × 12" (23m x 30cm)

BRUSHES
Nos. 1 and 2 scripts • ½-inch (13mm) and ¾-inch (19mm) one-stroke or flat brushes

ACRYLIC PAINTS
Anthraquinone Blue • Cerulean Blue • Diarylide Yellow • Quinacridone Magenta • Titanium White

OTHER
Lift-out tool

Since the lighting in your painting comes from the sky, it is important to create a believable one. Usually when something is wrong with a landscape, the first place to look is the relationship between sky and ground. Unless you're painting a skyscape, don't overdo the sky, particularly if there are a lot of other things going on in the painting. In other words, a plain, simple sky—maybe just blue—can be the best. Let's look at a few approaches to tackling clouds.

removing pencil lines

If you need to remove pencil lines from an acrylic painting (hopefully you have put them on with a very light or soft pencil), you can wash them off with soap and water. Do this before you paint over the area. Be sure to remove all soap residue, as acrylic paints cannot bond to soap.

1 apply a wash
Apply a graded wash with pale yellow made from Diarylide Yellow and Titanium White at the top and a slightly darker orange toward the bottom. Allow to dry completely.

2 spray the board
After the warm wash is dry, use the spray bottle to wet the surface just enough for individual beads to stand up. Don't overdo it, or you'll have to wait until it dries and then start over. You need the beads of water. Into the beads or drops of water, put a sky blue wash of Anthraquinone Blue and Titanium White in the shape of the cloud you want. The blue color should jump from drop to drop creating a lacy look. Allow this first cloud-shaping wash to dry.

tip

Painting a base color on your canvas is helpful in unifying the colors of the sky and ground.

3 spray again

Repeat the process in the previous step: spray with water so beads develop, apply wet pigment, watch the color jump from drop to drop. Now mix some gray for the undersides of the clouds. Make the gray from a mixture of the sky blue and a little orange. Work a little of the gray into the wet droplets. Expose the warm color down close to the horizon by using a lift-out tool.

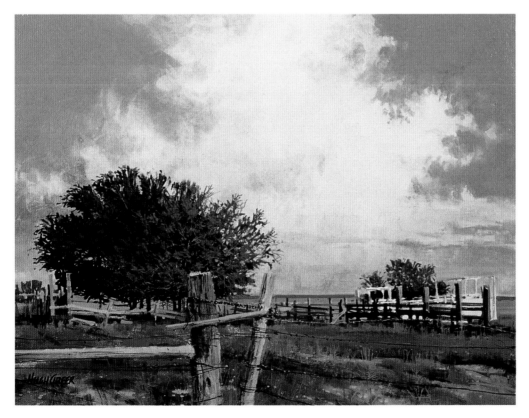

4 finish

The success of this procedure depends on your ability to capitalize on accidents. Work out the finishing elements of the cattle chutes, fence posts and trees.

Cattle Chutes
Hugh Greer · Acrylic on Crescent Illustration board no. 1
9" × 12" (23cm × 30cm)

storm clouds

materials list

SURFACE
Crescent Illustration board
no. 1, 9" × 12" (23m x 30cm)

BRUSHES
⅛-inch (3mm), ¼-inch
(6mm), ½-inch (13mm) and
¾-inch (19mm) one-stroke
brushes or flat brushes

ACRYLIC PAINTS
Anthraquinone Blue
• Cerulean Blue • Diarylide
Yellow • Quinacridone
Magenta • Titanium White

OTHER
Lift-out tool • Palette knife •
Paper towels

Early morning and late evening thunderheads
can be a spectacular sight with the warm colors
that usually highlight the tops of the clouds.

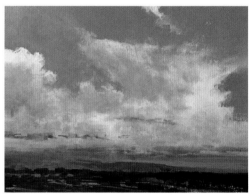

1 apply a wash
Take a ¾-inch (19mm) flat and wash with a vivid
orange (a blend of Diarylide Yellow and Quinacridone
Magenta). Allow the wash to dry. Use a paper towel to
lift out places where the highlights or transparent areas
will most likely be.

2 use a lift-out tool
For the shadowed side of the clouds, mix Ceru-
lean Blue, Titanium White, Quinacridone Magenta and
a bit of Diarylide Yellow to gray it. Use a ⅛-inch (3mm)
flat and a lift-out tool in the foreground.

tip
Use a light-spray bottle
to soften edges while you
brush the Cerulean Blue
and Titanium White to
create the cloud shapes.

how to tone down a mixture
When searching for the perfect color mixture, some-
times you create something that is almost right but
slightly too intense. To tone the color down without
wrecking it, add just a hint of its complement (the
color opposite it on the color wheel).

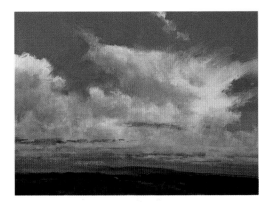

3 paint thin washes
Use thin washes with the ½-inch (13mm) in a dry-brush effect for the thin, wispy tails coming off the main thunderhead.

4 finish
Add the orange mixture from step 1 to the clouds and purple (a blend of Anthraquinone Blue and Quinacridone Magenta) to the horizon line to intensify the sense of impending rain.

choosing a ground color
The ground color you use for a landscape can contribute to the overall tone and mood of the painting. When painting bright midday scenes, work on a white surface. For late evening or early morning scenes, try underpainting a wash of pale orange or pale red.

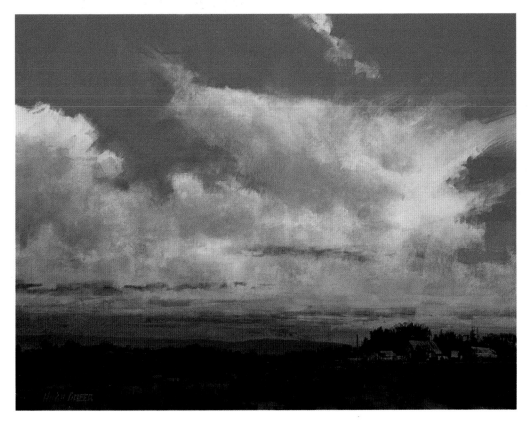

Looking Towards the Opera
Hugh Greer · Acrylic on Crescent Illustration board no. 1
9" x 12" (23cm x 30cm)

creating atmospheric depth

materials list

SURFACE
Gessoed hardboard 9" × 12" (23cm × 30cm)

BRUSHES
Nos. 1 and 2 scripts • ¼-inch (6mm), ½-inch (13mm), ¾-inch (19mm), 1-inch (25mm) and 1½-inch (38mm) one-stroke brushes or flat brushes

ACRYLIC PAINTS
Anthraquinone Blue • Diarylide Yellow • Dioxazine Purple • Jenkins Green • Quinacridone Magenta • Titanium White

OTHER
Pencil • Soft Gel medium

Creating depth in a painting will give the viewer a sense of space and perspective. Atmospheric layering is one way to achieve depth in your landscapes.

tip
Misting the surface of your canvas panel can help the paint to flow more smoothly. Just before you begin working on the panel, use a light-spray bottle to mist the entire surface.

1 apply the first wash
Use a 1½-inch (38mm) flat to make an orange wash mixed with the base palette from Quinacridone Magenta, Diarylide Yellow grayed down with a little Jenkins Green. Apply the wash to the support—darker at the bottom, lighter at the top. Let this dry. Sketch and transfer your drawing onto the support.

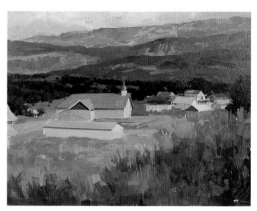

2 paint the mountains
Depth and atmosphere is going to be created in the mountains behind the chapel. You can see the layered effect of the mountains as they appear to recede (the colors become cooler and lighter). Use the ¾-inch (19mm) and 1-inch (25mm) flat with different greens mixed from Jenkins Green, Diarylide Yellow and Titanium White. Leave some spots of the undercoat showing through in the mountains. Keep the background mountain colors grayed so they are not strong and vibrant. The foreground colors should be a higher chroma and have a more intense color.

3 develop the painting

Create a wash of Titanium White and Soft Gel with a tiny bit of Anthraquinone Blue. Apply a thin wash of this mixture with a 1-inch (25mm) flat over the mountains; this will soften them further, adding more atmosphere. The low hill behind the chapel is darker, providing a nice contrast to the chapel's red roof and creating a center of interest. Paint the poplar trees with the edge of a ¼-inch (6mm) one-stroke loaded with a mixture of Jenkins Green and Dioxazine Purple. The poplar trees are the darkest part of this painting. Highlights on the poplar trees are from a mix of Jenkins Green, Diarylide Yellow, a touch of Quinacridone Magenta and Titanium White.

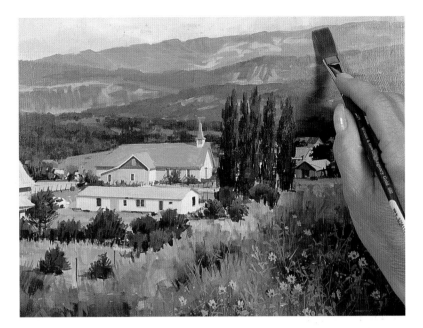

4 finish

Embellish the foreground with sunflowers, telephone poles, grasses, weeds and shadowed areas. Brighten the sky if you like.

Church at Rowe
Hugh Greer · Acrylic on gessoed hardboard
9" x 12" (23cm x 30cm)

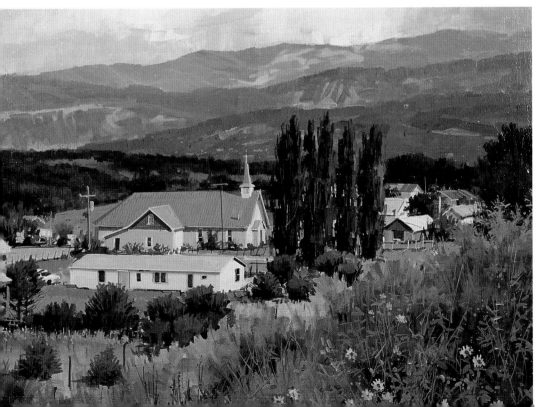

roads

materials list

SURFACE
Gessoed hardboard 12" × 16" (30cm × 41cm)

ACRYLIC PAINTS
Diarylide Yellow • Jenkins Green • Quinacridone Magenta • Red Oxide • Titanium White • Ultramarine Blue

BRUSHES
Nos. 1 and 2 scripts • ⅛-inch (3mm), ¼-inch (6mm), ½-inch (13mm), ¾-inch (19mm), 1-inch (25mm) and 1½-inch (38mm) one-stroke or flat brushes

OTHER
Drafting or masking tape • Lift-out tool • Paper towels • Ruling pen • Sand paper (fine) • Saral paper or pastel stick • Soft Gel Gloss medium • Tracing paper

Roads are arteries connecting us to one another. On them we travel home, venture off on vacation and conduct the business of daily life. Without them, we'd be pretty isolated. Try painting some of the places you encounter while traveling. Quite a few places have "no trespassing" signs on the property; in that situation, just pull your car off to the side of the road and start painting. The road itself may become part of your painting.

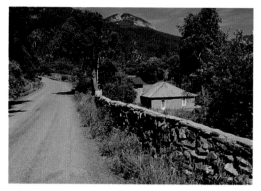

reference photo
The photo was taken on a bright sunny day on a mountain road in northern New Mexico. However, you can use it to depict an overcast day with fresh rain on the pavement.

1 create and transfer your sketch
Make a sketch on a piece of tracing paper. Transfer your drawing to gessoed hardboard, and you're ready to paint. Leave the surface white; no need to underpaint here. After the tracing is transferred to the support, coat the surface with Soft Gel Gloss to keep the line work from smearing when applying washes over it. This coating will also allow the paint to stand on the surface a bit longer before drying, making it easier to blend colors.

painting stone walls

The highly textured nature of stone walls can be established in a number of ways.
- Lay down the stone color, modeling the forms as you go with slight variations in value. Let this dry, then put down a very dark wash over the stones. While this is still wet, working quickly, use a lift-out tool to shape the stones, leaving dark ridges to represent the gaps between the stones.
- Use a fine brush, no. 1 or 2, and paint the joints over the light stone color.
- Consider judicious use of spattering to suggest the texture of variegated or mossy stone.

2 lay in the painting

Begin laying in some of the big shapes with the larger flats. Mix the sky, mist and mountain colors with combinations of Ultramarine Blue, Red Oxide and Titanium White. You will be using these grays for the reflective road as well. This combination of colors is used in several places throughout the painting to help unify it. For the rooftops use Red Oxide, Quinacridone Magenta, a touch of Diarylide Yellow and as much Titanium White as necessary to lighten the roofs just enough to catch the eye and make them the center of interest. Use the ⅛-inch (3mm) and ¼-inch (6mm) flats and the scripts for the edges. For the foliage, use a combination of Diarylide Yellow, Ultramarine Blue and Jenkins Green with the same flats. Remember, the background foliage will be lighter in value, so soften and gray the foliage in the background. The foreground foliage will be darker and higher in value and the chroma will be more intense.

using a mahlstick

If you paint large areas wet into wet with either acrylic or oils, consider using a mahlstick. This is a long stick with a padded knob on one end. You lay the padded end on a dry section of your painting, then hold the other end of the stick with your nonpainting hand and lay it at a low angle across the canvas. You then have something on which to brace your painting hand without touching the wet canvas. To make your own mahlstick, attach a wooden knob to the end of a three-foot (one-meter) length of dowel, then wrap the knob with soft cloth fastened with a rubber band.

3 streak the painting

Use a paper towel to vertically pull the paint toward the bottom of the support, leaving streaks in the paint for a wet appearance.

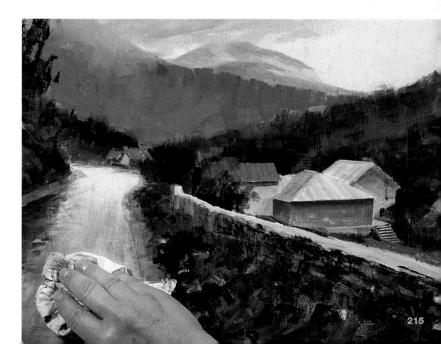

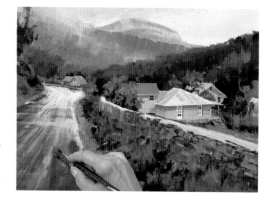

tips for painting grasses

- Make several sketches of grass shapes on tracing paper to see which one you like best.
- Use photos to refresh your memory of the grasses in a particular location.
- To create negative space between blades of grass, try scraping away paint with a toothpick or a small, sharpened wooden stick. Keep in mind that acrylic dries fast, and if you wait too long to scrape you will have missed your chance.
- Don't try to create individual blades of grass for distant fields of grass; just represent the area as a shape of color.
- If your grass appears too light, apply a dark blue-green transparent wash over it.

4 develop the road

Use a dry, ½-inch (13mm) one-stroke to lift pigment off the road. Create a bright white spot at the end of the road where it bends to the left to achieve balance with the bright spot in the sky. As the road comes toward you, it will be darker because there is more reflective light in the distance. You want the center of interest to be the houses, so the red roofs will come in handy to draw your eye there.

Use the no. 1 script and a mixture of Ultramarine Blue, Red Oxide and Titanium White for the loose gravel on the side of the road and the asphalt.

5 perfect the curve of the road

Make a careful study of the curve on tracing paper to get the perspective right.

6 use the ruling pen

Transfer the sketch of the road onto a piece of mat board and cut it out as a guide for the ruling pen. Make sure to sand the rough spots on the mat board before you use it to create the center line.

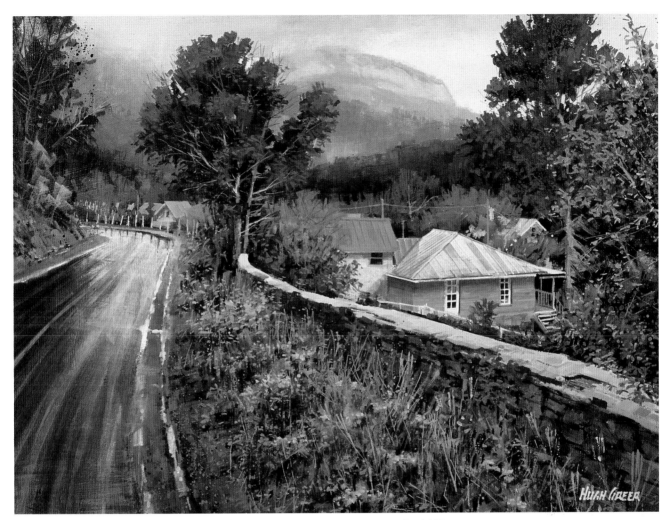

7 finish

Apply several layers of blue washes to the road using vertical and horizontal strokes with the ⅛-inch (3mm) flat with blends of Ultramarine Blue and Titanium White. The dark blue on the left is a result of the trees on the side of the hill reflecting onto the pavement.

Add detail to leaves, trees, grasses and wildflowers to complete the painting.

Road 230
Hugh Greer · Acrylic on gessoed hardboard
12" x 16" (30cm x 41cm)

four pelicans in pastel

materials list

SURFACE
30" × 44" (76cm × 112cm)
100% rag vellum finish white
paper

SOFT PASTELS
A selection of Rembrandt
and Schmincke pastels,
Derwent pastel pencils and
Conté pencils

OTHER
Drawing board • Artist's
low-tack tape • Craft knife
with no. 11 blade • Kneaded
eraser • Lascaux fixative •
No. 2 pencil • Masking film

Although the masking process used in this pastel painting may seem complex, it's essential and helps create a masterful painting. The comical demeanor of the pelicans is irresistible and provides a great starting point for an interesting painting.

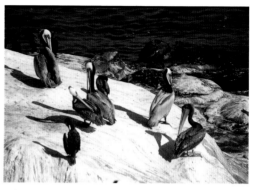

reference photo

1 paint the water

Make your drawing and cover with masking film. To begin laying in the water, cut around the masked area using a craft knife. Use light pressure when cutting. Remove the cut film and begin establishing the areas of color. For light areas, apply Rembrandt White, Cobalt Blue, Mars Violet and Red Violet Deep. Apply Schmincke Greenish Blue, White and Purple 2.

For the dark areas, apply Rembrandt Cobalt Blue and Schmincke Cobalt Blue Tone. After applying pigments, use your fingertips to blend pastels together.

To finish the water, blend with your fingers, working back and forth between light and dark areas. Use Derwent pastel pencils to define details, blending with the pencil rather than your fingers. Apply Rembrandt Ultramarine Deep, Schmincke Prussian Blue, Caput Mortuum Deep and Cold Green Deep. Apply Derwent Prussian Blue and Conte in Sepia to the darker areas of the water. For light areas, apply Rembrandt Cobalt Blue and White. Use Derwent Chinese White, Spectrum Blue and Dark Violet.

2 paint the background rocks

For the darkest rocks, remove the masking film from the darkest areas of the rocks to the right. Working on the dark shadows first, apply Rembrandt Black, Grey, Bluish Grey and Schmincke Black, Greenish Grey and Flesh Ochre. Use Derwent Indigo, Dark Olive, French Grey and Conte Sepia, Pierre Noire Black. Reapply the darkest darks and lightest lights after blending.

For the highlighted areas, apply Rembrandt White, Green Grey, Deep Yellow, Yellow Ochre and Orange. Apply Derwent Brown Ochre and Chinese White.

For the lightest rocks, apply Rembrandt Raw Umber, Burnt Umber, Yellow Ochre, Deep Yellow and Schmincke White. Apply Derwent Green Umber, Choc-olate, Deep Cadmium, Spectrum Orange, Dark Violet, Terracotta, Chinese White and French Grey. Finally, apply Conte Sepia.

Remove the masking film from the remaining rock areas, leaving the shadow areas. Lay in the details lightly, using Rembrandt Orange, Bluish Grey, Caput Mortuum Red and Raw Sienna. Finish with Rembrandt Deep Yellow, Grey and White. Use Schmincke Neutral Grey, White and Olive Ochre Deep.

Remove the masking film from the shadow areas and blend the edges where the shadows and rock meet with Derwent and Rembrandt pastels. Apply Rembrandt Bluish Grey and Red Violet Deep. Use Derwent Brown Ochre, Chinese White and French Grey.

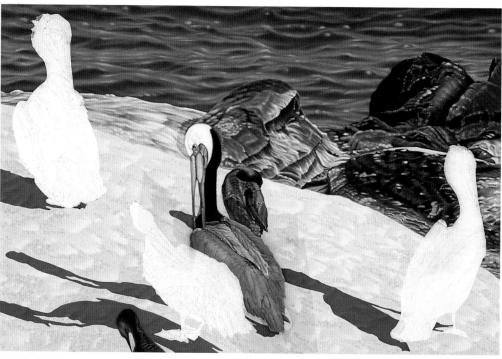

3 finish the foreground

Remove the mask from the light areas of the rock. Lightly underpaint these areas with Rembrandt Orange, Bluish Grey, Caput Mortuum Red and Raw Sienna. Finish the lights with Rembrandt Deep Yellow, Grey and White.

Remove the mask from the rocks' shadow areas. Blend the edges where shadows and rock meet with pastel pencils. On the dark areas, apply Rembrandt Bluish Grey and Red Violet Deep. Next, apply Derwent Brown Ochre, Chinese White and French Grey.

Remove the mask from the birds one at a time. Complete the light areas of the birds with Rembrandt Deep Yellow, Permanent Red Deep, Burnt Umber, Gold Ochre, Black, Burnt Sienna and Raw Sienna. Next, apply Schmincke Black and Derwent Brown Ochre and Chocolate.

Apply the previous list of pastels to the center birds' heads. Apply Rembrandt Permanent Red Deep, Burnt Umber, Burnt Sienna and Black. Finish the bodies with Derwent Terracotta and Burnt Sienna. To the light areas of the pelicans' heads, apply Rembrandt Burnt Umber, White and Deep Yellow. Add Schmincke Olive Ochre Deep and White. Finally, apply Derwent French Grey and Chocolate. To create the eyes, use Derwent French Grey, Brown Ochre and Chinese White, then Conte Sepia and Black.

On the bills, apply Rembrandt Permanent Red Deep, Permanent Red Light, Raw Sienna, Deep Yellow, Grey and Burnt Umber. Finish the bills with Schmincke Permanent Red 1 Pale and Neutral Grey, then Derwent Chocolate and Deep Cadmium.

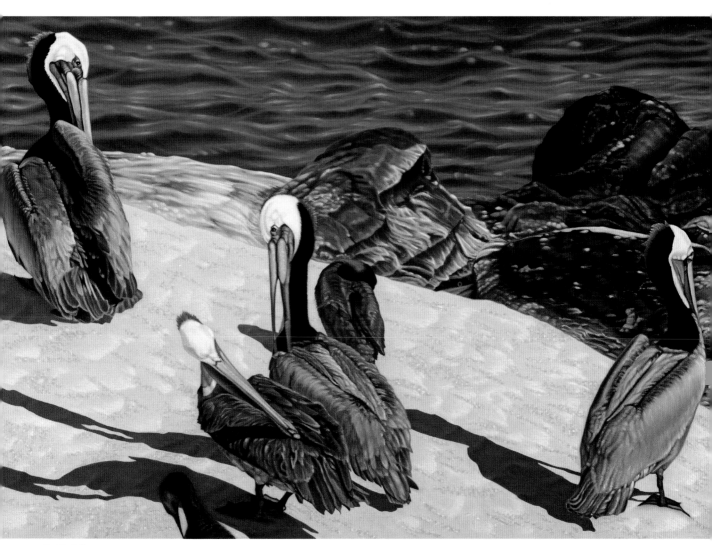

4 finish
Spray with fixative when the drawing is finished.
Spray the surface in a well-ventilated area. Remove the
artist's tape from around the edges of the painting.

Four Pelicans
Norma Auer Adams · Pastel on rag vellum
28" × 42" (71cm × 107cm)

index

learn to paint like the pros with these other fine north light books!

Painting the Elements
Edited by Kelly Messerly
ISBN-13: 978-1-58180-887-2
ISBN-10: 1-58180-887-9
Paperback, 192 pages,
#Z0275

The most dramatic landscapes come to life because of the artist's ability to render atmosphere. Whether it's painting a crisp autumn day or an overcast morning before a storm, *Painting the Elements* provides all the step-by-step instruction you need to accurately portray a wide variety of climates and conditions. Over 25 projects by North Light Books' bestselling authors enable you to learn from a multitude of artistic styles and approaches.

Finding Your Visual Voice
By Dakota Mitchell
with Lee Haroun
ISBN-13: 978-1-58180-807-0
ISBN-10: 1-58180-807-0
Hardcover with spiral binding,
176 pages, #33486

Discover your own individual artistic style! With *Finding Your Visual Voice*, you will learn to recognize your visual preferences and focus your painting efforts thanks to insights from accomplished painters, step-by-step demonstrations and numerous examples. In addition, review and reflect question-and-answer sections at the end of each chapter will help direct you to the style of art you want to create. Learn about the painting process, determine exactly what you want to express through your art and identify specific skills needed to accomplish your goals!

Artist's Digital Photo Reference: Landscapes
Edited by Erin Nevius
Photographs by Gary Greene and Bart Rulon
ISBN-13: 978-1-58180-901-5
ISBN-10: 1-58180-901-8
Hardcover with CD-ROM, 64 pages, #Z0313

Find the inspiration to paint stunning landscapes with *Artist's Digital Photo Reference: Landscapes*. Created by artists for artists, this book/CD-ROM set blends masterful art instruction with a virtual library of more than 1,000 richly detailed images organized into categories such as mountains, oceans, trees and many more. To help you get from photograph to finished painting, this guide features 11 step-by-step painting demonstrations in various mediums. With this must-have tool, you'll learn how to get fantastic results in your work without ever leaving home!

these books and other fine north light titles are available at your local fine art retailer or bookstore or from online suppliers